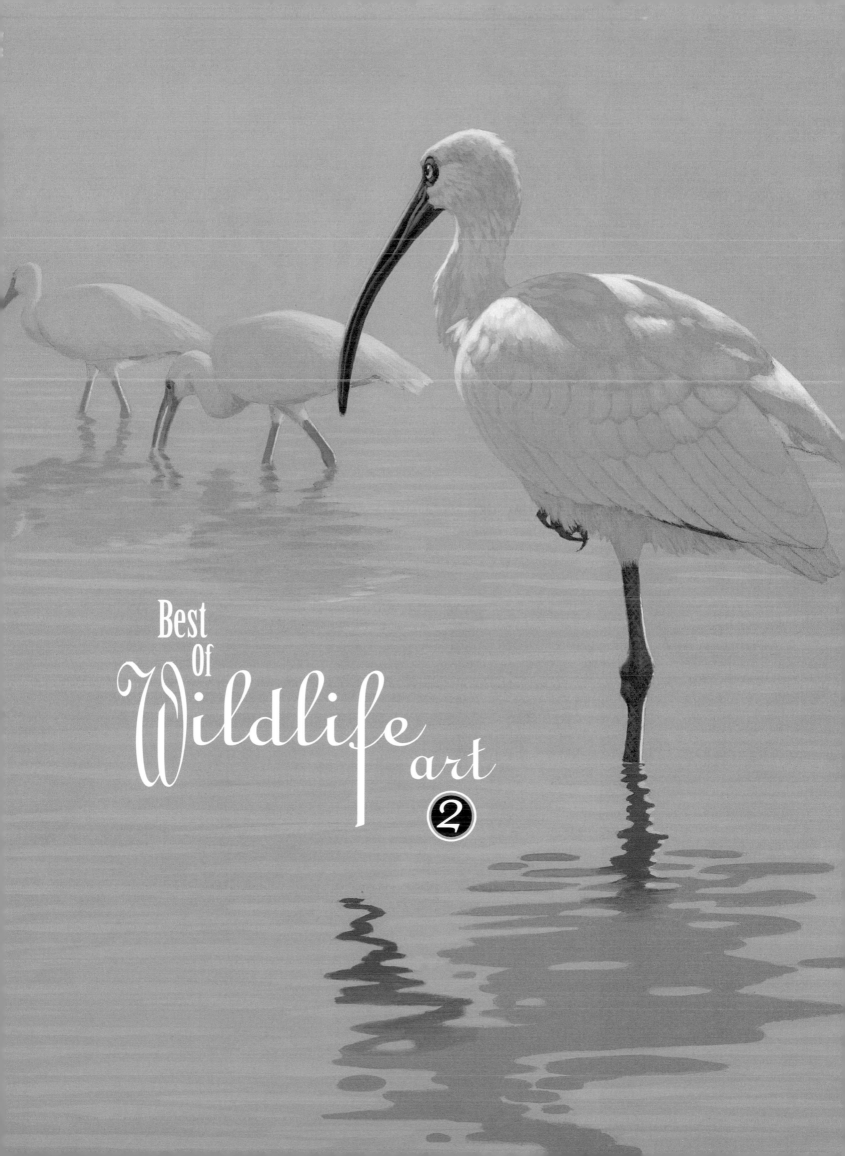

Best
Of
Wildlife
art
2

Best
Of
Wildlife
art
②

NORTH LIGHT BOOKS
CINCINNATI, OHIO
www.nlbooks.com

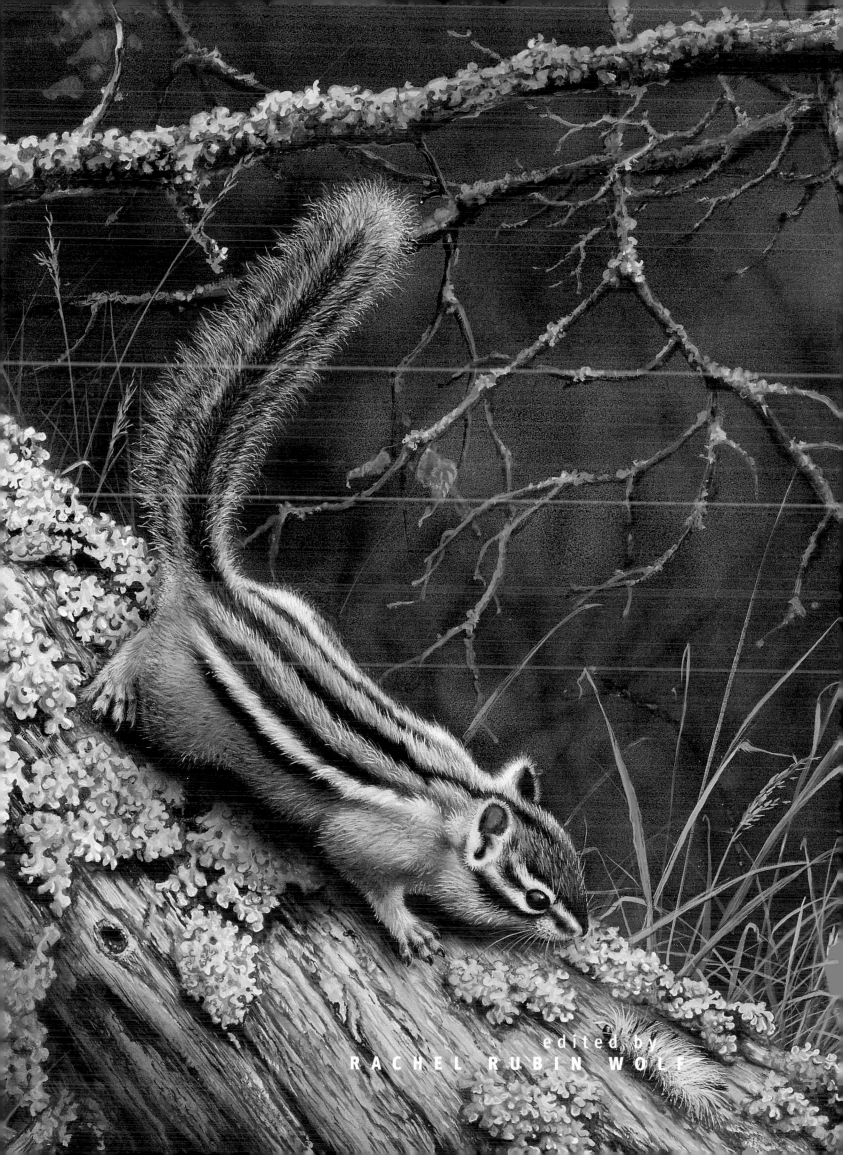

edited by
RACHEL RUBIN WOLF

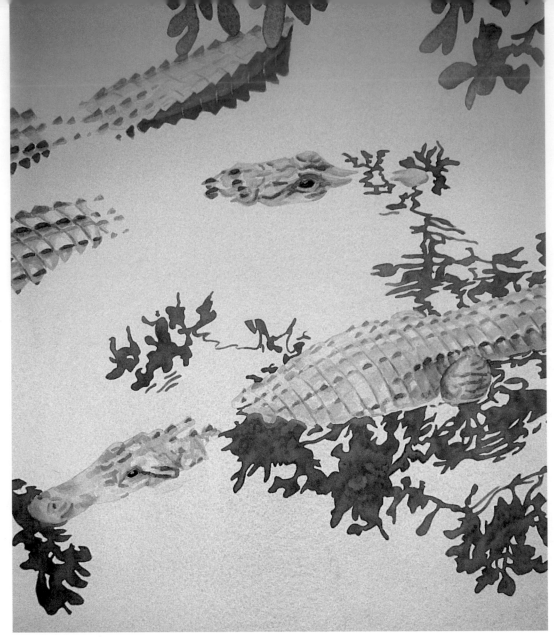

To promote this mirrored effect, I applied many light washes until I achieved the correct value. Using a limited palette helped to unify the painting and make the design the most important element.

—VICTORIA SIMS

(at left)
STILL...THE EVERGLADES (ALLIGATORS)
Victoria Sims, watercolor on Arches 140 lb. watercolor paper, 22" x 15" (56cm x 38cm)

(half title page)
MORNING MIST (WHITE IBIS)
Richard Sloan, acrylic, 12½" x 20" (32cm x 51cm)

(title page)
CHIPMUNK
Harro Maass, gouache, 15" x 22½" (38cm x 57cm)

Best of Wildlife Art 2. Copyright © 1999 by North Light Books. Manufactured in China. All rights reserved. No part of this book may be reproduced in any form or by any electronic or mechanical means including information storage and retrieval systems without permission in writing from the publisher, except by a reviewer, who may quote brief passages in a review. Published by North Light Books, an imprint of F&W Publications, Inc., 1507 Dana Avenue, Cincinnati, Ohio 45207. (800) 289-0963. First edition.

Other fine North Light Books are available from your local bookstore, art supply store or direct from the publisher.

03 02 01 00 99 5 4 3 2 1

Library of Congress Cataloging-in-Publication Data

Best of wildlife art 2 / edited by Rachel Rubin Wolf.—1st ed.
 p. cm.
 Includes index.
 ISBN 0-89134-959-6 (alk. paper)
 1. Wildlife art. I. Rubin Wolf, Rachel, 1951- . II. Title: Best of wildlife art two. III. Title: Wildlife art two.
N7660.B48 1999 99-27122
704.9'432—dc21 CIP

Edited and production edited by Pamela Wissman and Stefanie Laufersweiler
Designed by Stephanie Strang
Production coordinated by Erin Boggs
Cover illustration © Matthew Hillier

The permissions on pages 140-142 constitute an extension of this copyright page.

About The Editor

Rachel Rubin Wolf is a freelance writer and editor with a special interest in wildlife art. She has edited many North Light books, including the *Splash, Basic Techniques* and *Keys to Painting* series; *The Best of Portrait Painting;* and *Best of Flower Painting 2*. Wolf is the author of *The Acrylic Painter's Book of Styles and Techniques; Painting Ships, Shores and the Sea;* and *Painting the Many Moods of Light*. She is also a contributing writer for *Wildlife Art Magazine*. Wolf studied painting and drawing at the Philadelphia College of Art (now University of the Arts) and the Kansas City Art Institute, and received her B.F.A. from Temple University in Philadelphia.

Acknowledgments

Thanks to all of the editors and designers at North Light Books who worked with me on this project, particularly Mary Dacres, Pam Wissman, Stefanie Laufersweiler and Stephanie Strang.

Most of all, thanks to all of the artists who enthusiastically sent in their artwork, including those whose works would not fit in the book. I would also like to extend a special thanks to the artists whose work does appear in this book for your patience and cooperation. Thank you for your "eye for the awesome," bringing us, through your paintings, to some of the most wonderful places and creatures on this earth.

AUSTRALIAN BLUEWINGS
Fred Szatkowski, pastel pencil on Stonehenge paper, 14" x 36" (36cm x 91cm)

The color of these bluewings and the intricate design in their feathering make them irresistible to depict. The surface of Stonehenge paper helps to achieve a soft, natural realism. It forces you not to become carried away with detail and overwork your painting.
—FREDERICK SZATKOWSKI

table of contents

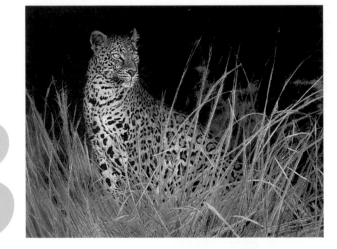

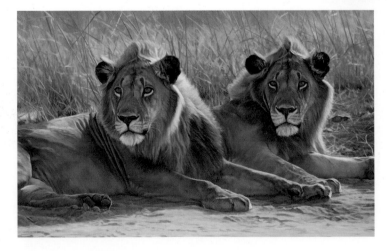

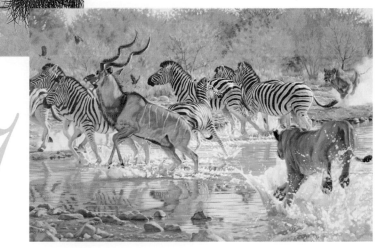

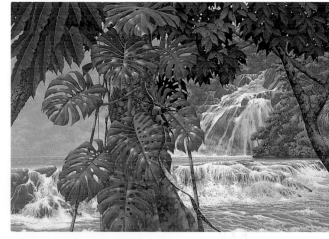

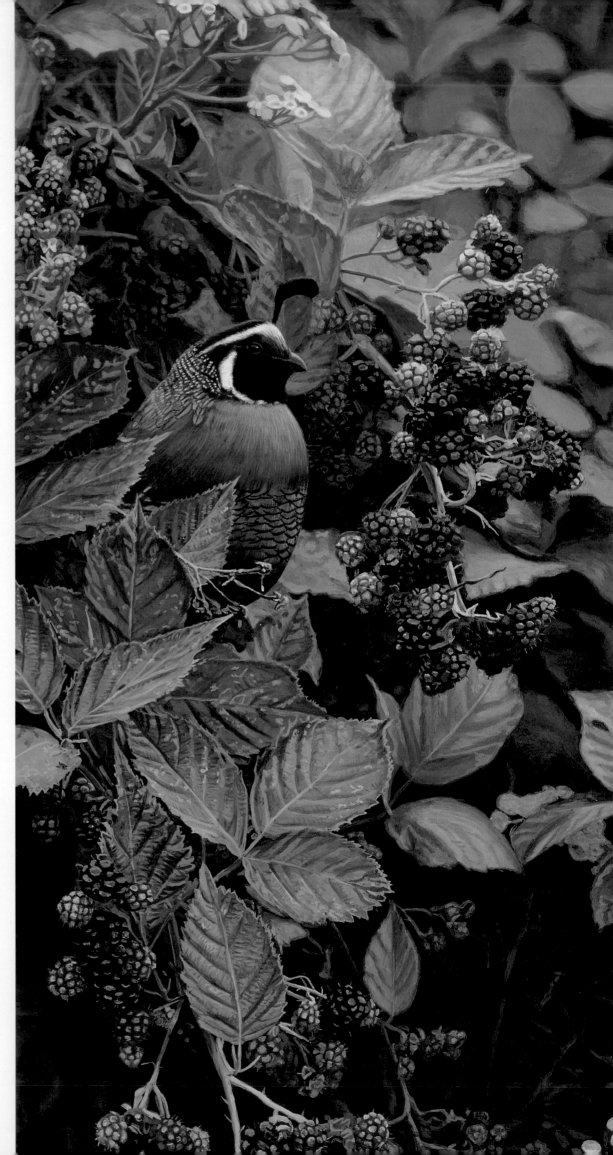

BRAMBLES AND BRASS BUTTONS
(CALIFORNIA QUAIL)
Terry Isaac, acrylic on Masonite,
24" x 9" (61cm x 23cm)

Introduction

Welcome to *Best of Wildlife Art 2*. The response to *The Best of Wildlife Art* (first edition) was very enthusiastic, and I think you will find the same cause for celebration here. The skill and personal investment in these works of art will reach you at both "eye" and "heart" levels.

Art can either reflect the troubles of society, as a way to put before our faces the chaos and ills that the artist observes, or reflect the beauty around us. Though both can have value, I prefer the latter. Beauty can lift our heads above the turmoil around us.

It is this eye for the awesome that sets wildlife art apart and in particular the paintings in this book. Wildlife art has come to mean much more than just a painting of an animal. The wild "life" in these paintings encompasses plants and animals, as well as a spiritual life sensed in the places artists go to gather ideas and reference material. From *The Best of Wildlife Art:* "It is this love for the natural gifts we have been given, and increasingly the fear of losing the same, that is the unifying theme of all of these works of art."

If I can put words into the mouths of these wonderful artists, perhaps they are trying to say to us, "Look, look at the incredible variety of beauty that miraculously exists on this small planet of ours. To appreciate it is to elevate your soul above the daily grind of life. Please join us in keeping it safe, for wild life is the foundation of all biological life on earth." Please read on to elevate your soul.

—Rachel Rubin Wolf

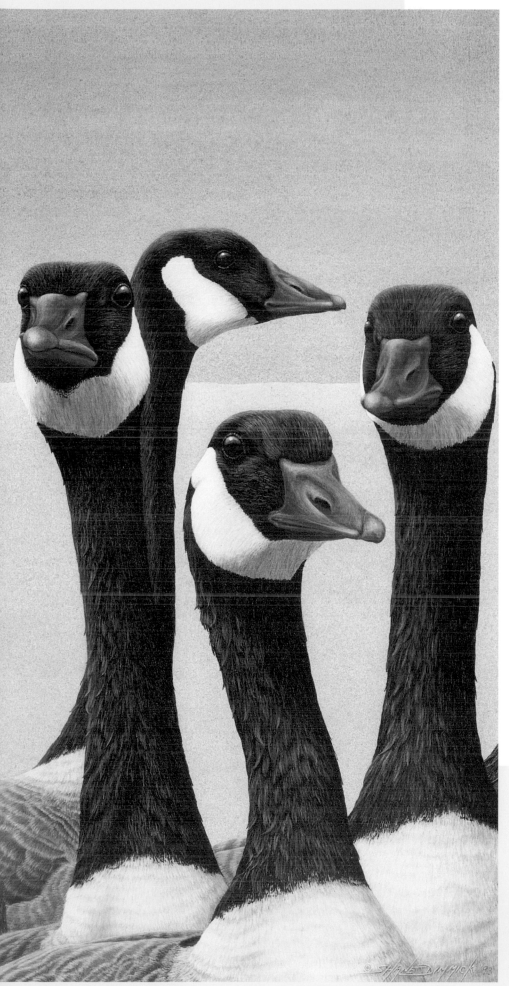

DEVELOP A
Unique Design Concept

The paintings in this chapter, whatever the subject, are built around unusual or interesting design concepts.

While generally viewed as one large group, closer inspection reveals that individuals comprise a flock or gaggle of Canada geese. In *Gaggle*, the geese are first seen as one flowing, dynamic unit from which the viewer then singles out individuals. Aware of an intruder, the geese all react but with different levels of caution, curiosity and indifference. The simple horizon emphasizes the horizontal lines of the geese's heads and bodies while balancing the vertical lines of their necks.

—SHANE DIMMICK

GAGGLE (CANADA GEESE)
acrylic on rag illustration board, 16" x 22 ¼" (41cm x 57cm)

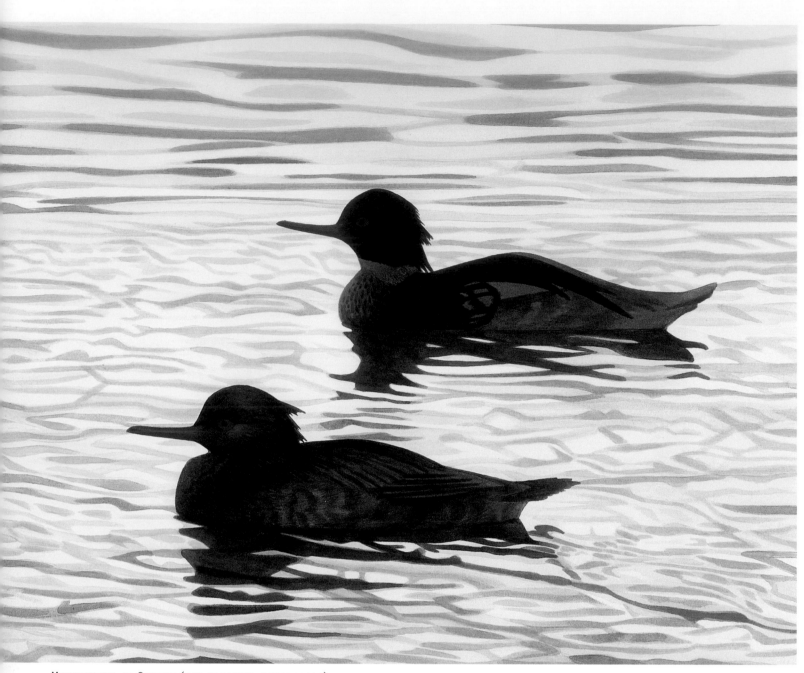

MERGANSERS AT SUNSET (RED-BREASTED MERGANSERS)
watercolor on museum board, 15" x 19" (38cm x 48cm)

Thomas Anderson

SHOW STRONG SHAPES
AGAINST WATER PATTERNS

The important design considerations here are light, color, patterns and shapes. The water reflects the bright yellow-white light of the setting sun; some blue of the sky; and the warm shadows of the birds and shoreline, providing a minimal range of color. The bright backlighting and minimal color simplify elements enough to find a pattern that captures the movement of light on water and weaves an abstraction across the board. The setting sun has made almost complete silhouettes of the mergansers. Their reflections help weave the birds into the surface of the water. The clear light, limited color, varied water patterns and strong silhouettes create a sense of drama.

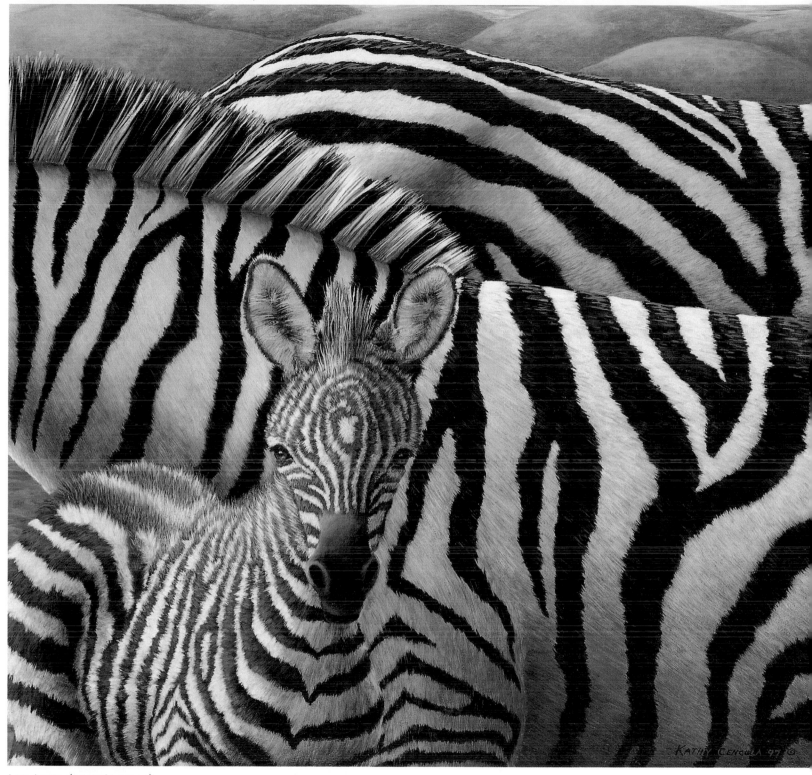

LIFE LINES (GRANT'S ZEBRA)
acrylic on Masonite, 17" x 18" (43cm x 46cm)

Kathy Cencula

FOCUS ON THE PURE BEAUTY OF NATURE'S DESIGN

The black-and-white patterns of the zebra have always attracted me. For the stripe pattern to remain the primary focus, I have removed the head interest of all but the foal, whose direct gaze adds emotion to the design. The background hills repeat the form of the zebra's rump and add softness to the design.

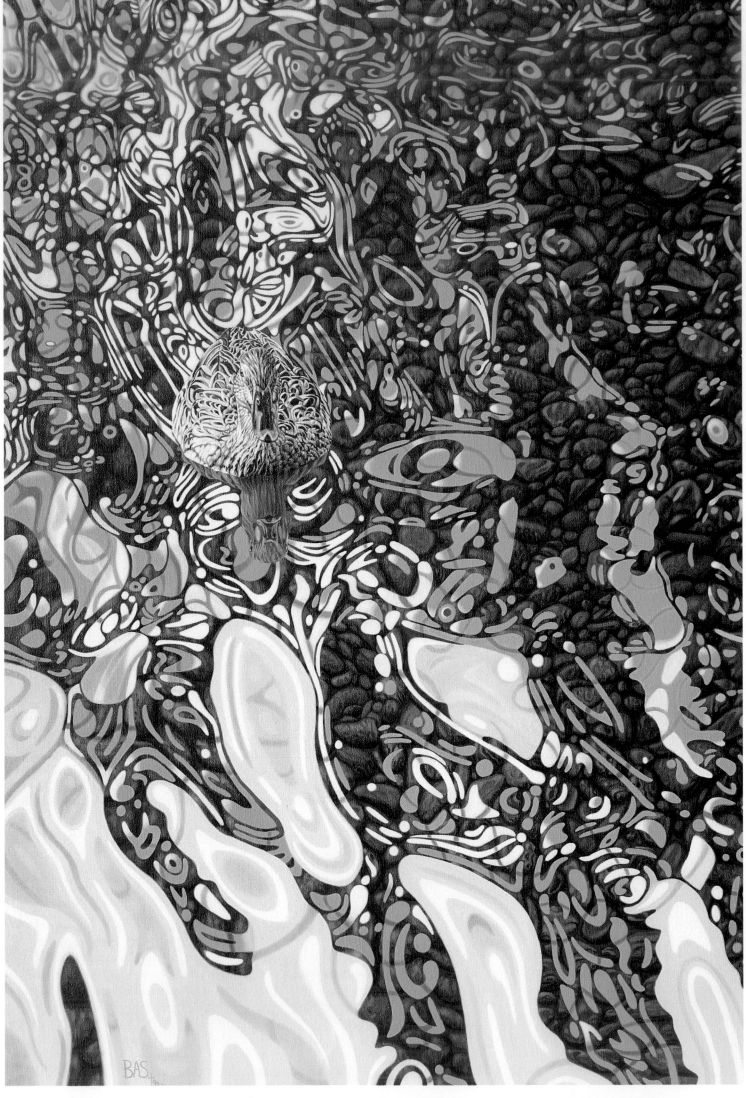

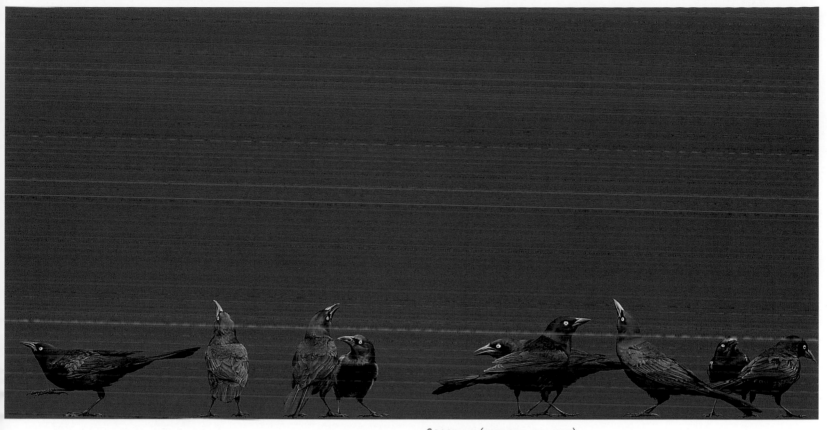

GRACKLES (COMMON GRACKLE)
acrylic on canvas, 29" x 53" (74cm x 135cm)

Mark Eberhard

PLACE INTERESTING SHAPES AGAINST A FLAT BACKGROUND

Every spring, on their migration north, grackles stop at my feeder for a couple of weeks. This year—having found a free lunch—they never left. I decided to take advantage of their extended stay because I find them visually interesting, with their elongated shapes, their habit of pointing their heads upward and their ever-changing iridescent quality. I photographed them from a blind I set up next to the feeder. From my photos, I did drawings of the grackles in a variety of positions, then scanned these drawings into the computer. In a short period of time, I was able to experiment with an infinite number of arrangements—combinations of rhythms and shapes. Since the focus of the painting was the visual relationships between the grackles, I left the background plain. Its color is the result of experimentation, again on the computer, with different colors found in the iridescent feathers. Another element of the painting, which is not evident in this reproduction, is the treatment of this iridescence. I used Golden acrylic interference colors painted on top of the normal acrylic colors. The interference colors react to light just as the real feathers do.

BAS

CONTRAST OPAQUE AND TRANSPARENT FORMS

The duck glides gently through the clear shallows, through which the pebbled riverbed is visible. Light plays across the dancing surface of the river, creating rhythmic abstract forms. The design concept is based on the contrast of "opaque" reflections and transparent elements in the painting. I set the "opaque" water that reflects the sky against the transparent water showing the underlying riverbed. Abstract shapes attract the eye through the painting, leading to the mallard and accentuating the water's uneven surface. I applied paint wet in wet *(alla prima)*, allowing for easy blending of the water forms and pebbled riverbed. Then I applied a single glaze over the pebbled areas to create more depth in the painting.

FEATHER AND FORM (MALLARD DUCK)
oil on canvas, 30" x 20" (76cm x 51cm)

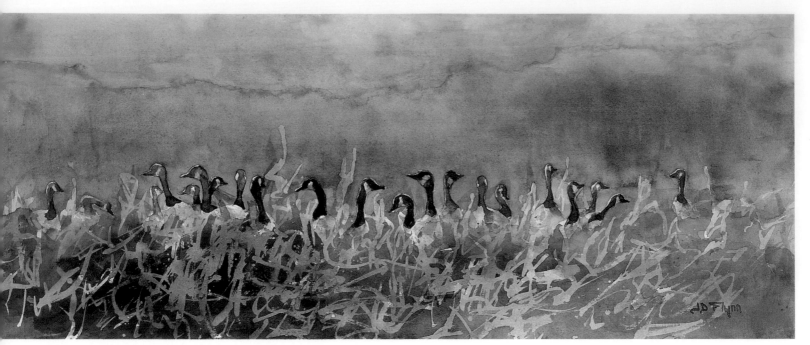

HEADS UP (CANADA GEESE)
transparent watercolor on Fabriano Artistico paper, 12" x 30" (30cm x 76cm)

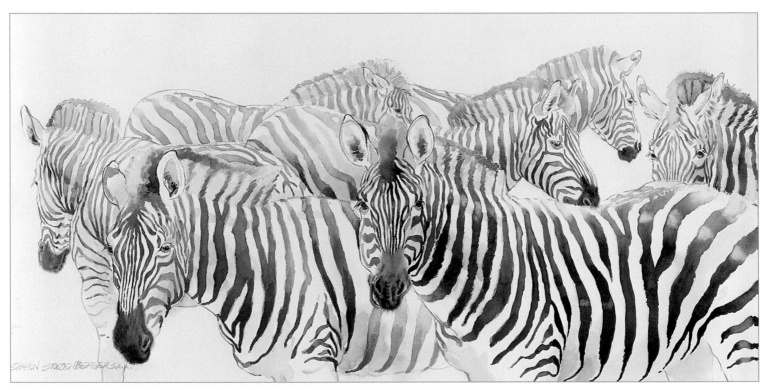

VIBRATIONS (GRANT'S ZEBRAS)
transparent watercolor on 140 lb.
Arches watercolor paper, 18" x 30"
(46cm x 76cm)

Sharon Stolzenberger

ADD PIZZAZZ WITH UNUSUAL COLORS

I love painting zebras in nontraditional colors such as blues, purples and browns. These add pizzazz to the subjects, contributes a lively bounce of light that enhances their forms and gives the viewer a fresh point of view to consider. I love watercolor for its loose and spontaneous characteristics. I work mainly with the wet-in-wet technique. In *Vibrations* I first put in the shadows to indicate body mass, then painted the muzzles, all while the paper was moist. I painted the stripes while the paper was damp but dry enough to hold hard edges.

Janet Flynn

During autumn in Wisconsin, the Canada geese stop in the harvested fields and animate this beautiful landscape. In this piece I wanted the viewer to smell autumn in the air and hear the chatter among the geese, who are lost behind a golden field except for their necks and heads. I particularly wanted to capture the layers of textured grasses, as well as the geese's necks and heads, with a softened outline of Baraboo Hills in the distance. I created the texture of the foreground foliage and detail for the geese with the aid of a masking fluid applied to different areas at various stages of layering in watercolor washes.

Diane Burns

DESIGN ON IMPERFECT SYMMETRY

Pas de Deux, meaning "dance for two," is a term typically used in ballet. I chose two opposing poses to create a sort of symmetry. The negative space supports the posture of the two birds preening and displaying an array of colorful feathers. The subject here is actually just one macaw who, as I circled him to photograph his many sides, was quite the exhibitionist, fluffing and grooming like a narcissistic prima donna while I clicked away. I created this batik on a soft-weave silk that allows fine detail, as shown in the feathers. In batik, the artist adds colors (cold water dyes) one at a time. She masks out areas with a brushed application of melted paraffin and beeswax before dipping the fabric into the next color—the lightest color first, working gradually to the darkest. She removes the wax at the end of the process with a hot iron applied to the finished batik, which is sandwiched between layers of paper toweling.

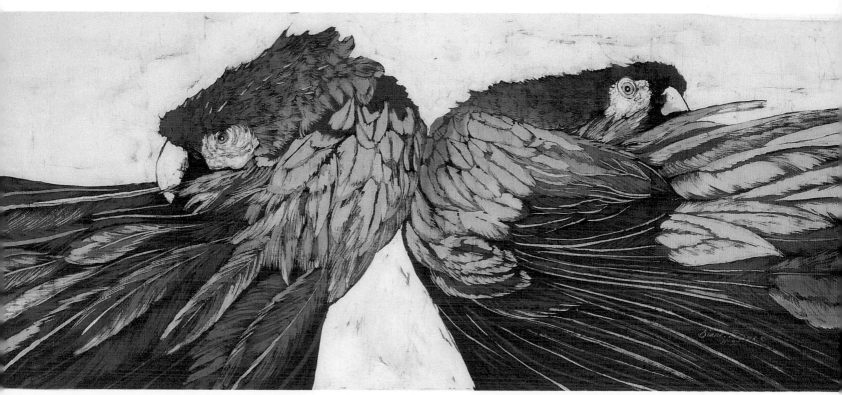

PAS DE DEUX (RED MACAWS)
batik on silk, 14" x 32" (36cm x 81cm)

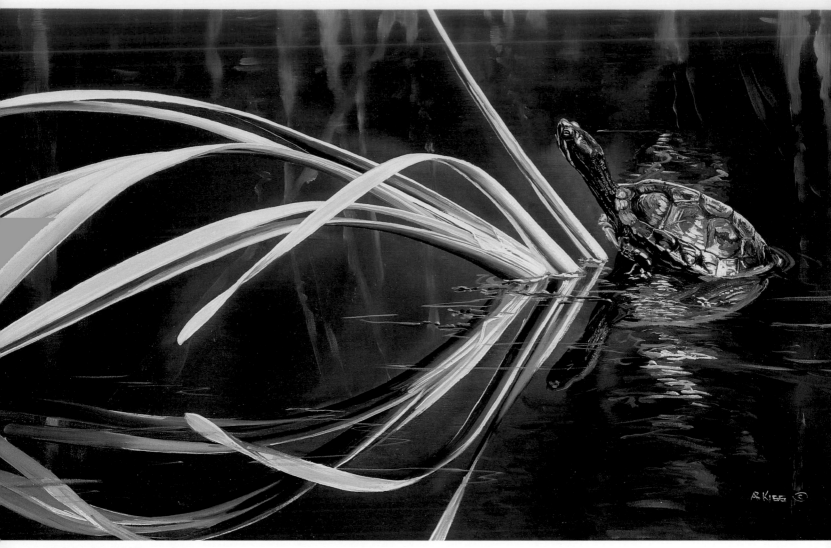

SLIDER (TURTLE)
oil on canvas, 14" x 20" (36cm x 51cm)

Andrew Kiss

ELEMENTS LIKE REEDS ALLOW LINEAR DESIGN

I discovered a number of these wonderful creatures in a bog in southern British Columbia. They were sunning themselves on rocks and logs. Any disturbance by me made them slide into the black water. I waited patiently as one reappeared, stretching its neck to see if the coast was clear. The placement of the reeds allows eye movement through and out of the composition. The water, being quite dark, makes the reeds stand out and helps to camouflage the turtle. Not placing the turtle in the center helps to create wonderful movement and space. I use oil paint on a very finely woven cotton canvas to achieve an effect almost like watercolor. I sketch subjects directly on the canvas, undercoat with basic colors and then work in detail.

John Cody

ENLARGE YOUR SUBJECT FOR DOMINANCE

I was stunned by my first view of this huge moth, an inhabitant of the slopes of Mount Kinabalu. I wanted to emphasize the stream-lined design of the animal in my painting; its unique, marvelously proportioned shape. I greatly enlarged it, letting it dominate the space, and provided a single, simple leaf as a perch. When one observes a moth close up, the tangled rain forest background is a kaleidoscopic blur. I wanted to suggest this. A pencil outline came first. I covered the subject (moth and leaf) with masking fluid. This freed me to go wild with the negative space around the subject. I began with foundation glazes of warm Sepia. In soup bowls, I prepared dark solutions of Neutral Tint and Van Dyke Brown. I sprayed the dry painting, covering it with discrete beads of water. I then dumped on the two colors simultaneously. The neutral tint, dashed into the center, produced interesting tendrils, avoiding the dry spots. I moistened the paper again and dribbled a few drops of various greens, thereby creating an impressionistic jungle ambiance. Once it was dry, I peeled off the masking fluid, then painted the leaf and the moth, using a fresh leaf and a live moth, recently emerged from its cocoon, as models.

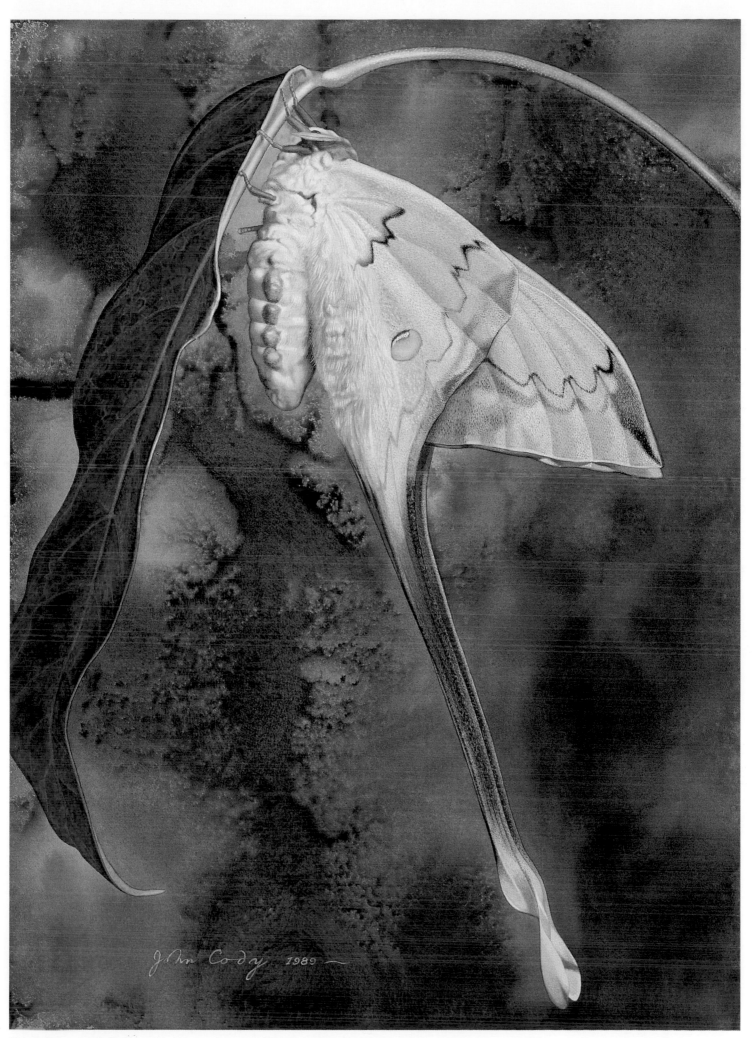

MOON MOTH OF BORNEO
transparent watercolor on Arches 300 lb. cold-pressed watercolor paper, 30" x 22" (76cm x 56cm)

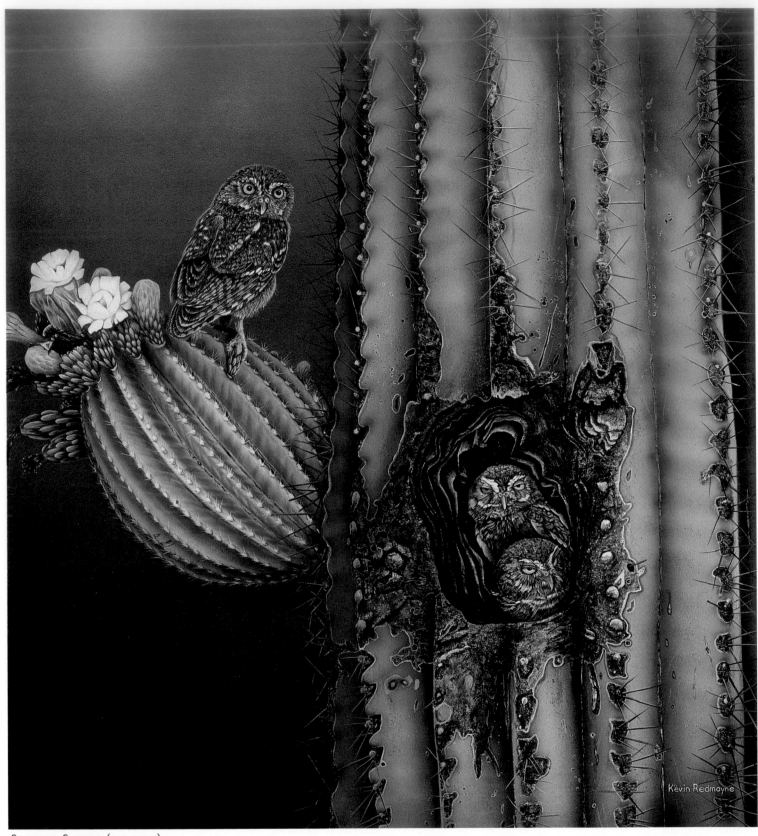

SONORAN SUNSET (ELF OWLS)
mixed media on watercolor board, 22" x 20"
(56cm x 51cm)

Kevin Redmayne

ESTABLISH A FOUNDATION OF PRIMARY SHAPES

I paint for realism, but primary abstract shapes are the foundation for my work. The flowers of the saguaro cactus add interest to this overall design, and also establish the diminutive size of these smallest of all owls by comparison. The warm, ambient light of sunset unites the painting, creating an overall feeling of harmony. However, rather than create a subdued, backlit painting, I introduced an artificial light source from the lower right, to keep the focus on those wonderful elf owls.

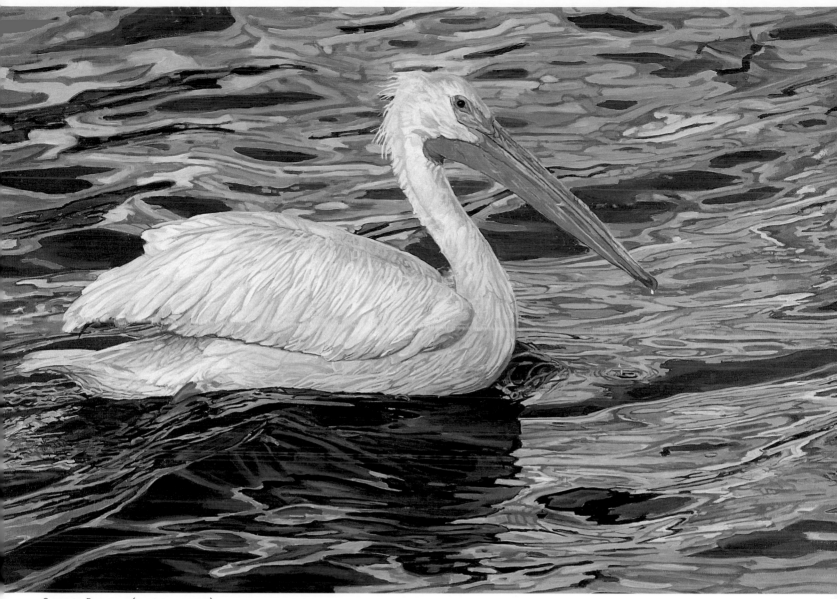

SUNSET PELICAN (WHITE PELICAN)
oil on Belgian linen canvas, 28" x 42" (71cm x 107cm)

Mary Louise O'Sullivan

FREEZE THE DESIGNS OF WATER

I love the abstract designs of water stopped by using a camera at a very high speed. The ribbons of colored water are in striking contrast to the pale, luminous white pelican. I chose the location and time of day very carefully. I wanted the sun to be setting just at the time a certain fish boat returned to dock. At that time we could count on pelicans coming in from the Pelican Island National Refuge for scraps. The fish boat always comes at five, but the sunset varies. Too early, and the water and white bird are too bright; later and they are too dark. There is about a two-week window of opportunity, and it is usually very cold. I work on a canvas primed with colored gesso—in this instance a soft gray. The middle-toned underpainting makes the white bird particularly vibrant, giving a punch and unity to the whole work. I start with thinner, softer mixes and use thick pigments only at the end to brighten it up.

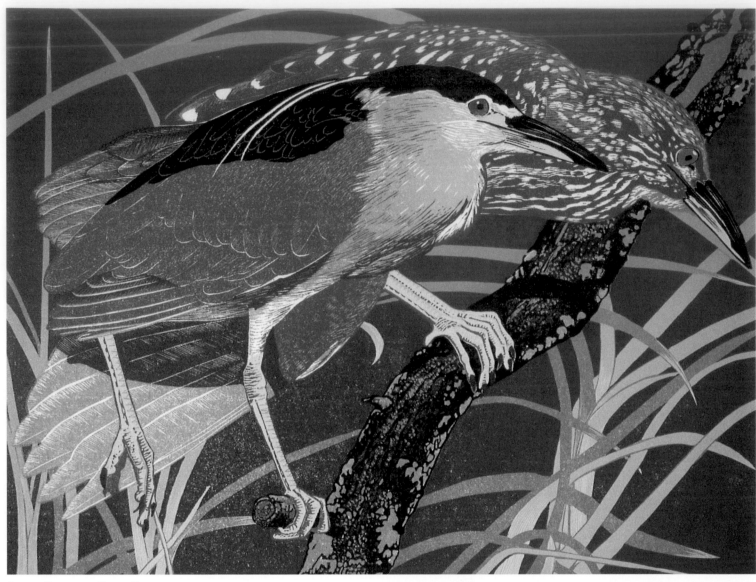

BLACK-CROWNED NIGHT HERON
woodcut print on Kozo paper, 12" x 16" (30cm x 41cm)

Andrea Rich

WILDLIFE DESIGNS IN WOODCUT PRINTS

This print shows the elegant plumage of the black-crowned night heron, as well as the contrast between its immature and mature coloring. The birds fill the frame; I have included just a few reeds in the background to help direct the eye around the image. There is a pond near the beach in Santa Barbara, California, where the herons roost at night and where I have often observed them. It was only after trying to find the immature birds in my field guide that I realized they are the same species as the striking black-and-white adults.

The characteristic marking of the pileated woodpecker can give it an unusual, flat, cartoon-like appearance. I gave the image depth with several layers of highly textured trees. The contrasting shaded and flat leaves complement the fairly flat silhouette of the woodpecker. The purples on the trunks keep the print rich and lively.

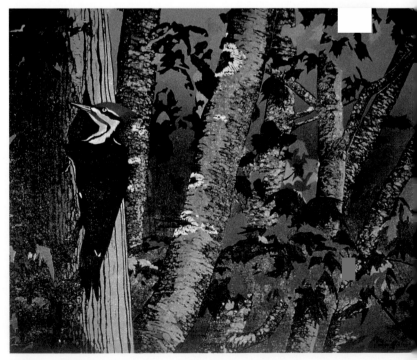

PILEATED WOODPECKER
woodcut print on Kozo paper, 16" x 20" (41cm x 51cm)

Joe Garcia

Many times an artist will overlook a possible painting scene because it is not dramatic or obvious. I had often passed this setting before I saw a painting in it. I used an unusual vertical format to bring drama to the design and composition, an important aspect of which is the use of opposites: value and color; turtles facing right with coot looking left; and turtles grouped together while the bird stands alone. I used glazes to create many colors and value changes. Scrubbing and lifting helped create the highlights on the turtles. The success of the painting depended on getting all these elements to work together.

ODD MAN OUT (AMERICAN COOT AND TURTLES)
watercolor on 300 lb. Arches watercolor paper,
28" x 10 ½" (71cm x 27cm)

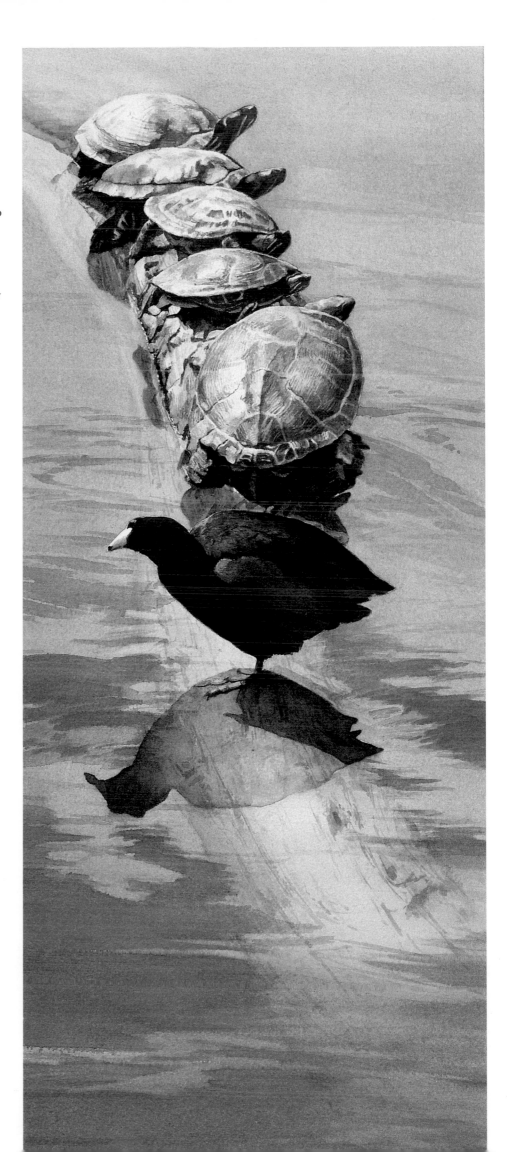

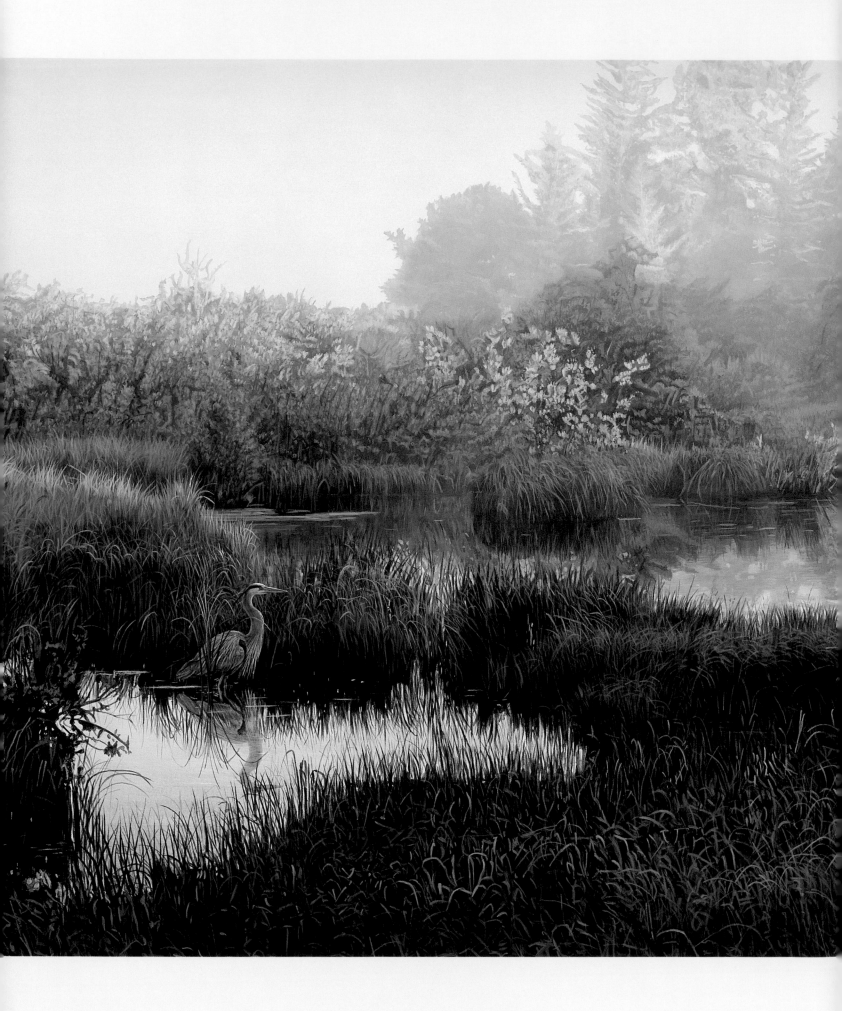

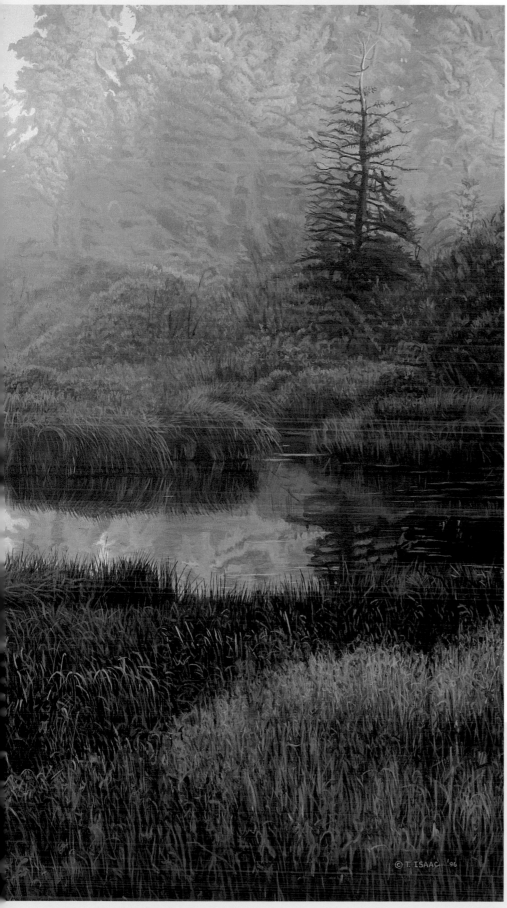

CONVEY A
Particular Mood

The paintings in this chapter convey a particular mood or feeling beyond their literal subject. The environment, the lighting or the attitude of the animal may express this mood.

A natural wetland just after sunrise is a complete experience of sight, sound, scent and touch. The heron is solitary, waiting and watching, with its plumage echoing the various colors of the water. Mist, veiled light, green marsh and woods compose a beautiful, reflective image. A fragile world such as this, too often threatened by development, must be kept safe.
—TERRY ISAAC

MORNING MARSH (GREAT BLUE HERON)
acrylic on Masonite, 19 ¼" x 30" (49cm x 76cm)

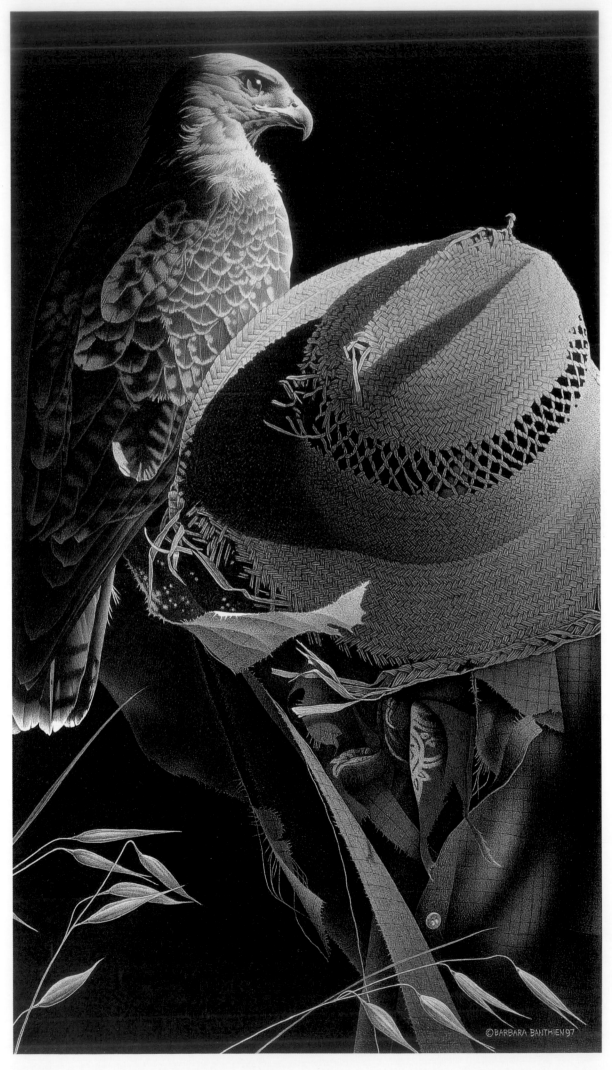

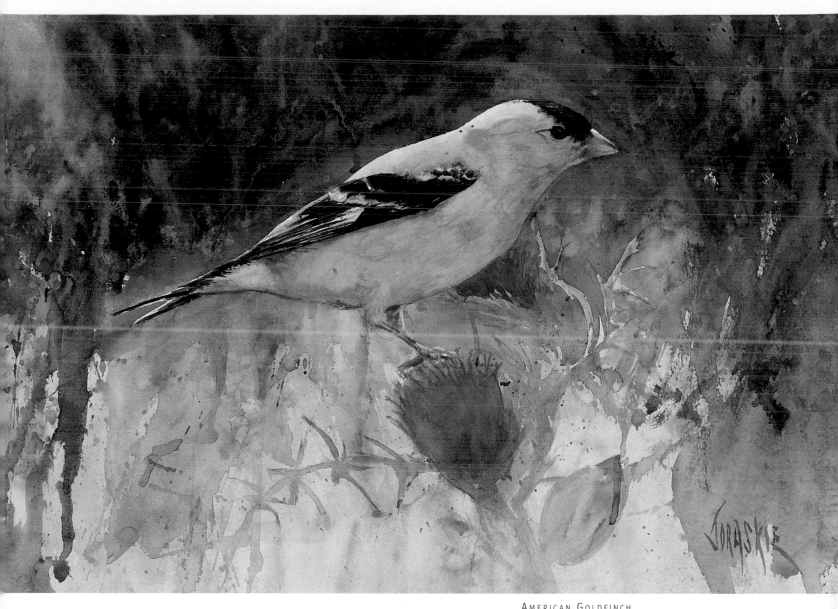

American Goldfinch
watercolor on Waterford paper, 14" x 21 ½" (36cm x 55cm)

Lisa Joraskie

LET YOUR SUBJECT EMERGE FROM A LOOSE BACKGROUND

Establishing a mood is one of the main objectives of my watercolors. If I stir an emotion in the viewer, I have done my job. In this painting, the paint dissolves into drips and splashes as the American goldfinch emerges from a dark, abstract Sap Green mixture. The color and brightness of the thistle complement the background and set the bird in an environment. The play of sunlight and shadow, along with the increased blurring of detail as the viewer's eye moves down the work from the bird, help create atmosphere.

Barbara Banthien

A SYMBOL OF NOBILITY AMIDST EMPTINESS

I had been working for a while on the concept of a very noble animal set amid worn-down and crumbling human elements. I perched the regal red-tailed hawk on a bedraggled scarecrow that's long past its usefulness. The weeds in the foreground indicate this field no longer produces anything sustaining; but the hawk endures. As I worked on this painting, the sky changed color, from golden to rust to near night; and the shadows lengthened so that the scarecrow almost disappeared. Only then did the mood of stark isolation and emptiness begin to work. I paint with gouache, working in small sections, building up layer after layer of pigment to get deep darks. Although this is a very time-consuming process, the richness and suppleness of the medium are worth the effort.

October (red-tailed hawk)
gouache on rag board, 22" x 13" (56cm x 33cm)

LEYBURN RUN (RED FOXES)
oil on canvas, 24" x 36" (61cm x 91cm)

Lanford Monroe

FOXES HELP CONVEY EXUBERANCE

Leyburn Run is essentially a painting of a wonderful morning—one of many spent in the Yorkshire countryside of England. The sun rises on this moist, lush landscape and coats everything in a buttery golden light, making it impossible not to feel good. The addition of the bounding foxes helps to convey the sense of exuberance.

Lanford Monroe

A MUTED PALETTE PRODUCES
A SENSE OF STILLNESS

I usually start with a landscape, deciding what mood I want to express about that place, then decide what animal would best convey that feeling. *Ghosts* began with an early morning of animal watching in Yellowstone National Park. I soon became fascinated by the water patterns in a marshy field and by the total stillness in the mist. The scene held great mystery and the idea to "people" it with coyotes, a pretty magical animal at any time, seemed natural. I kept to a very limited, muted color and value range to accentuate the "vanishing" quality of the coyotes. It is amazing how many viewers never see the pair of coyotes until someone calls it to their attention, even though they are relatively large in the composition.

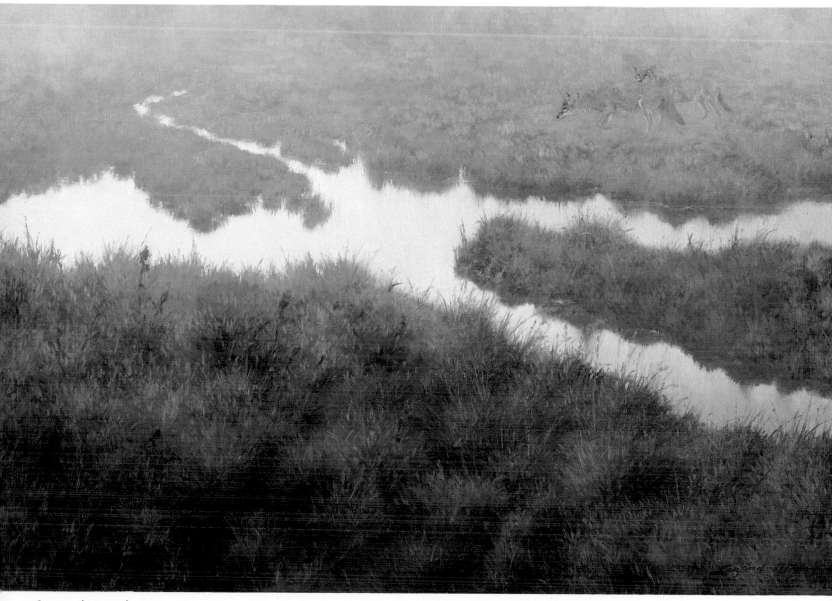

GHOSTS (COYOTES)
oil on canvas, 24" x 36" (61cm x 91cm)

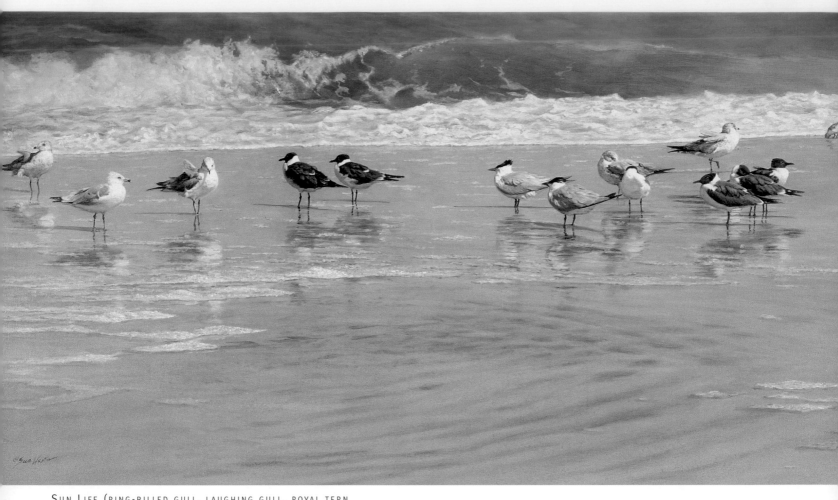

SUN LIFE (RING-BILLED GULL, LAUGHING GULL, ROYAL TERN
AND SANDERLING)
oil on linen canvas, 36" x 67" (91cm x 170cm)

Sue Westin

BIRD POSTURES REVEAL PEACEFULNESS

When I watch a gathering of birds such as these, I see more than
birds. I see life—the steady yet changing movement of waves, the
shifting flow of the tide, the lift of feathers as the breeze catches one
here and another there. The interaction of colors and the reflection
of coral on the birds' bellies lend the feeling of sunlight. I create
much of the mood with subtle postures, as birds in various stages of
wakefulness interact with one another and with their surroundings.
Because the birds are not all facing the same direction and do not
appear to be on the verge of flight, their body attitudes give the feel-
ing that all is well with the world. The ring-billed gull at far left and
the small, feeding sanderling at far right balance the composition
and add to the sensation that what the viewer observes continues
beyond the edges of the painting.

Daniel Smith

EXPERIENCE YOUR SETTING FIRSTHAND

Ancient Mariners glide through the pristine waters
of the Pacific Northwest as the sun struggles to
penetrate low-hanging clouds. Mood has always
been a primary focus in my art, and the best way
to capture the feeling of a setting is by experienc-
ing it firsthand. I have studied orca whales in their
natural environment in the Pacific Northwest. I
have also spent many hours studying them up
close at Sea World. The research is always enjoy-
able and pays great dividends in the finished prod-
uct. I found this painting challenging to compose
in a vertical format. I kept the pod tightly grouped
and overlapped the massive dorsal fins to better fit
the shape of the painting. The wedge of landscape
and cloud formations echoes the shape of the fins,
helping the flow of the composition. I partially
rendered the cloud formations with an airbrush—
a great tool for creating soft edges and smooth gra-
dations in acrylics.

ANCIENT MARINERS (ORCA WHALES)
acrylic on Masonite, 30" x 18" (76cm x 46cm)

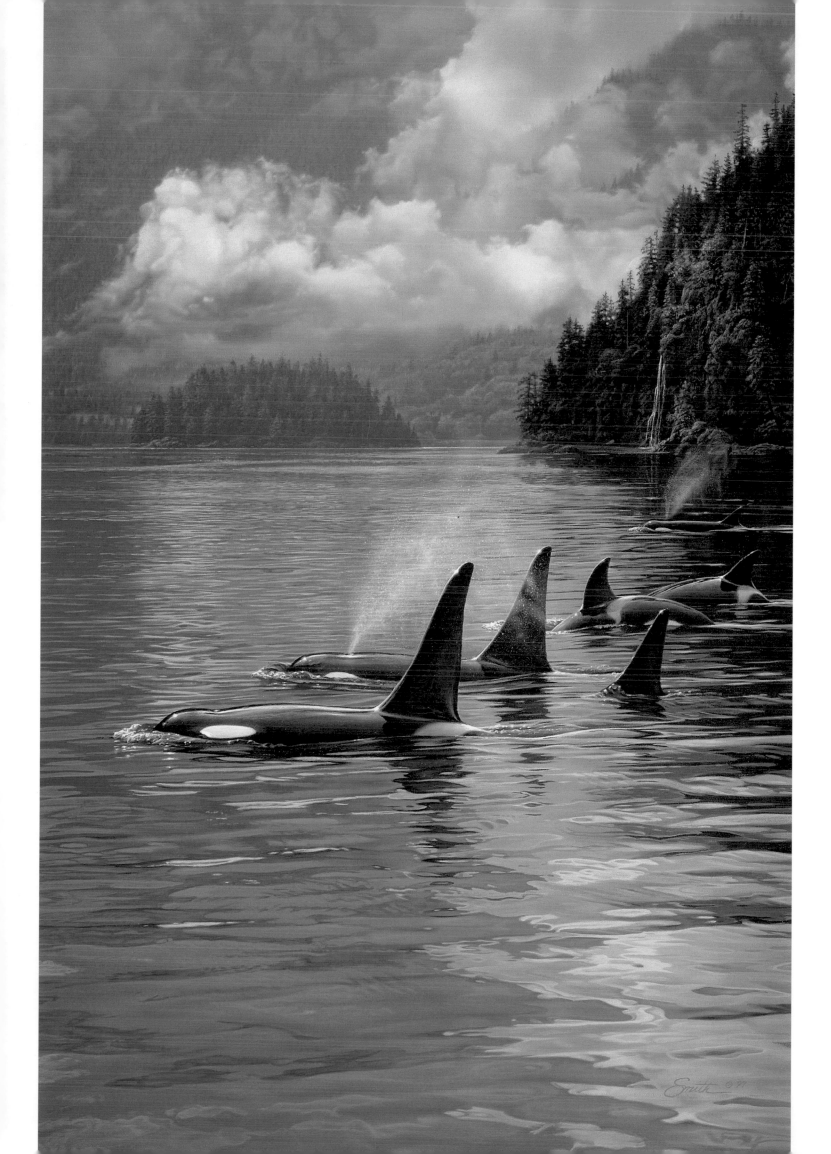

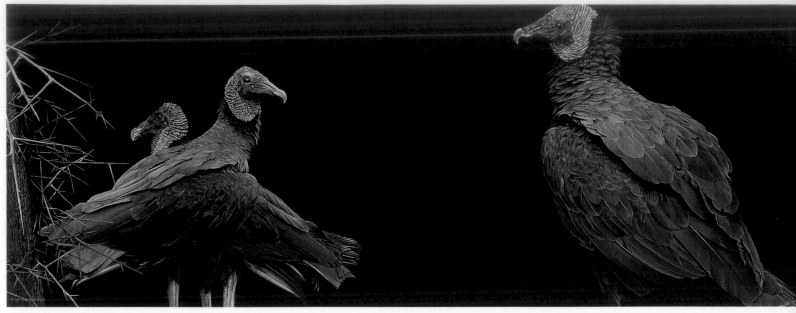

JUDGE NOT (BLACK VULTURE)
acrylic on canvas, 20" x 54" (51cm x 137cm)

Mark Eberhard

EMPHASIZE UNEXPECTED BEAUTY

I observed these black vultures while they were feasting on the remains of an alligator in Everglades National Park. I wanted to portray them not as ugly, repulsive and threatening, but as beautiful birds with an important role in the balance of nature. I achieved this by emphasizing the beauty of their feathers. I placed the birds on a black background to dramatize their feathers and contribute to the mystery surrounding this species. I started with the background and worked forward. When painting feathers, I paint one at a time, starting with the middle value, then going to the darkest and working forward to the lightest.

Ulco Glimmerveen

FOR MYSTERY, KEEP DETAILS VAGUE

My challenge was to create an atmosphere of tranquillity and mystery. Nature and animals fascinate me, as do remnants of old cultures, which I have often explored during my travels. Perhaps it is a romantic longing for an unreachable world. Overgrown, decaying pillars, mosaic floors and statues; these are what remain of ancient Roman, Greek and Middle Eastern architecture and art. They are part of a rich heritage and exude a certain mystery. What was life like in those days? Wildlife, at least, must have been extremely plentiful back then. In the technique of the English painter Joseph Mallard William Turner (1775-1851), but using alkyd medium with my oils, I work in layers of light and medium-toned glazes, with some opaque layers to get the hazy effect. Glazing, rubbing out, adding, glazing, adding, rubbing out, adding, etc., I work towards a subtle mix of detail and vagueness. I strive for an image with room for interpretation—a landscape that I would like to enter and explore, in which not all is immediately clear. So I do not paint details, but suggestive shapes. The egrets, kept in low profile, blend in with environment and the light, so they do not absorb all of the viewer's attention.

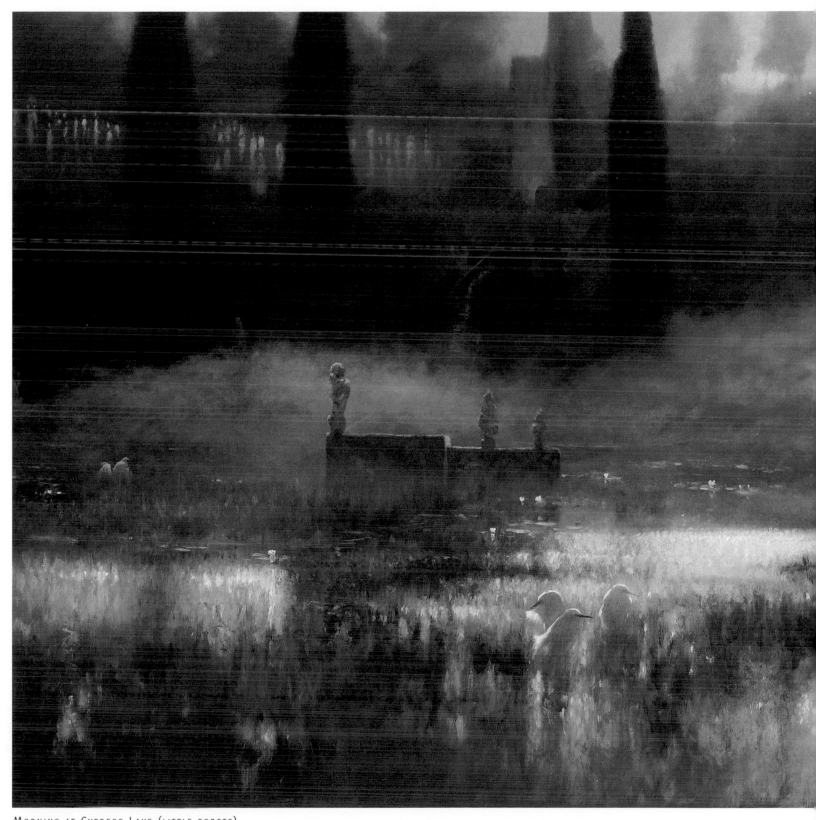

MORNING AT CYPRESS LAKE (LITTLE EGRETS)
oil on Masonite, 22" x 28" (56cm x 71cm)

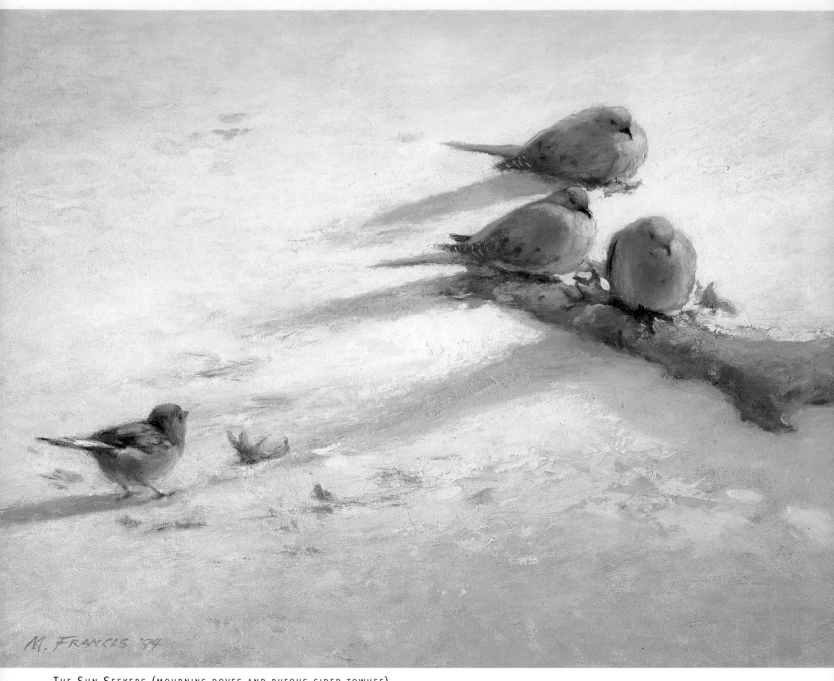

THE SUN SEEKERS (MOURNING DOVES AND RUFOUS-SIDED TOWHEE)
oil on gessoed Masonite, 12" x 16" (30cm x 41cm)

Margaret Francis

WARM SUNLIGHT ON COOL SNOW

An unusual snow and sleet storm prompted my resident mourning doves to seek the comfort of a sunlit tree root for a snooze. I resisted painting the bright, sweet gum leaves which littered the actual scene so that they would not compete with the subtly colored doves. Of the other birds present, I did include the rufous-sided towhee as a useful lead-in. I underpainted light and shadows to represent warm sunlight on cool snow without falling into the artificial look of over-exaggerated color. Then I scattered short strokes of warm over cool and vice versa, in matching values, varying hues.

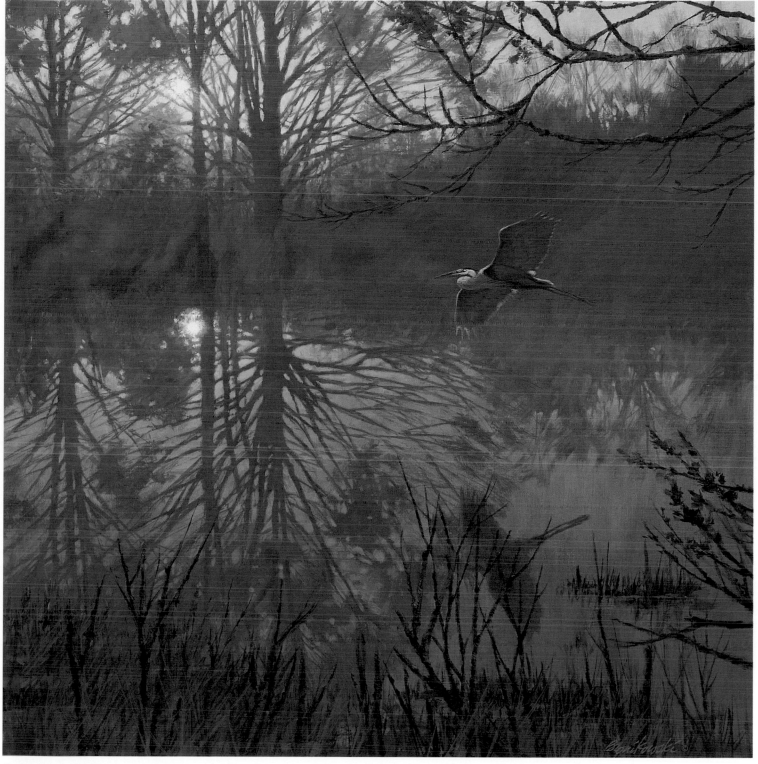

GREAT BLUE HERON
acrylic on board, 18" x 18" (46cm x 46cm)

Kenneth H. Bronikowski

USE A FAMILY COLOR FOR A HARMONIOUS MOOD

One morning a great blue heron landed within forty feet of me and began to hunt while I stood still under the canopy of our pontoon boat. As he stalked the shoreline I saw him catch a dragonfly in midflight with one swift snap of his beak. His speed and accuracy were amazing. With a few strokes of his enormous wings, he became airborne (the flight I am depicting here) and flew effortlessly to a new location. I start with what I call a "family color"—red, in this case. As I paint, I am careful to control values by squinting, and I use drybrush for edges. When I mix various colors, I continue to blend a little red into each mixture, which gives the painting color harmony throughout, from start to finish.

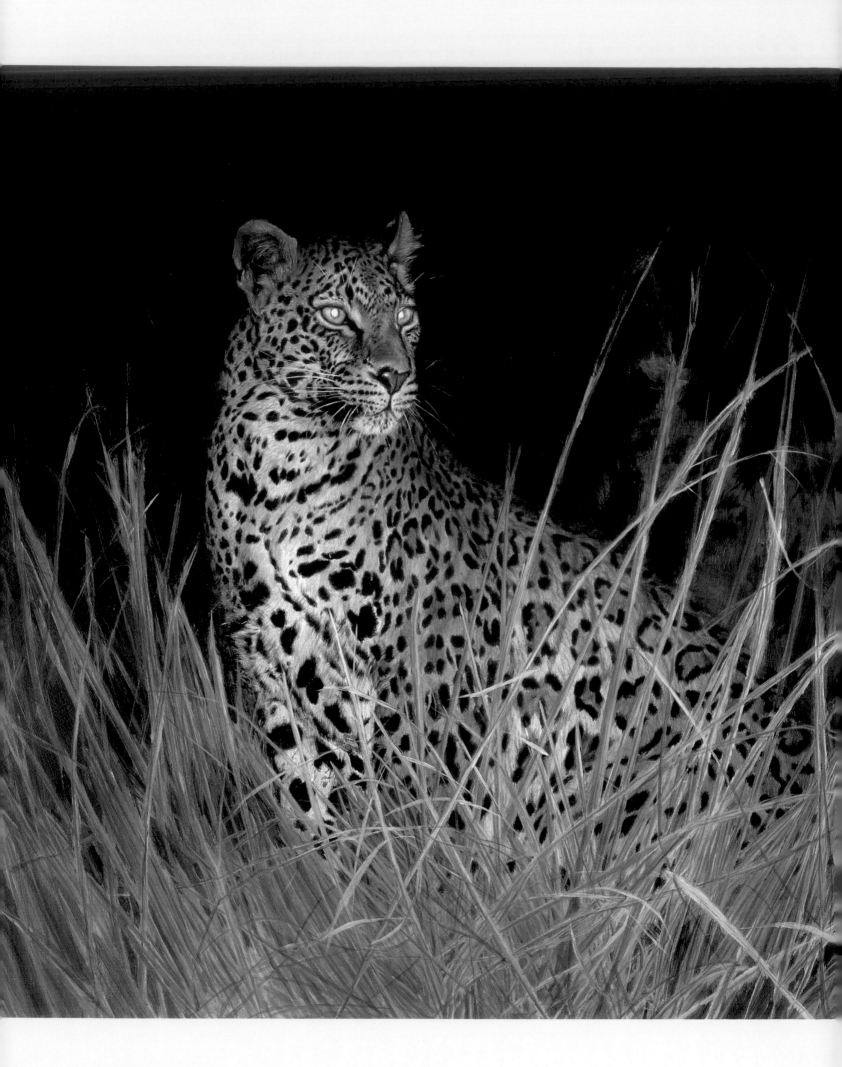

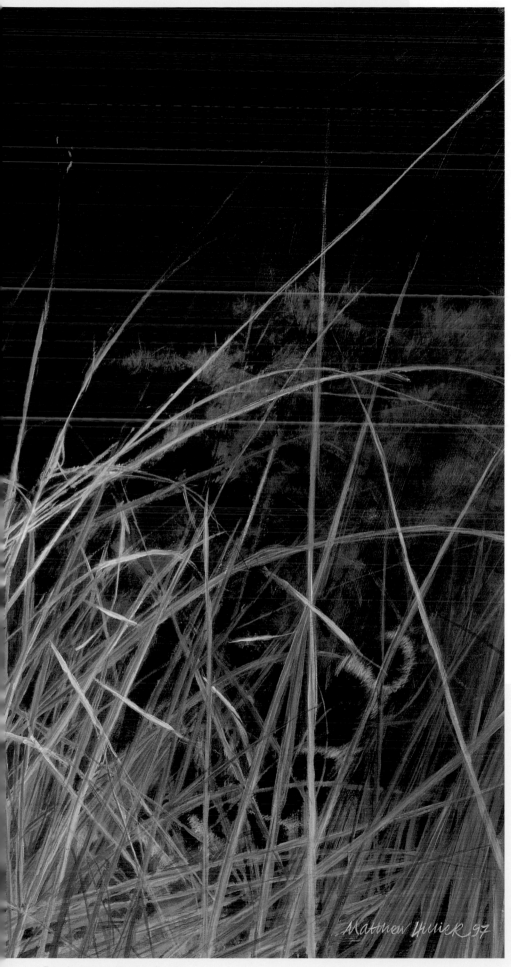

3

GRAB YOUR VIEWER WITH

Tension

The paintings in this chapter show a sense of action about to happen, the threat of something looming outside the picture plane or a sense of alertness in the animal.

For me, nothing compares to the thrill of having seen a wild leopard for the first time. During a stay at a private game reserve bordering Kruger National Park in South Africa, I went on a night drive. We had been enjoying the antics of bush babies when suddenly, as we scanned the blackness with a flashlight, we picked out the golden glow of a pair of eyes watching us. As we approached, we realized that it was a female leopard, sitting on a termite mound. She allowed us to admire her for several minutes before melting away into the African night. It was one of the most haunting few minutes of my life.

—MATTHEW HILLIER

THE LEOPARD HUNTS ALONE
acrylic, 24" x 36" (61cm x 91cm)

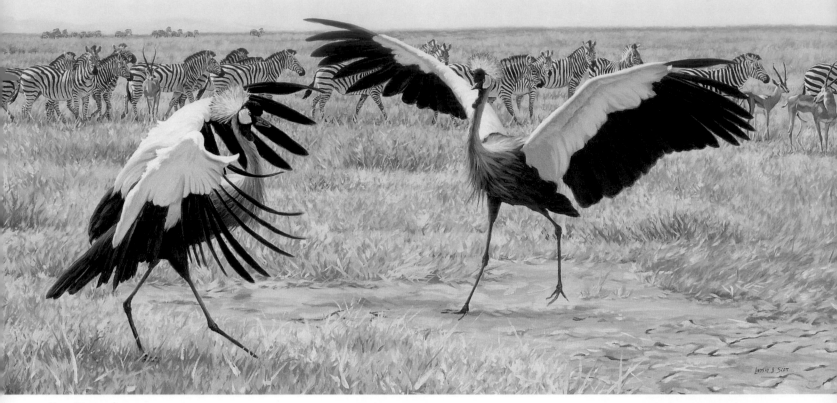

THE DANCE (CROWNED CRANE, ZEBRA AND
GRANT'S GAZELLE)
oil on linen, 24" x 54" (61cm x 137cm)

Lindsay Scott

CREATE TENSION WITH POSE, CONTRAST AND LINE

Birds often release suppressed aggression and tension during their ritualized courtship displays. I wanted to portray some of this tension. First, the dramatic pose of the birds creates a tension across the canvas. Second, the strong contrast of lights and darks, such as the black-and-white coloring on the birds' wings, gives visual movement. The line of animals behind the courting birds creates another kind of tension as your eye moves between the foreground, middle ground and background.

Victoria Wilson-Schultz

AN UNSEEN FOCUS DRAWS ATTENTION

An artist can create tension quite effectively by excluding something from a painting. In *Princes of the Serengeti*, the key to the painting is the unseen focus of these three young cheetahs. Perhaps another animal has passed by, or maybe they are waiting for their mother to return from the hunt. I did not put their ears forward or have them in the traditional hunting stance, so that viewers could draw their own conclusions as to what has caught their attention. I chose suede mat board for this painting because it gives the subjects such a rich, soft look. I began painting by layering my shapes in with soft pastels, defining the shape and anatomy of the subjects. Then, using the harder pastels, I added the highlights and detail.

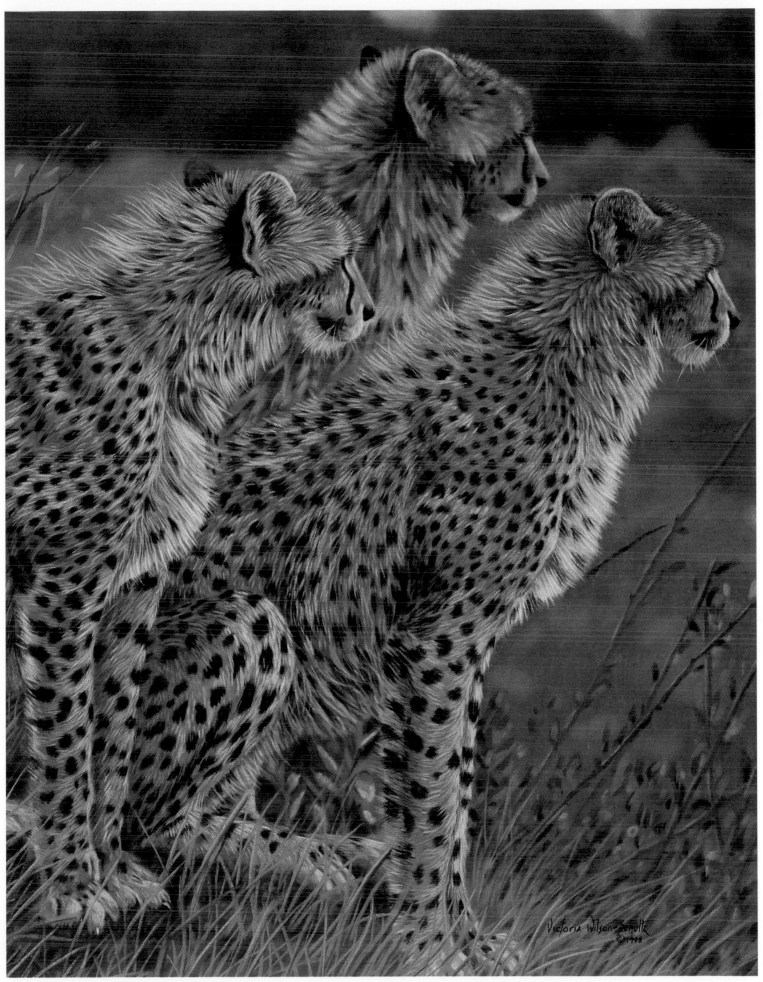

PRINCES OF THE SERENGETI (CHEETAHS)
pastel on suede mat board, 14" x 11" (36cm x 28cm)

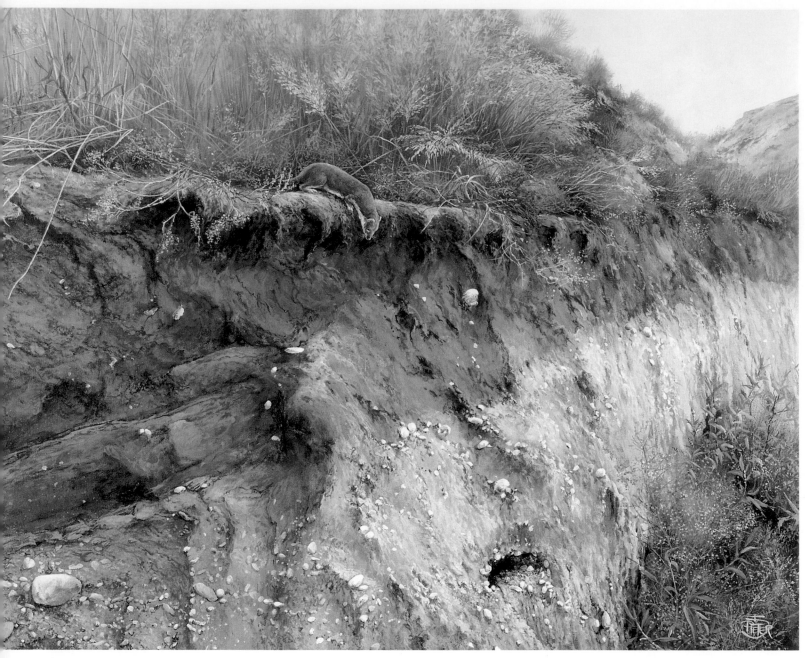

WEASEL HUNT (ERMINE)
acrylic on canvas, 27 ½" x 35 ½" (70cm x 90cm)

Pieter Verstappen

AN UNUSUAL DAYLIGHT HUNT

I spied this scene in the neighborhood of a gravel pit. The bank swallows had left their nests, but their scent was still there. The ermine cannot resist the smell, and even though it's daylight he is hunting. The biggest challenge in this work was to keep the dominant gray sand wall as simple as possible, balanced by the warm colors of vegetation. I have done a lot of paintings at the gravel pit in my neighborhood. The area fascinates me. Within very short periods, digging activities change the landscape. It is rather a miracle to see how fast nature takes over again. I strive to reveal the essence of animals, not merely record their external traits. I try to express their character and behavior, and their relationship to their environment.

Arnold A. Nogy

WITNESS THE STRUGGLES OF NATURE

Venturing outdoors one day, a dark streak went by in my peripheral vision. As I turned to look, I saw this female kestrel struggling with something on the ground. By the time I got closer, her prey had escaped and the kestrel was still standing there, mouth open, with her wings open to the breeze. Her eyes and attention were keenly searching for any new opportunities. In the picture the bird looks relaxed but ready for anything. In a moment the kestrel could fly away. For this life-size piece, I collected sticks, leaves, shells, snails, ants, stones and clumps of grass. I brought all of them back to my studio from the actual location. Drawing from life ensures accuracy, maintains a natural look and avoids a contrived appearance.

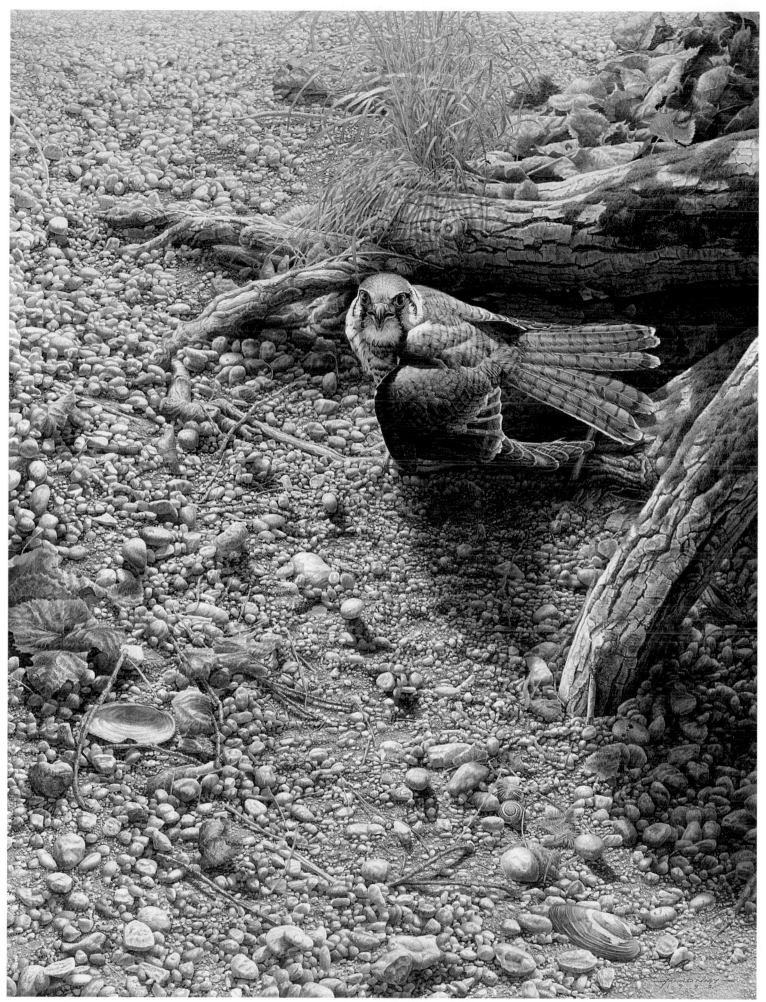

SHADOWS (AMERICAN KESTREL)
transparent watercolor on Arches paper, 24" x 19" (61cm x 48cm)

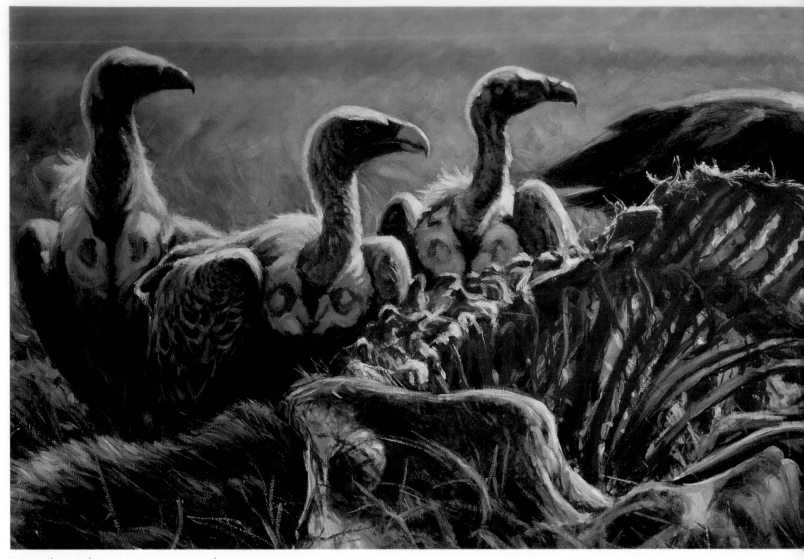

INNER CIRCLE (WHITE-BACKED VULTURES)
acrylic on canvas, 24" x 36" (61cm x 91cm)

Michael Todoroff

WARINESS IMPLIES IMPENDING THREAT

When red occurs in nature, it's hard to ignore, whether it's a stream bank full of flowers or the bloody bones of a wildebeest. *Inner Circle* is an observation of the pecking order between various species of vultures; within that idea is where tension exists. I kept the scene tightly focused to pull in the viewer. In the upper right corner I have suggested a fourth bird. Visually this pulls out the rib cage of the wildebeest and leads the viewer's eye down and around the composition, in a clockwise spiral toward the birds. Wary, the vultures have stopped feeding. Their heads now point in the same direction, ready to react to the impending threat.

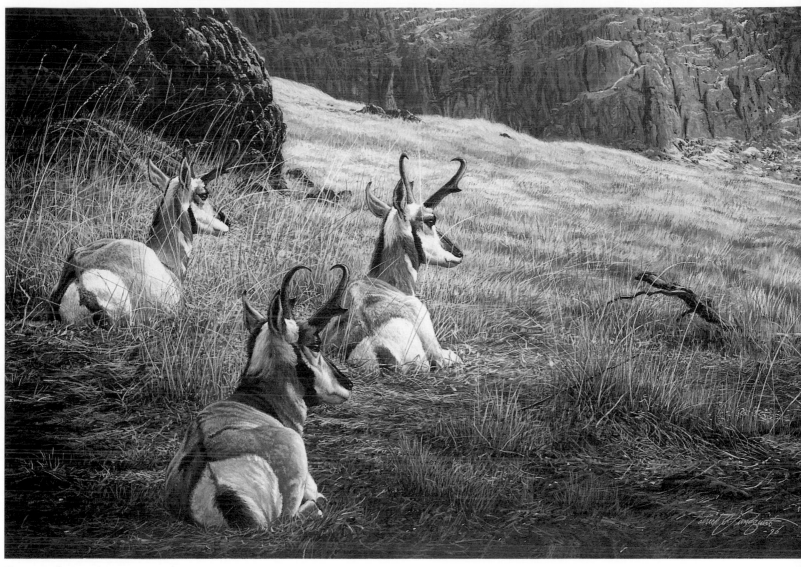

OUTLOOK (PRONGHORN ANTELOPE)
acrylic on Crescent watercolor board,
20" x 30" (51cm x 76cm)

Patrick A. Lundquist

BIOLOGICAL CLUES INDICATE TENSION

At first blush this appears to be only a painting of resting pronghorn. However, it also conveys the unseen, the fear of the unknown. Action is taking place outside the picture plane. A flicker of motion and heads snap up; all eyes lock on a single spot. Is it simply a jackrabbit hopping over a rock, or something more deadly? Poised for flight, the pronghorn are not quite ready to leap from the cool shade. There are subtle clues to what is occurring. With fantastic vision the pronghorn can detect movement up to four miles away. Their ears point backward to make sure nothing sneaks down from above while they focus on the distance below. Noses are used to detect any threats from the rear. Bending grasses indicate a breeze that would carry a predator's scent. The odds are in favor of the pronghorns' escape if they detect something dangerous. Able to hit speeds of seventy miles per hour, they are the fastest animals in North America. The pronghorn are far to the left side of the composition. The background provides an indication of great distances. I created tension through the hill's diagonal crest, the direction of the animals' focus and the jagged branch on the ground. This painting started with an underpainting of warm red that gives the final work warmth.

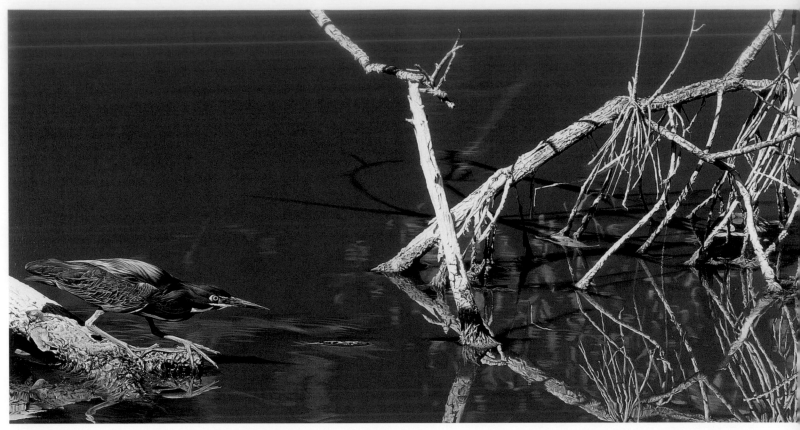

LITTLE GREEN HERON
acrylic on canvas, 19" x 37" (48cm x 94cm)

Mark Eberhard

LEAVE SOMETHING TO THE IMAGINATION

I observed this green heron at Ding Darling National Wildlife
Refuge on Sanibel Island in Florida. The heron, with its eyes on din-
ner, was cautiously and slowly walking down the limb. I created ten-
sion by not showing dinner, leaving it to the imagination of the
viewer. To draw emphasis to the heron and add interest to the
design, I left the rusty color of the water, a result of the mangrove
trees, around the heron. There is additional visual tension between
the tree branches and other reflections on the right and the heron on
the left. The leaf that floats just to the right of the heron's bill acts as
a visual bridge between those elements. The reflections are painted
with opaque acrylic, like the rest of the painting, and then toned
down with a thin brown wash.

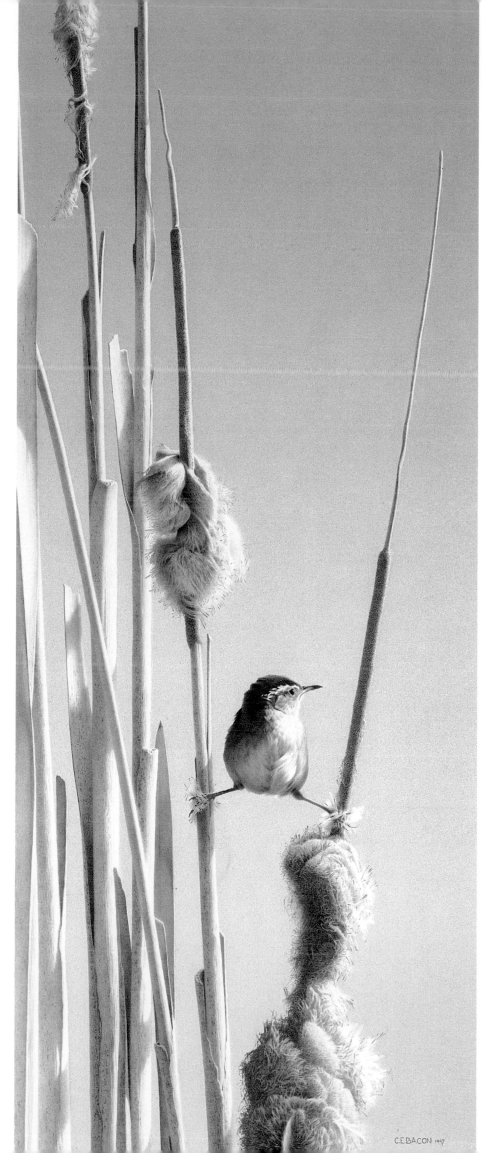

Chris Bacon

ENTICE THE VIEWER

This painting is about a sense of place and my response to it. It is about space, and success hinges on its ability to entice the viewer to an exact location both in and in front of the piece. In order to achieve and maintain a sense of light, I executed this watercolor using only transparent pigments.

SPRING! (MARSH WREN)
transparent watercolor on 140 lb.
hot-press Arches paper, 20" x 7 ½"
(51cm x 19cm)

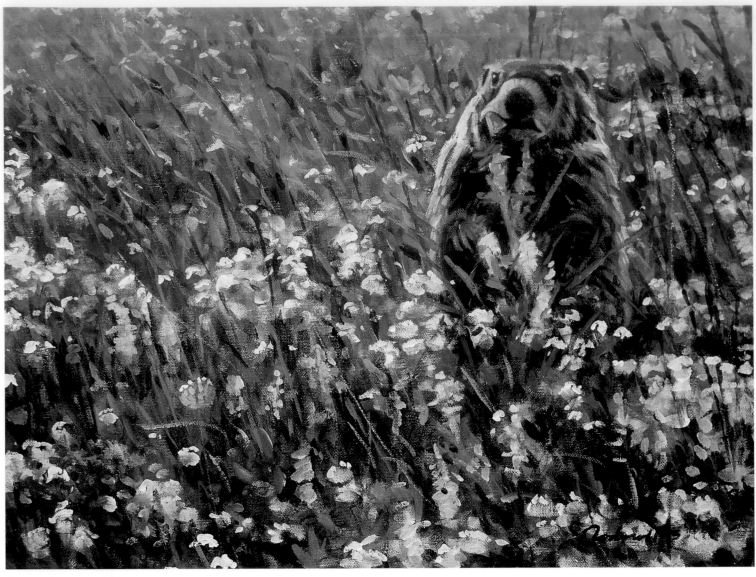

CLOVER (WOODCHUCK)
acrylic on canvas, 12" x 16" (30cm x 41cm)

Michael Todoroff

FIND INTEREST IN THE COMMONPLACE

This is a very common sight in the fields around my home. Woodchucks are not the most dynamic of animals, and one could easily overlook this scene. I challenged myself to find something interesting in the commonplace. The woodchuck looking directly at the viewer gives the feeling of witnessing a brief moment in nature. In the bottom left corner I threw in a stroke of pure Cadmium Red to pull the viewers' eyes down into the clover.

John Banovich

SHEER SIZE CREATES TENSION

I found this old bull at a water hole in Botswana as he made his way down to the water's edge. Because of his sheer size, all of the other creatures (and my vehicle) readily gave him the right-of-way. I wanted to portray the feeling I had as this 12,000-pound bull came straight towards me with no intention of changing course. I conveyed movement by the sway of the trunk and elevated right forefoot, as well as the slight tilt of the head. I placed his ear going off the page to emphasize his enormous size. With elephants I do quite a detailed drawing on the canvas, because the wrinkles and shape of the body must be correct. Then I add oil paint in the middle-value range and later push the darks and lights.

RIGHT OF WAY (ELEPHANT)
oil on linen, 60" x 40" (152cm x 102cm)

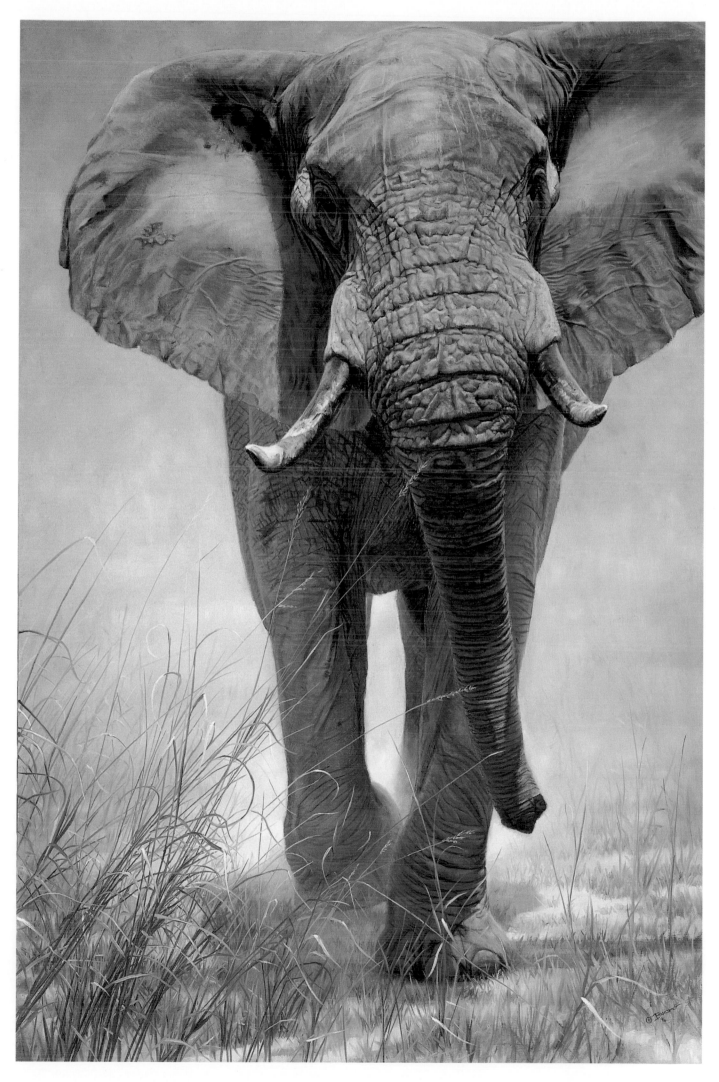

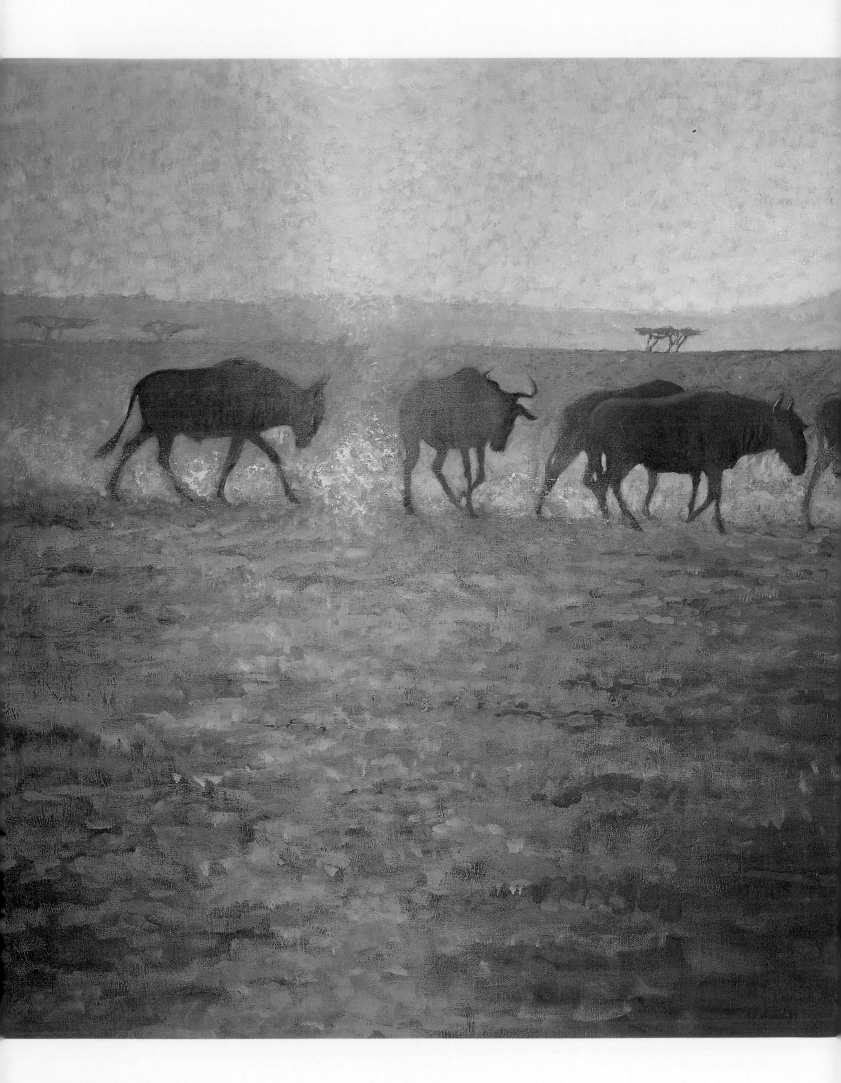

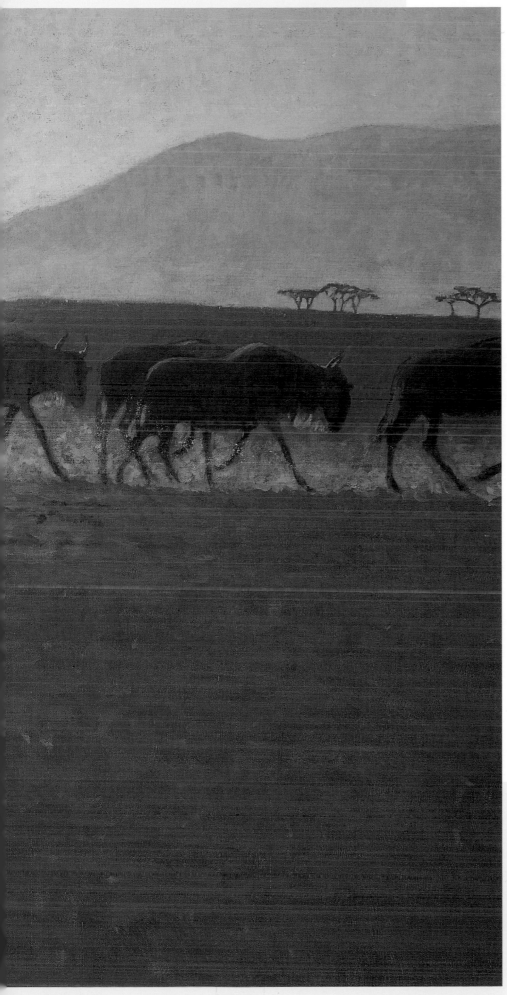

BEDAZZLE YOUR SUBJECT WITH

Light

Light and shadows are the main theme for the paintings in this chapter. Light can spotlight, enhance or hide the animals in these paintings.

I used backlighting to set off the dust as a small herd of wildebeest pass through this scene in Kenya. This was painted on an orange canvas. Afterwards I put in little strokes of purple to create vibrancy. The last thing added was the sun; to make it look extra hot, I used a paint knife for its application. I cropped the first wildebeest to give the feeling that there are more; who knows how many have passed already?

—GIJSBERT VAN FRANKENHUYZEN

WILDEBEEST
acrylic on canvas, 36" x 48" (91cm x 122cm)

EDGE OF THE POND (MOOSE)
oil on canvas, 24" x 36" (61cm x 91cm)

Lanford Monroe

SUBDUED HIGH CONTRAST
FOR PREDAWN LIGHT

Edge of the Pond shows the special light of early morning. There is a hint of warmth in the predawn sky while cool shades of night still cloak the world. I enjoy playing with contrast while trying to keep it as subtle and quiet as possible. I keep the paint surface thin and flat, particularly in the background. I find that obvious brushwork distracts from the quiet mood and "texture" of the mist. I reserve any heavier paint for the grass in the foreground, which helps distinguish its texture from the water.

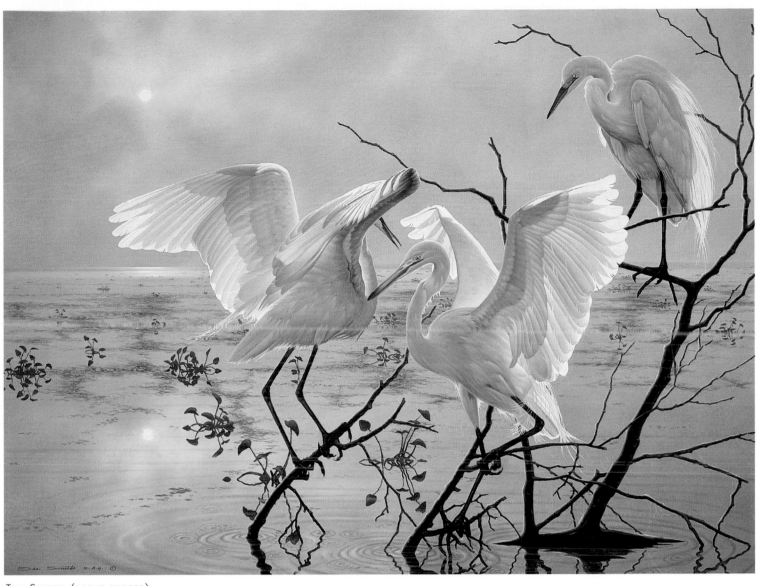

THE SUITOR (GREAT EGRETS)
oil on canvas, 36" x 48" (91cm x 122cm)

Dee Smith

KNOW WING ANATOMY FOR BACKLIGHTING

I wanted to show the effect of light passing through the layers of feathers. This requires an understanding of the structure of a bird's wings. One feather passes more light through it than if there are two or three underlying feathers. As the feathers overlap, the intensity of the light diminishes. I paint in the lights first and then tone down the intensity of light as I go along. I also wanted to convey the tension between the two birds on the left. The bird at far left (the suitor) tries to impose upon this mated pair of great egrets and the bonded male tries to drive him away.

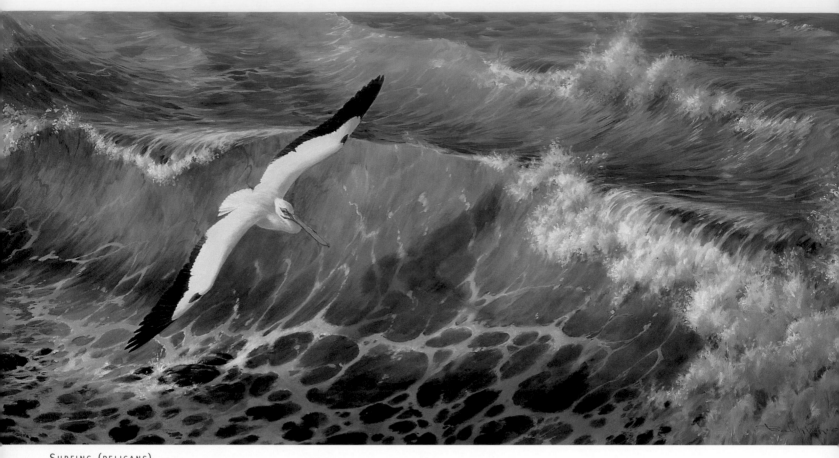

SURFING (PELICANS)
acrylic on canvas, 24" x 28" (61cm x 71cm)

Victor V. Bakhtin

A MYSTERIOUS SHADOW

Pelicans look strange and awkward on land, but they are magnificent flyers. They are particularly good at making use of air turbulence near seashores where three elements meet: waves, wind and rocks. I will never forget the moment when I saw the sliding shadow of a bird on the rising California waves. To paint water, do not spare water in creating the necessary paint consistency. Wet solutions of acrylic color applied with a wide brush helped create the vivid surface of the water.

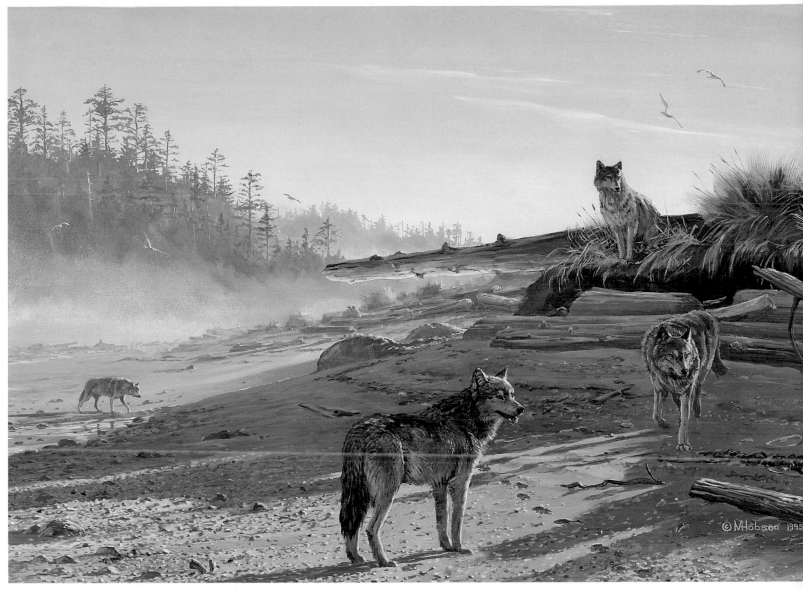

MORNING SHADOWS (TIMBER WOLVES)
acrylic on Masonite, 24" x 36" (61cm x 91cm)

Mark Hobson

WINTER LIGHT, MAUVE SHADOWS

The winter light of a January morning on the west coast of
Vancouver was the starting point of this painting. The long, mauve-
colored shadows across the logs and beach gravel caught my eye.
The highlight, though, was the way light from the beach reflected
on the log's underside in the middle of the painting. I reversed the
shade on the log, thus giving a sense of brilliant light coming up
from somewhere below. People do not often associate wolves with
beaches, but on the remote western shores of Vancouver Island their
tracks are a common sight along the line of the high tide at dawn.
These timber wolves are excellent swimmers. They frequently travel
between islands hunting for deer and food washed up by the tide.
On two occasions I was lucky enough to get photographs of these
elusive animals, and used the images as references for this piece. I
painted the misty sections of the background by dabbing the wet
acrylic paint with a fine-celled sponge to soften the brushstrokes.

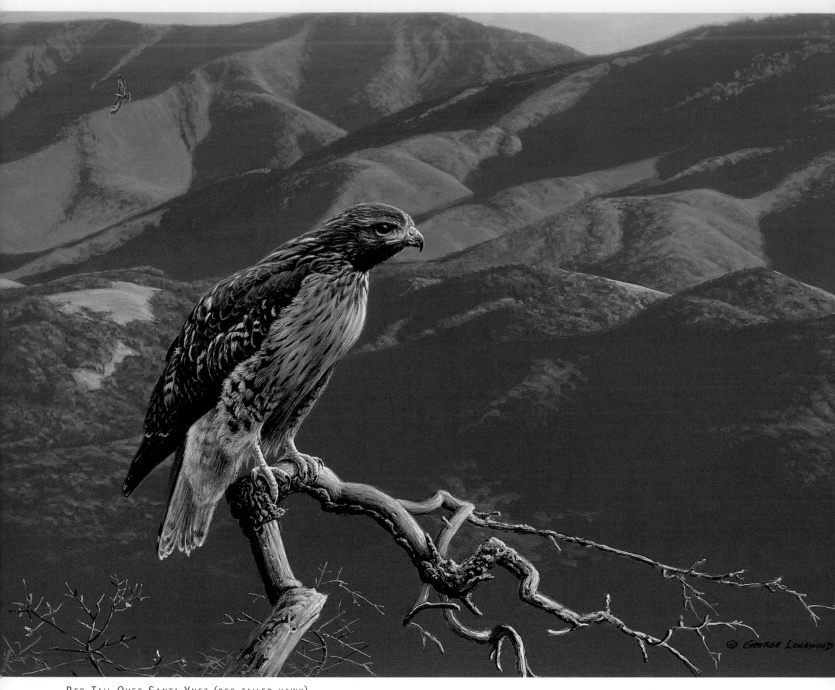

RED-TAIL OVER SANTA YNEZ (RED-TAILED HAWK)
acrylic on board, 18" x 24" (46cm x 61cm)

George Lockwood

LAYER BLUISH-GRAY WASHES FOR DISTANCE

I view this mountain range every day from my home. On a clear evening, for just a few minutes, the light is particularly dramatic. This is what I wanted to capture. I painted nearly the entire background in the same value, then put bluish-gray washes over the mountains, with the most layers over the most distant. I saved the richest tones and highlights for the foreground, creating a three-dimensional effect. Red-tailed hawks are very common in this area and seemed to be a fitting subject. The warm, intense tones of the hawk made a nice contrast to the cool, placid background. I wanted the bird perched on an old, twisted oak branch that was interesting in form but not distracting.

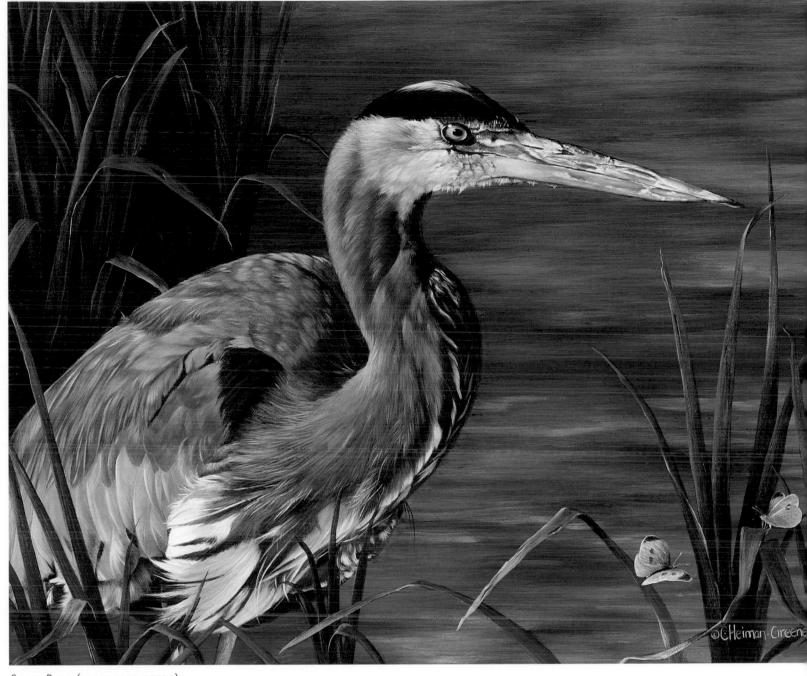

GREAT BLUE (GREAT BLUE HERON)
acrylic on Claybord, 14" x 18" (36cm x 46cm)

Carol Heiman-Greene

CRISP LIGHT FOR STRENGTH AND DELICACY

The great blue heron is a blend of strength and delicate beauty. Crisp, clear morning light enhances both qualities, showing the strong musculature in his neck and the gleam in his eye. By contrast, using this same light, I can explore the subtle, delicate colors of his feathers—blues, grays, hints of violets and warm siennas. When creating my images, I glaze layer upon layer of umbers, grays and indigos to establish all lights, darks and detail. I only add color when the image is strong enough to stand on its own as a monochromatic piece. Again I work in glazes, adding layers of different colors. In this way, the dark areas gain depth and light areas come forward.

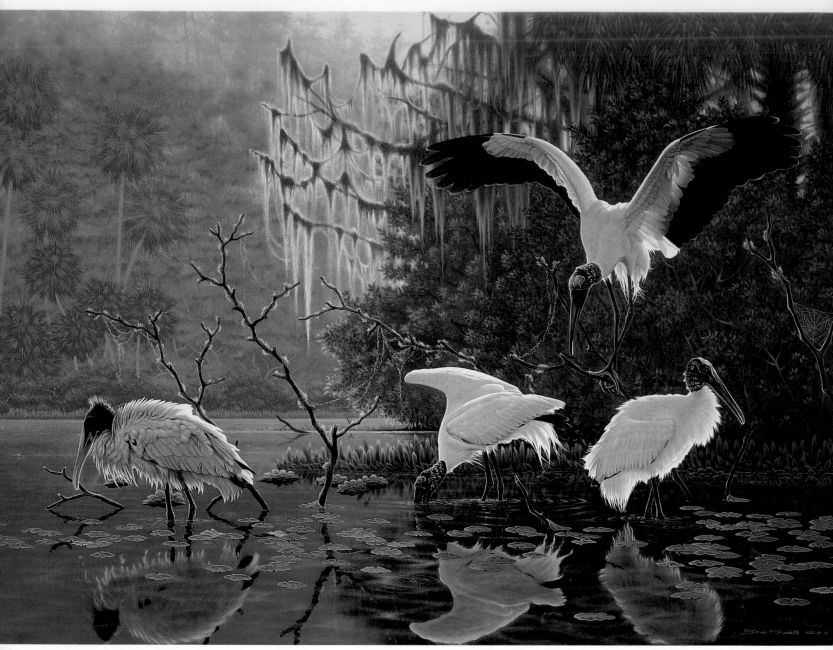

STILL WATERS (WOODSTORKS)
oil on canvas, 30" x 42" (76cm x 107cm)

Dee Smith

BACKLIGHTING SHOWS A SETTING SUN

Woodstorks, also known as "old flint head" because of the bare,
bumpy skin on their necks and heads, are some of the most beautiful
of the wading birds. I wanted to show more of their habitat than the
birds themselves. The sun sets behind them as they settle down for
the night in a secluded cove. I like to paint the background loose
and toned down. I leave the foreground and subject more focused
and detailed to create depth.

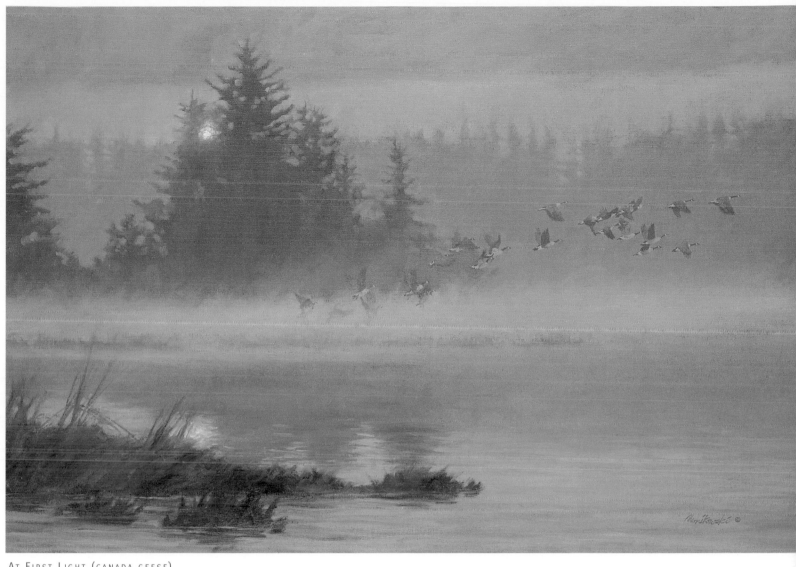

AT FIRST LIGHT (CANADA GEESE)
oil on canvas, 24" x 36" (61cm x 91cm)

Kenneth H. Bronikowski

SUBTLE GRAYS FOR A DAWN FOG

I painted *At First Light* after viewing this type of morning numerous times in northern Wisconsin. A cool front passing over a warm lake during the night and predawn hours creates a surface fog just above the water. When I hear geese overhead, I can imagine this scene with the birds rising up and flying off, just as the first light of dawn begins to burn through the fog. Grays have always attracted me more than primary colors; this type of light and mood seems to be right for this painting. I create harmony with combinations of green and violet.

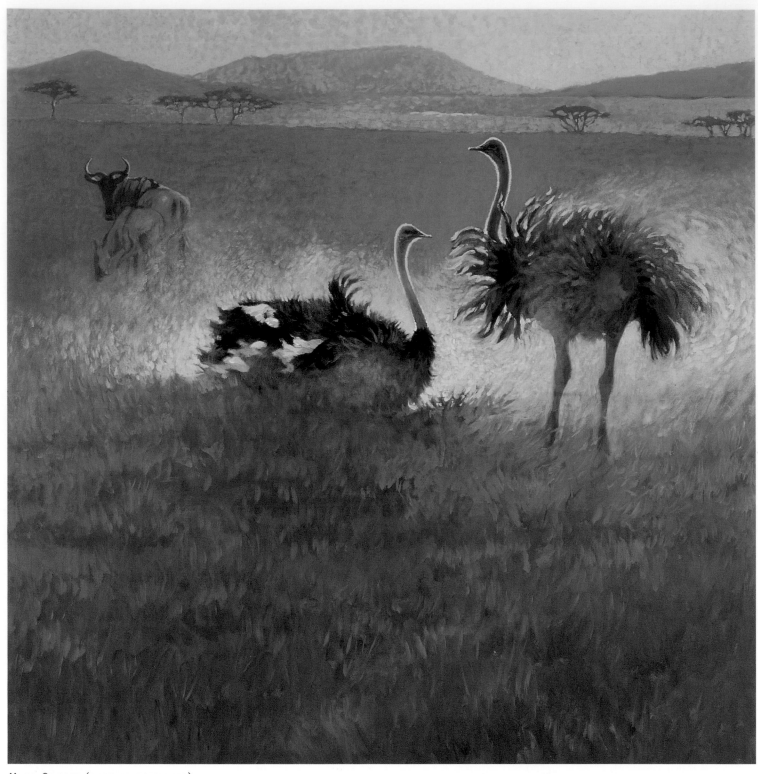

MARA SUNSET (DUSTING OSTRICHES)
acrylic on linen, 48" x 48" (122cm x 122cm)

Gijsbert van Frankenhuyzen

DUSTY BACKLIGHTING CREATES
A WARM, LAZY MOOD

Backlighting brings out the dust, sets off the birds and creates the
mood—a warm, dusty afternoon in the Masai Marain, Kenya. I
painted the whole scene on an Ultramarine Blue ground—still visi-
ble in the foreground, the birds, and the trees in the background.
Together with the warm oranges and yellows, it makes the painting
vibrant without losing the warm, dusty feeling.

Jay J. Johnson

CAREFUL LIGHTING FOCUSES ON FORM

Subtle light focuses attention on the avocet's elegant shape, beauti-
fully curved bill, perfect posture and long legs. These shapes are
what struck me the most about this bird and they are what I wanted
to convey without distractions. A dark background allowed me to
fully utilize the effect of light, creating shadows that show the avocet
in three dimensions while its white back feathers and rusty head
color glow. I applied layers of acrylics thinned with gloss medium
until I achieved the right balance of light and shadow.

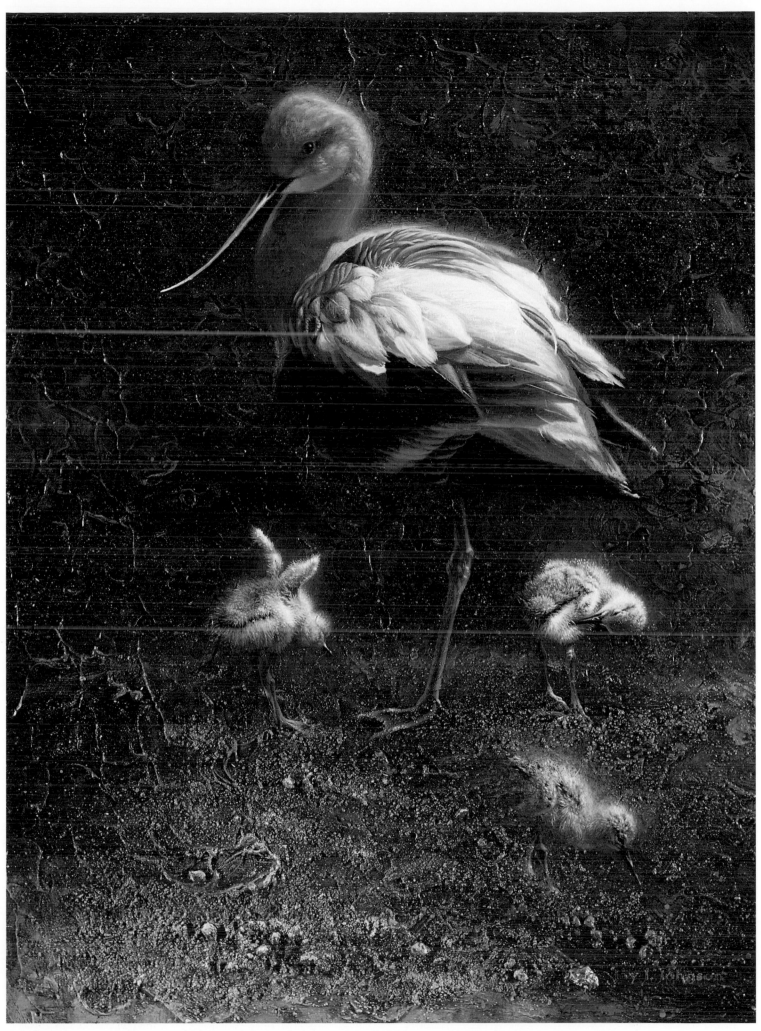

AVOCETS
acrylic on panel, 24" x 18" (61cm x 46cm)

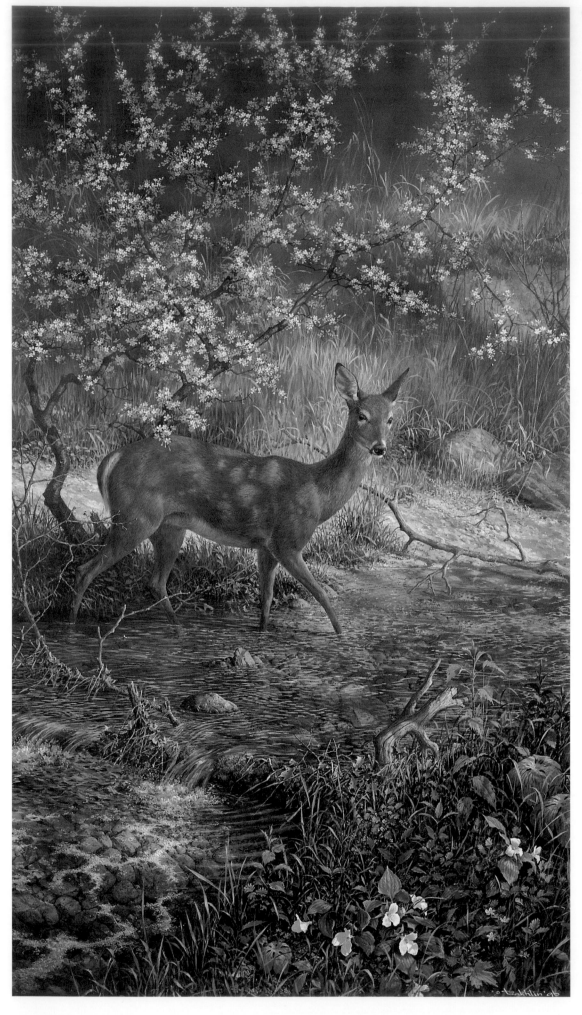

Victor V. Bakhtin

PORTRAY DELICATE SPRING SHADOWS

The play of shadows is the most important condition in creating a three-dimensional environment. Spring shadows are very special. They are not deep and solid like summer shadows. Slightly opened leaves create sunny spots. The trickiest part is to catch unsteady shadows on the body of the animal while describing the whole shape of the creature. My solution was to keep the silhouette shape, whether it's dark on light background or vice versa.

SPRING SHADOWS
acrylic on Masonite, 60" x 36"
(152cm x 91cm)

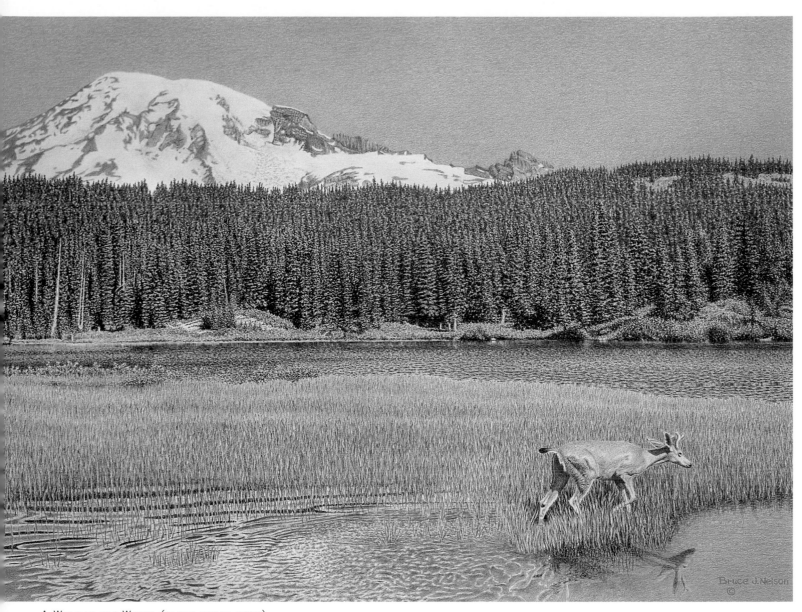

A WALK IN THE WATER (BLACK-TAILED DEER)
colored pencil on Rising Gallery 100 paper, 18" x 25" (46cm x 64cm)

Bruce J. Nelson

FRONT LIGHTING FOR
A BRIGHT, CLEAR LOOK

The view and the light (over my right shoulder) were perfect when I arrived at Reflection Lake and looked north to Mt. Rainier. I raised my camera. Noticing some movement in the left side of my viewer, I saw a black-tailed deer making his way into the foreground through the shallow water. Did I have enough depth of field to bring the deer into adequate focus? I did! My colored-pencil techniques are layering and pointillism on white paper. I used pointillism in the trees, foliage and middle-ground water, as well as the rocks on Mt. Rainier. All of the white seen here is the white of the paper.

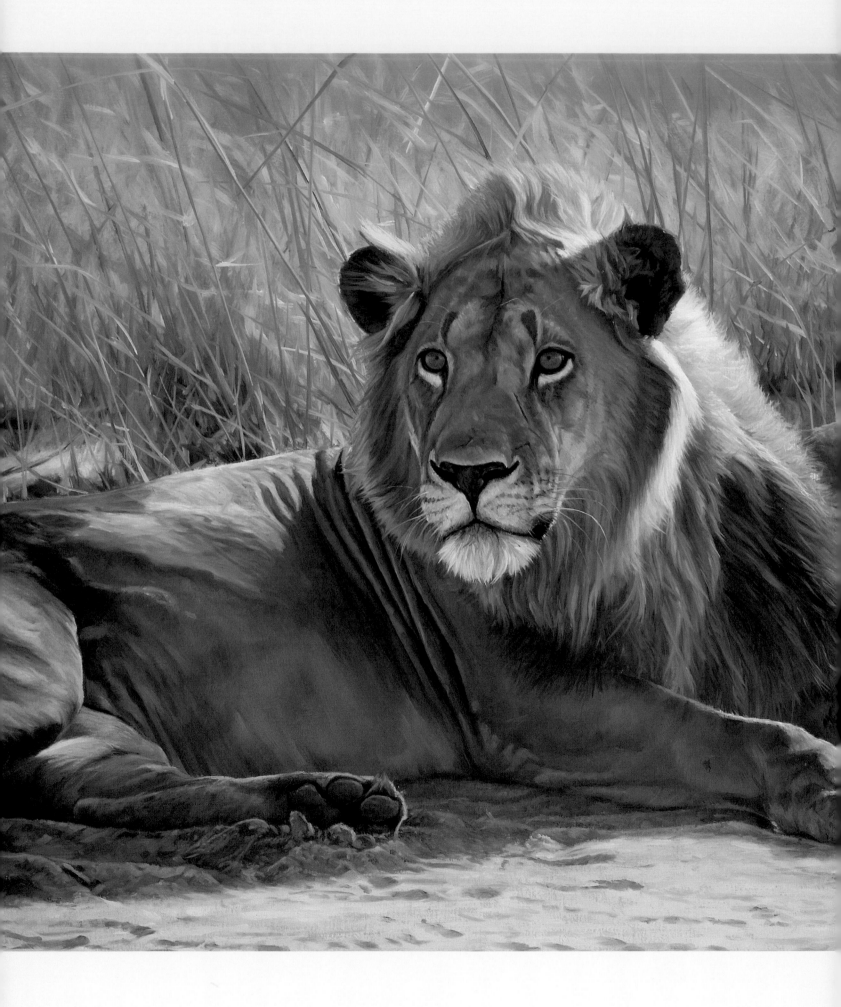

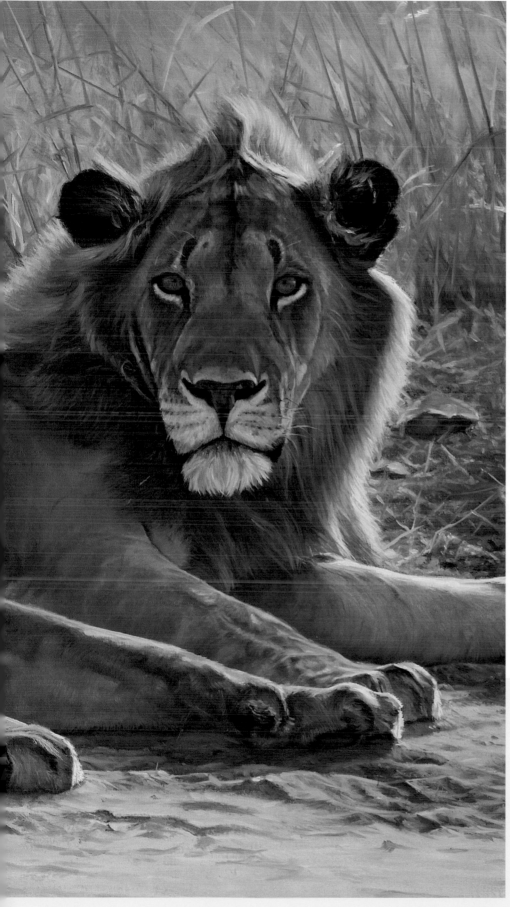

5

Animal's Character

The paintings in this chapter catch wildlife in the act of simply being themselves. Here you see animals in typical poses or close up, expressing their personalities.

Every time I see lions in the wild, it's as if I'm seeing them for the first time. I designed this composition to emphasize the eyes, one of the most distinctive characteristics of lions. When you lock eyes with them it's as if they are looking into your soul. In *Lion Eyes*, something has awakened the two brothers. These two large pride males possess the sparser mane typical of lions from the southern part of Africa. Nothing blurs the focus of their stares.

—JOHN BANOVICH

LION EYES
oil on linen, 24" x 40" (61cm x 102cm)

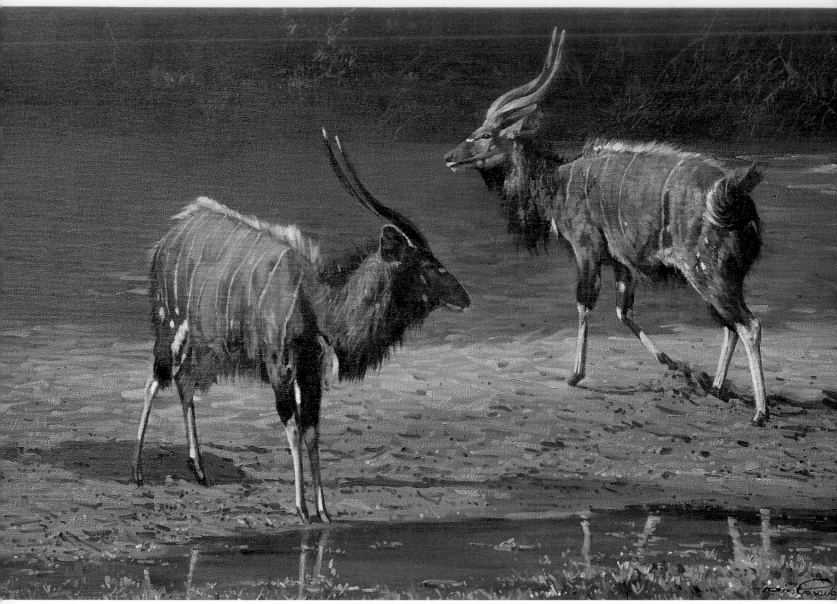

SQUARING UP—NYALA MALES
oil on canvas, 20" x 30" (51cm x 76cm)

Dino Paravano

IT'S A GUY THING

I found this scene at Mkuze, one of my favorite
game reserves, particularly for nyala. I had never
before seen such behavior with this species,
though it is characteristic of male bucks vying for
dominance. The two males circle one another in
slow motion, like boxers in the ring. They size
each other up and wait for an opening. This goes
on for quite some time. Eventually one gives in
and leaves the water hole without quenching his
thirst. I use oils for the rich depth of color and
tone. I start off with washes then build on mostly
wet on wet. I finish with highlights, accents and
last details.

Diane Garrick Scholze

DEPICT A FAMILY RELATIONSHIP

A highlight of our visit down under was the rare sighting of several
koalas in the wild near Murgon, Australia. The koala's deliberate
movements are slow and graceful, its gaze lingering. I wanted to cap-
ture this peaceful quality. Mother and baby quietly move about
together consuming voluminous amounts of leaves. I wanted to
express this typical mother-child attachment through the eyes of the
baby, who usually attaches himself to mother but now finds himself
on another, though nearby, branch. Light highlights the fur and
body structure as late-afternoon sun filters through the leaves. I built
up many layers of pastel and fixative to create depth. Strokes sealed
between fixative, from dark colors to light, define the layers and
directions of fur.

OUT ON A LIMB—KOALAS (QUEENSLAND KOALA)
pastel on Crescent board, 30" x 20 ½" (76cm x 52cm)

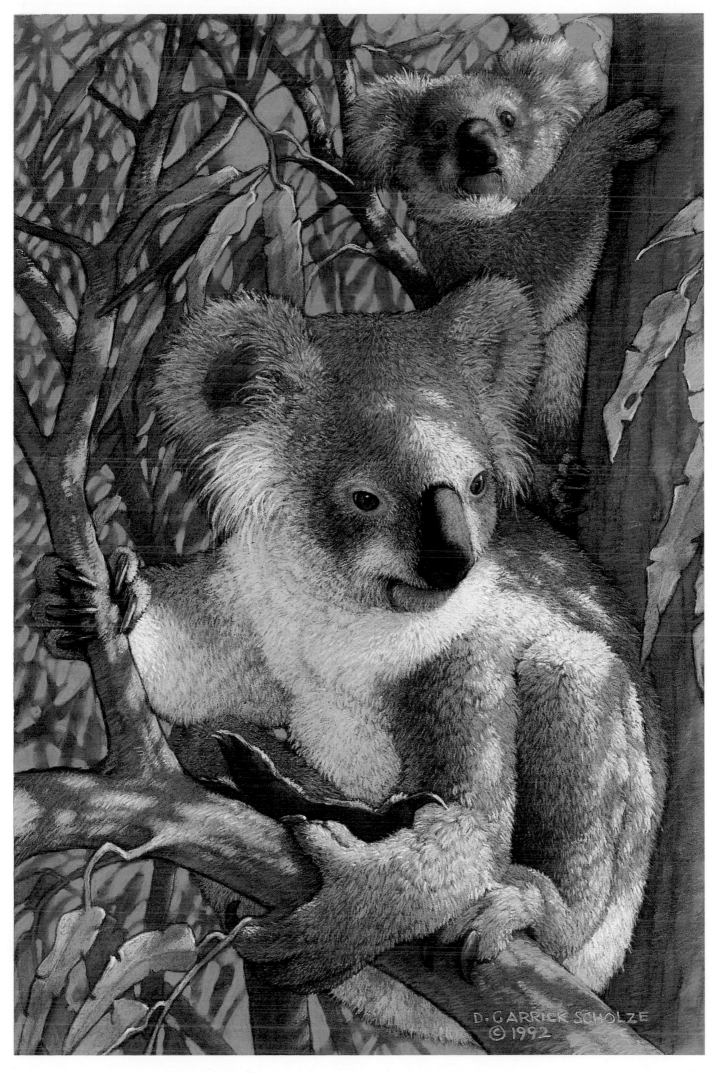

D. GARRICK SCHOLZE
© 1992

Walter Ferguson

PORTRAIT OF A SURVIVOR

An old male orangutan presents a variety of shapes, textures and colors. His body is bizarre—a hulk of dull brownish-yellow hair that hangs like Spanish moss surmounted by a face that only a mother could love. Yet inscrutable intelligence lies behind his slothful demeanor. Extinction now threatens this marvelous survivor. I painted his portrait—using glazes and scumbling—to call attention to his precarious existence and to commemorate his life on earth.

SNOWSHOE HARE
oil on linen, 18" x 24" (46cm x 61cm)

Dwayne Harty

A HARE FOR ALL SEASONS

I have observed the snowshoe hare in all seasons and weather conditions. Our property near Georgian Bay, Ontario, is perfect snowshoe country. The alder and willow along our creek provide ideal dense cover from predators. The hare seldom ventures too far from its safety, except through the night. A clean blanket of snow, trampled by morning, may well give a clear picture of the hare's nocturnal activities. These well-used nightly corridors connect one safe haven with the next. The autumn hare I have painted browses the edge of a spruce thicket. While clearly exposed, its large, powerful, snowshoe-like hind feet will quickly send it under cover. With each movement the large hind legs are beneath the torso and the forelegs tucked under as well. The arched spine and coiled hind legs act as a spring, loaded and ready to release with immediacy should it be required. I love the seasonal molts of the hare's pelage. The coming season's new wardrobe adds a beautiful patchwork pattern to the hare that mimics the snow's departure or arrival.

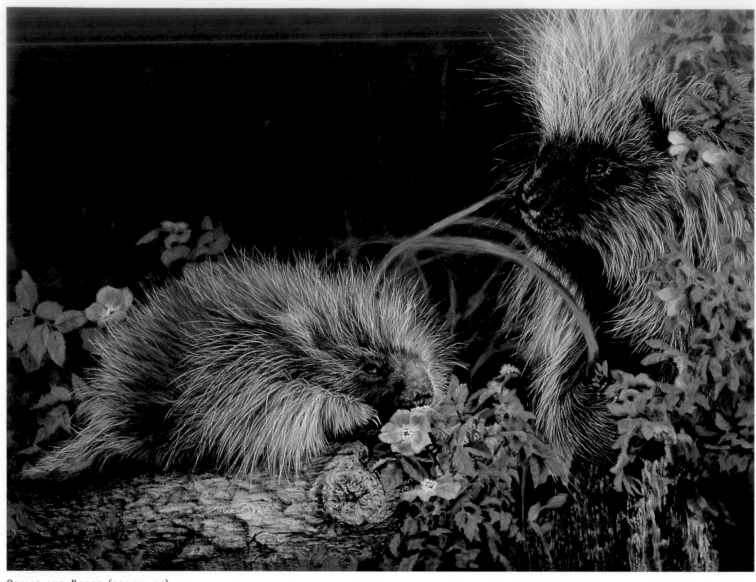

QUILLS AND ROSES (PORCUPINE)
oil on Masonite, 12" x 16" (30cm x 41cm)

Linda Walker

OBSERVE ANIMALS
WITHIN THEIR ECOSYSTEM

Although the porcupine is primarily nocturnal, I observed these during the late afternoon in the deeply shaded edge of the forest. My first impression of these dignified, slow-moving animals was "punk regal." They became more beautiful as I studied them. The mother was extremely protective and nurturing to her baby. It was a pleasure to watch her make sure it received its fill of a favorite delicacy. My paintings evolve through a progression of sketches. I transfer finished drawings onto a gessoed, tinted board and begin with very thin washes to set the patterns of dark and light. I then work with layers of thin, transparent glazes and opaque detail to impart luminosity and depth. I finish with highlights and final details.

Patricia Savage

POSE A BIRD IN A
LESS COMMON SETTING

An opportunistic feeder, the Harris hawk will pursue anything that moves. A visual predator itself, the lizard freezes to avoid becoming prey. Although hawks are well-known aerial hunters, I posed this female on the ground to show another of her behaviors, as well as her richly detailed New Mexico habitat. I first formed the needles with tiny strokes of masking fluid and a layer of several hues, working in drybrush. Then I masked some of the paint and added another layer of slightly darker hues. I worked from tan to pure blue and red, then lifted the masks and repeated the entire process. This captures the habitat's color complexity, in the patches of sunlight and shadow.

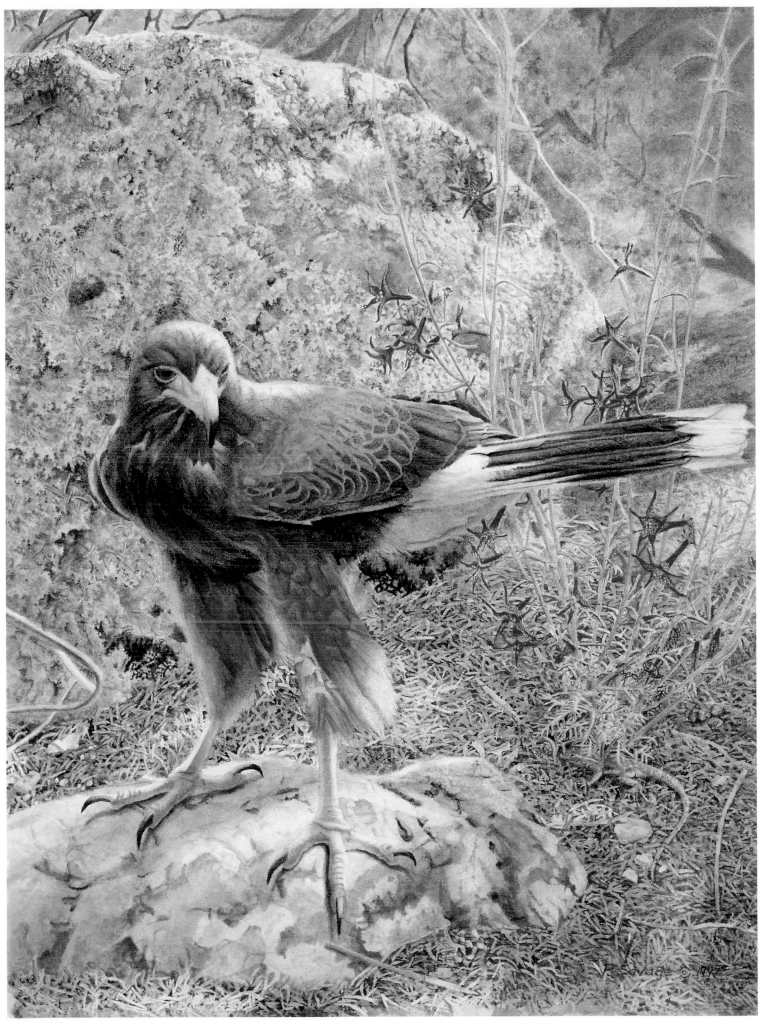

SEARCH IS ON (HARRIS HAWK AND SIDE-BLOTCHED LIZARD)
watercolor on 300 lb. hot-pressed Arches paper, 12" x 9" (30cm x 23cm)

THE CURIOUS LOOK (EMU)
Wood burning on basswood board,
10 ¼" x 14 ¼" (26cm x 36cm)

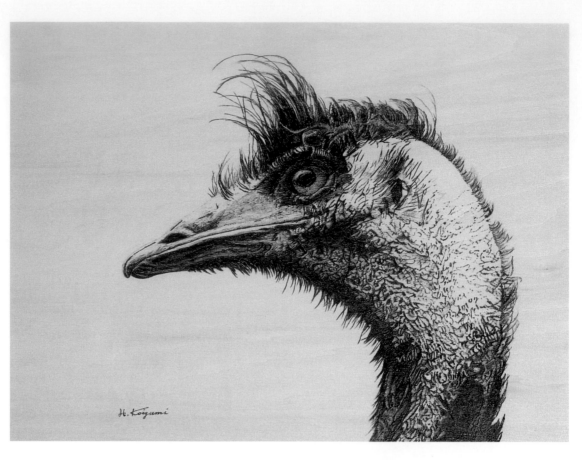

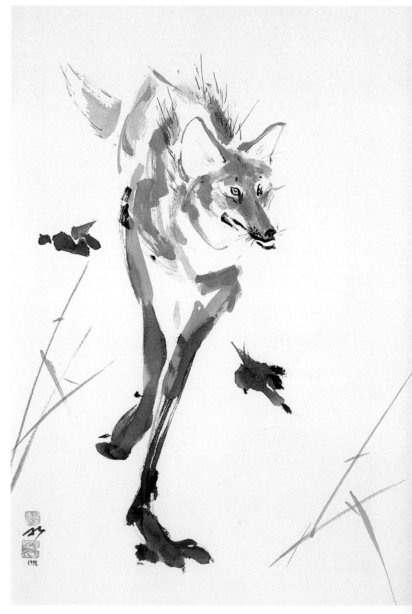

Alejandro Bertolo

RENDER AN ANIMAL'S SPIRIT

These large animals inhabit the subtropical expanses of northeast Argentina. Their stilt-like legs, which move like a giraffe's, give them a very elegant swing as they progress through tall grasses. This elegance disappears when these solitary hunters run. In this work I tried to express that disorganized gallop. Having studied sumi-e, the art of ancient brush painting, each work constitutes one uninterrupted creative act, executed directly with brush, ink and colors. My intention is that the very spirit of the animal will reveal itself through a few brushstrokes.

MARSH WOLF (MANED WOLF)
Japanese ink and watercolor on Chinese Pixuan paper,
27" x 17 ½" (69cm x 45cm)

Haruki Koizumi

EYES EXPRESS CHARACTER

When using the wood-burning method, plenty of preparation is necessary to determine the composition and design, because it is impossible to make changes once I start the burning process. Eyes best express an animal's character. Here, the attitude of the emu, full of curiosity, is seen in a close-up around the eyes.

L. Kent Rous

PORTRAY CHARACTER WITH BODY LANGUAGE

I photographed this bear from the car while driving through an animal park in South Dakota. My husband drove while I shot from the window and gave directions to stop or go. I usually like to paint an animal's eyes, but I have learned from fifteen years of portraiture that you do not have to see a subject's face to convey personality. I deliberately elected not to show this subject's face so it would not take away from the feeling of this rotund, lumbering animal basking in the sun with his thick, heavy coat. After applying two or three layers of oil-base primer on Masonite, I blocked in an underpainting with contrasting colors. I use a limited palette with rich umbers and siennas.

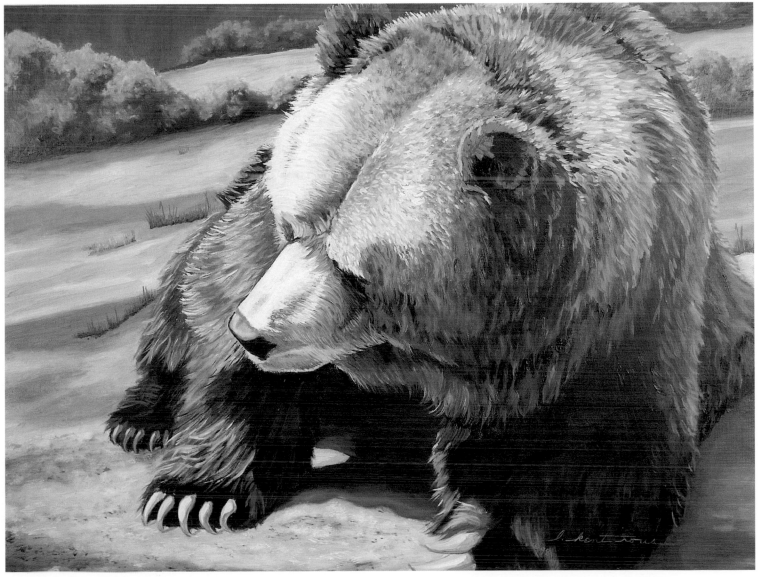

THE OL' MAN (GRIZZLY BEAR)
oil on Masonite, 18" x 24" (46cm x 61cm)

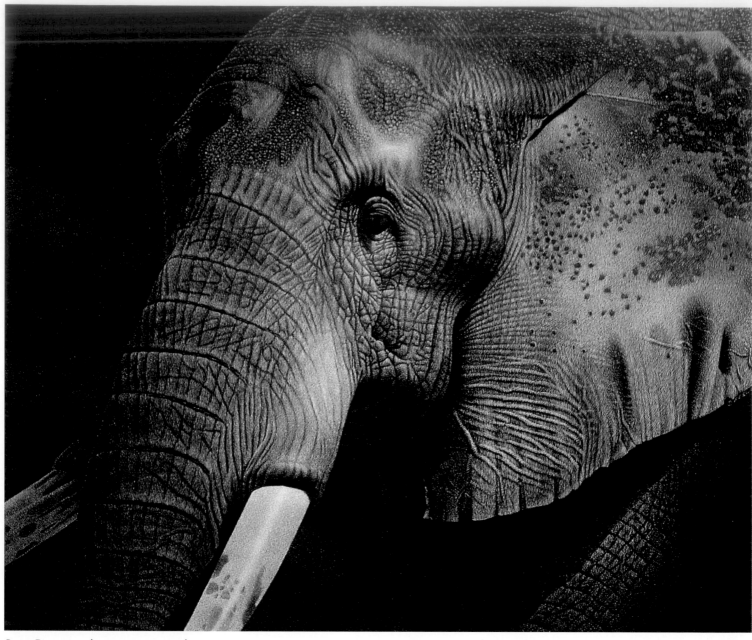

BULL ELEPHANT (AFRICAN ELEPHANT)
scratchboard, 18" x 23" (46cm x 58cm)

Francis E. Sweet

SHOW AN ANIMAL AT EASE

African elephants command attention not only for their size but also
for their declining numbers. The animals' demise is an example of
human greed. Many artists present these beautiful creatures to make
the public aware of their plight and to draw attention to what we
will lose if we continue to ignore the facts. My depiction focuses on
the elephant's massive head and trunk in a passive pose that simply
shows the animal at ease.

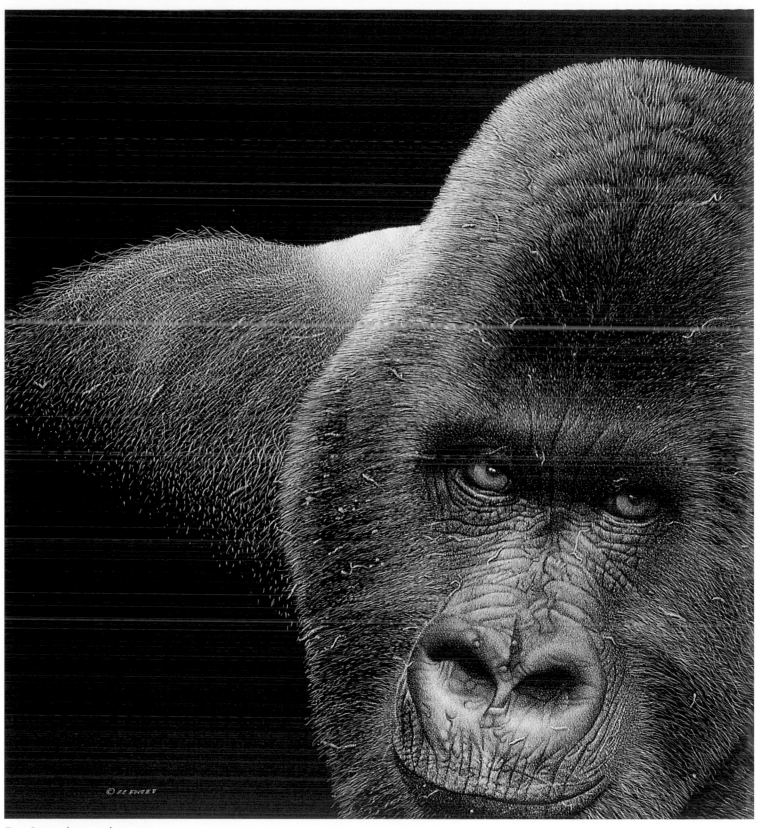

THE STARE (GORILLA)
scratchboard, 23" x 18" (58cm x 46cm)

Francis E. Sweet

EYES REVEAL THE SOUL

The gorilla's strength and capability to defend itself hide its gentle character. This is a species devoted to family love and protection. I executed this particular piece with a close-up of the face to show that gentleness. I used scratchboard because of its capacity for detail. It gave me the ability to show not only every hair but also to put emphasis on those kind eyes through pointillism.

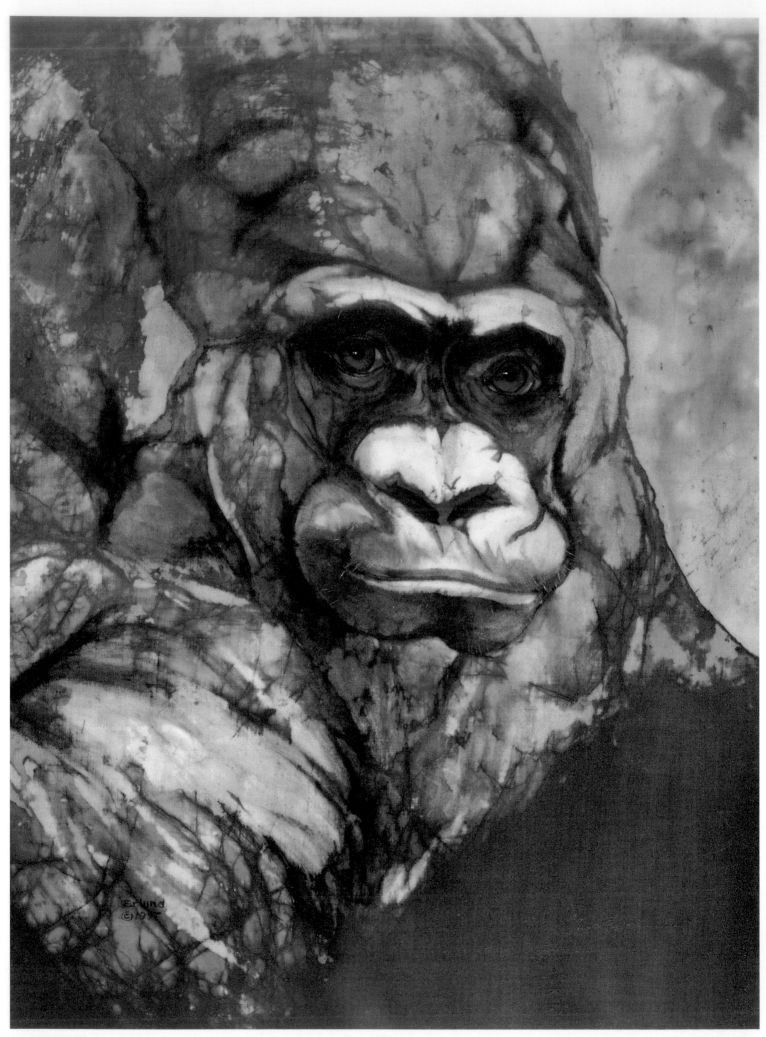

I Could Be You (LOWLAND GORILLA)
batik on cotton with acrylic paint, 14" x 11" (36cm x 28cm)

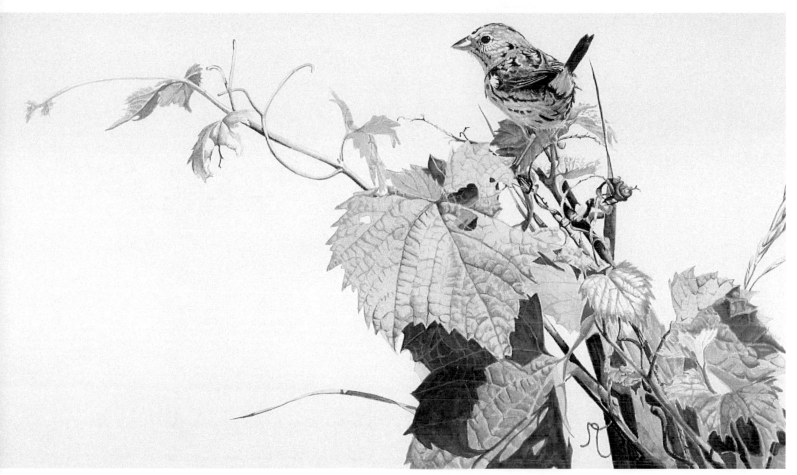

HENSLOW'S SPARROW AND GRAPEVINE
watercolor on Strathmore board, 8" x 14" (20cm x 36cm)

Scott Krych

CHOOSE SIMPLE LIGHTING TO EMPHASIZE PLUMAGE

While walking through a field one afternoon, I watched as several sparrows flew about and perched near me. The sparrows did not inspire me until I began to look more closely at their behaviors, as well as their wonderful plumage. I quickly sketched the birds in various poses noting identifiable field marks, posture and body shapes. I wanted to emphasize the subtle colors in the sparrows' plumage and to awaken interest in the ordinary. I chose a grapevine wrapped around an old goldenrod stem as the perch. First I worked on several sketches with full backgrounds and backlighting to set mood and give depth; however, these attempts drew attention away from the colors of the sparrows' plumage. Eventually, I chose watercolors on a white background to capture the delicacy of the plumage and midday light.

Beth Erlund

FOCUS ON THE FEELINGS IN THE EYES

When I looked at this gorilla he confronted my gaze directly. He showed neither fear nor shyness. He seemed to say, "It could be you in here." I took lots of pictures, and there was a quiet strength about him. I began to formulate my image and I really wanted the focus to be on the eyes. I could feel his sadness at being captive, and his sense of defiance. Batik is a process of producing a design with the use of wax resist and dyes. As I began to draw with the hot wax, I worked very hard to capture these feelings in his eyes. In traditional batik, the artist applies hot wax with a tjaunting (a brass cup mounted on a wooden handle). I used a large brush to make the hair more impressionistic, using lights and darks to indicate shape. I reserved the use of the tjaunting for drawing the face, particularly the eye area. I did my final details with the addition of some acrylic paint to the facial features.

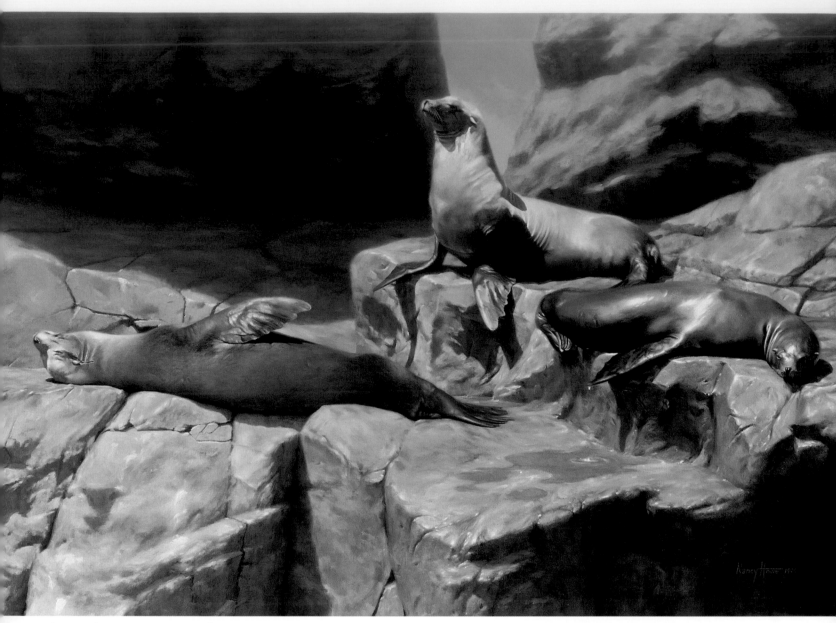

Sunday (California sea lions)
oil on linen, 24" x 36" (61cm x 91cm)

Nancy Howe

BEAUTY IN EVERYDAY ACTIVITY

These California sea lions fit comfortably into their rocky habitat. My initial attraction was to their languid body shapes as well as the contrast of their wet and dry surfaces. They also offered me a good excuse to indulge my fascination with the effects and warmth of sunlight. The key to the design rests on the location and shapes of the dark portions; they direct attention, providing contrast and quiet areas. First I painted the darker shadows and created the background with the proper structure of the rock formations in mind. A stab of Cobalt Blue sky interrupts the overall warm palette of the sea lions, breathing life into the painting and drawing attention to the animals.

Janet N. Heaton

TEACHING THE LITTLE GUY

Though I have seen groups of thousands of sandhill cranes, I had never before had the experience that I had observing this crane with its baby. As I sat on the bank of a marsh, a pair of these magnificent birds with one baby emerged from the thick, reed-like grass and walked slowly towards me. I sat still and watched until they were within five feet. Neither the parents nor the young bird ever appeared anxious about my presence. They continued to teach the little guy the technique of dipping their bills and most of their heads in the water to stir up and move potential food. The intense and watchful eye of the baby on its parents gave me the title of this piece—*The Lesson*.

The Lesson (sandhill crane)
pastel on Schoellershammer, 40" x 28 ½"
(102cm x 73cm)

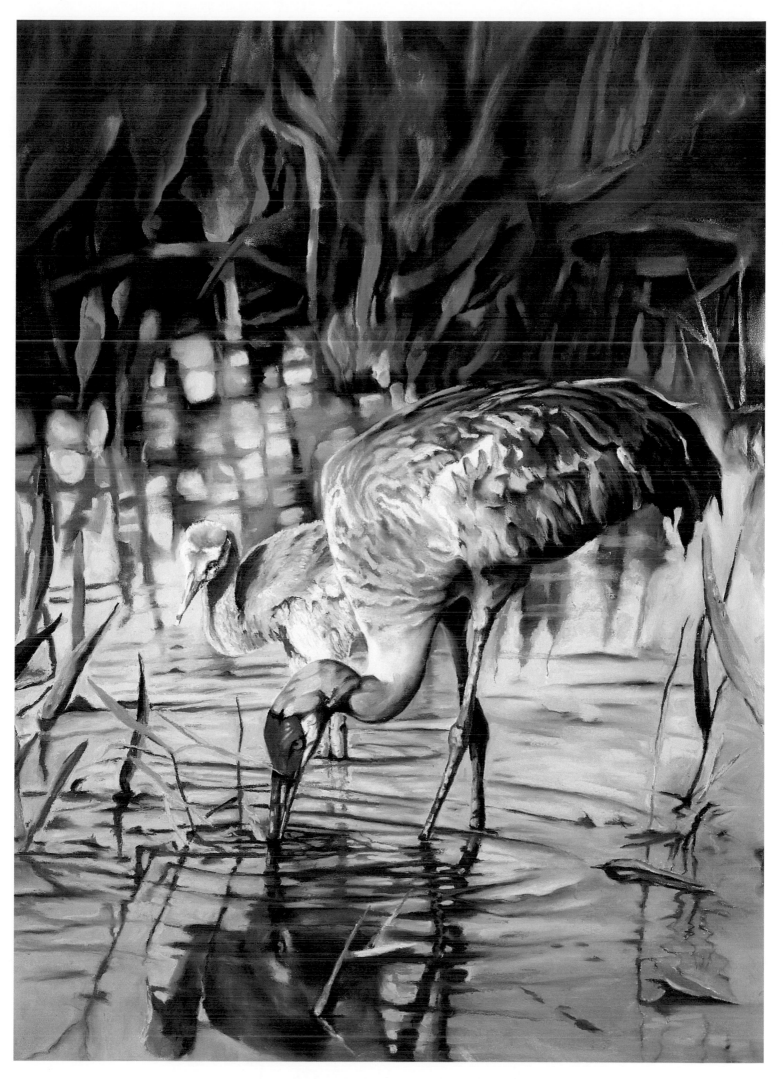

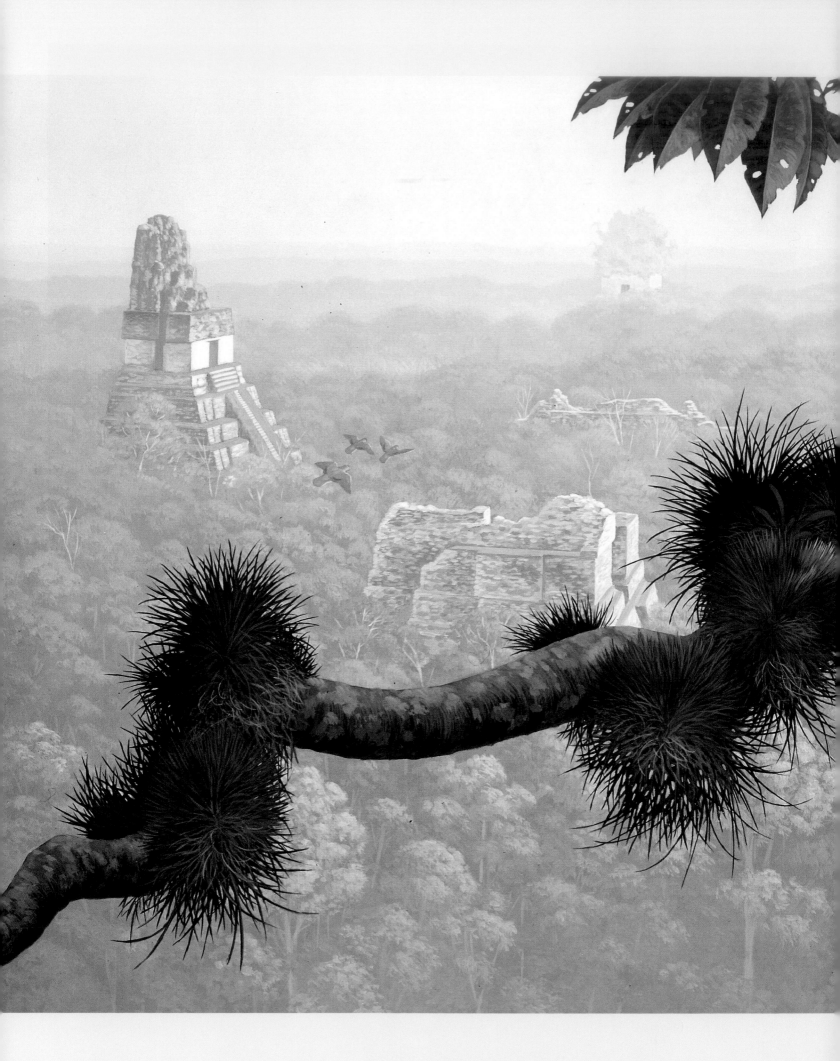

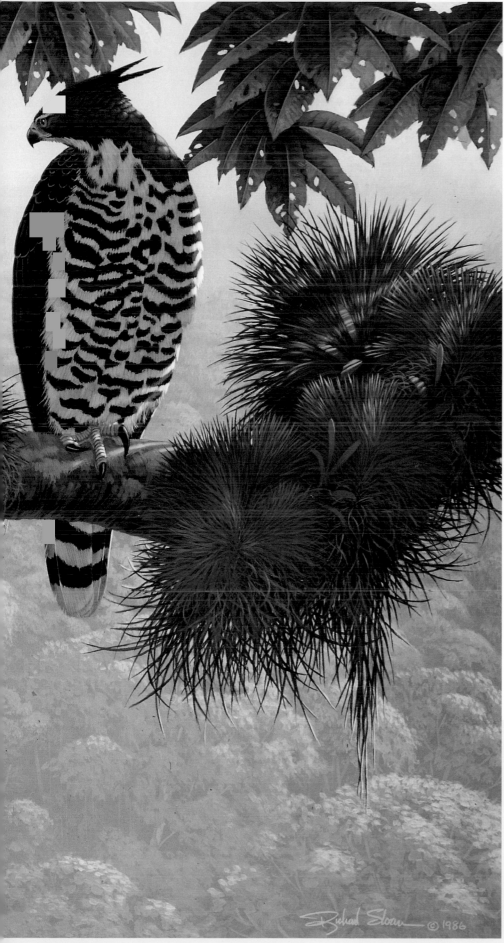

6

TAKE A

Different Viewpoint

The paintings in this chapter take an unusual or significant viewpoint, whether it is physical or psychological.

THE CITY AT SUNRISE (ORNATE HAWK EAGLE)
acrylic, 20" x 30" (51cm x 76cm)

I first visited the Mayan archaeological site of Tikal in the jungles of northeastern Guatemala in 1972. I went looking for birds, but the timeless beauty of this city and the art created by the Maya has been an inspiration. I thought it would be unique to paint this scene from the viewpoint of the ornate hawk eagle. The raised horizon line gives a heightened viewpoint. Lessened color intensity and lightened values cause the ruined temples to recede into the distance.

—RICHARD SLOAN

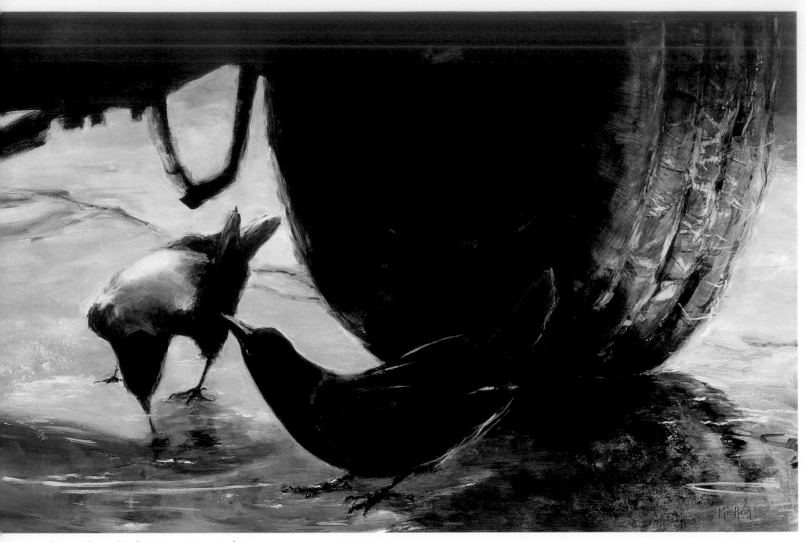

TRUCK STOP #2 (EASTERN GRACKLES)
acrylic on Masonite, 24" x 36" (61cm x 91cm)

Mae Rash

TRY LOOKING DOWN UNDER

One of the ideas from my series of street bird paintings came to me as I watched my
son wash his truck in our driveway. The strong black forms of tires and shadows
beneath the truck's frame suggested a powerful backdrop for the dark shapes of grack-
les, a common bird often seen in urban environments. I thought a view from under-
neath the vehicle looking out into the light would be memorable. You can read *Truck
Stop #2* as a black-and-white abstraction. I often position my paintings in sideways or
upside-down positions as I work on them, to keep abstract forms and compositional
values as important as content. Although this painting is about neutral tones of light
and dark, the suggestion of green grass at upper right gives a surprise splash of color.

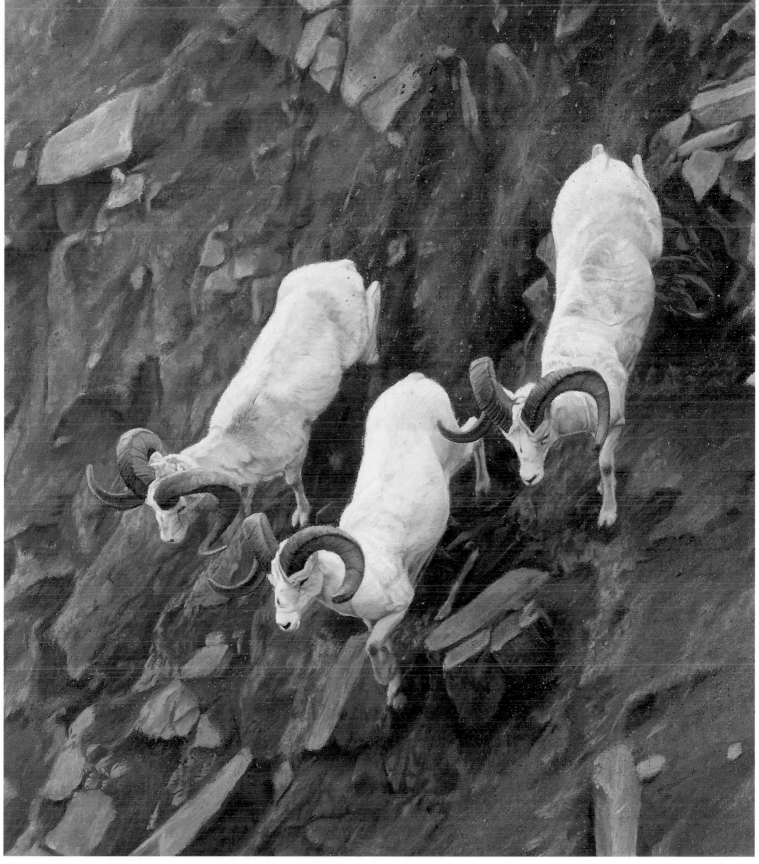

EXTREME (DALL SHEEP)
oil on linen, 30" x 25" (76cm x 64cm)

John Banovich

PAINT AN UNUSUAL ANGLE OF MOTION

The idea for *Extreme* originated while I was watching extreme skiers descend sheer cliff faces with an impressive display of skill and confidence. I placed the rams in a **V**-shape to mimic the shape of an arrowhead and emphasize movement. The simple, painterly background adds to the motion. I used an acrylic underpainting over the original pencil sketch to set a foundation of warm hues. Values bring the drama to life. The stark white bodies of the sheep contrast perfectly with the warm hue of the rocks.

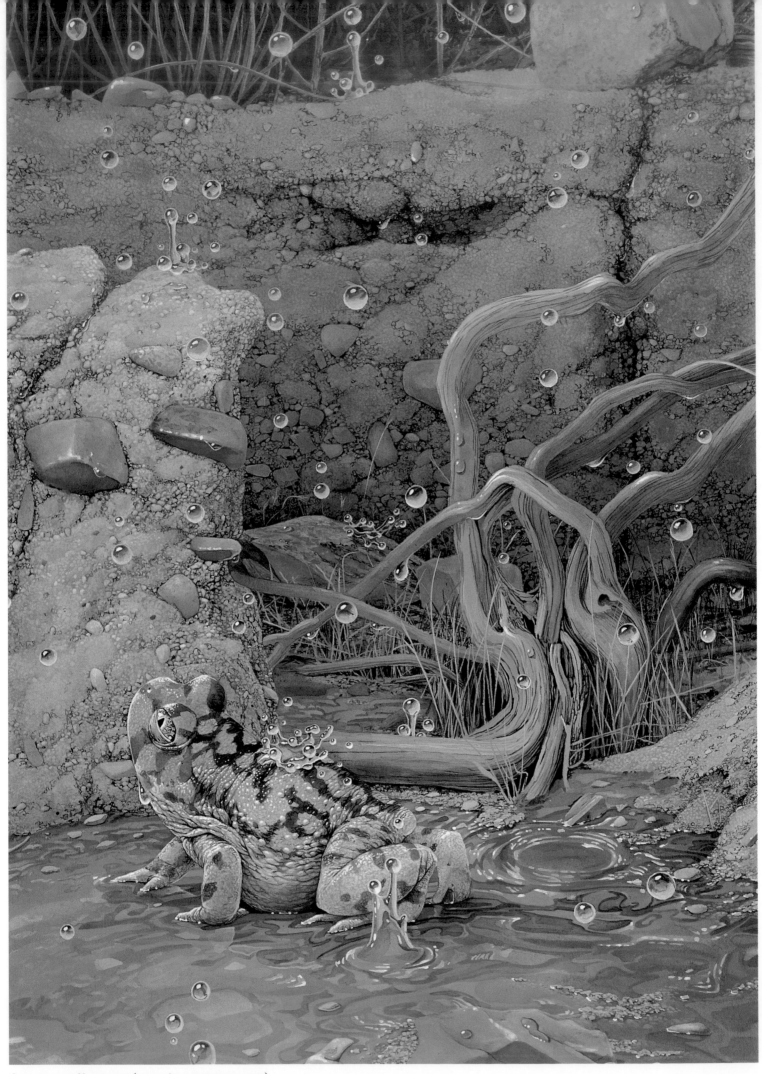

CALL OF THE MONSOON (COUCH'S SPADEFOOT TOAD)
acrylic on illustration board, 18" x 12" (46cm x 30cm)

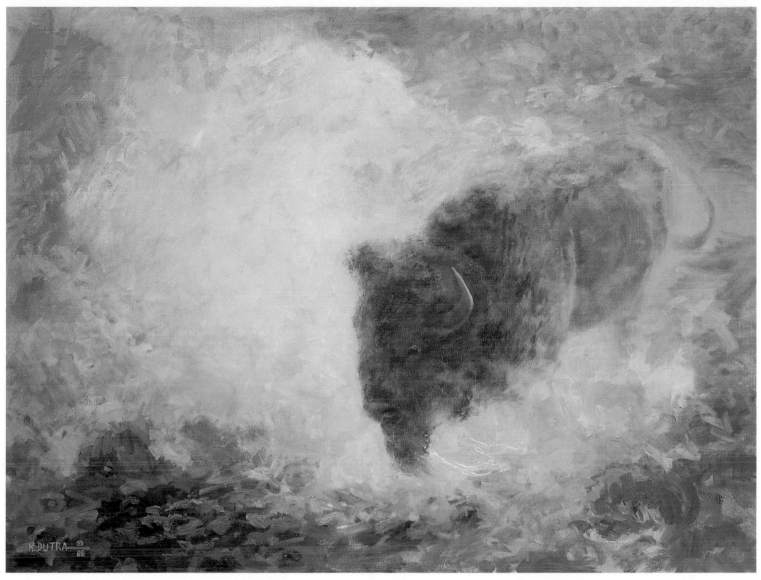

DUST DEVIL—AMERICAN BISON BULL
oil on canvas, 30" x 40" (76cm x 102cm) © 1998 Randal M. Dutra

Carel Pieter Brest van Kempen

GETTING A TOAD'S-EYE VIEW

Inhabitants of the arid American Southwest, Couch's spadefoot toads spend most of the year inactive beneath the ground, awaiting the summer monsoon rains. When raindrops finally strike the hard desert soil, the sounds beckon them to the surface where they breed in temporary pools. The rain is as important as the subject here is, so I drew the toad at the bottom of the piece with the viewer's eye level roughly equivalent to its own. The edges of a tiny gully tower above and form vertical lines that suggest the descending rain. I tried to position the subject in a way that suggests the ecstasy I imagine the toad must feel when revived like this. The same showers that draw out the toads cause the darkling beetle at top right to seek shelter under a rock. The diffused light and high reflectivity of water make painting a close desert scene during a rain challenging. Liberal use of Phthalocyanine Blue throughout the piece helps cool the colors and gives form to objects.

Randal M. Dutra

OBSCURE THE SUBJECT TO INCREASE INTEREST

I reduced this bison to a simple silhouette. The bold statement of a dark mass against a light background immediately draws the viewer's attention. The startled bull rises amid a blanket of choking, hot dust. Backlighting allows for greater color saturation in the dust clouds while it adds drama. The trodden soil and sage at the bottom of the canvas fix this beast on the ground. Otherwise, the powdered earth obscures his legs. The paint quality varies from thin, stained canvas to heavy impasto passages.

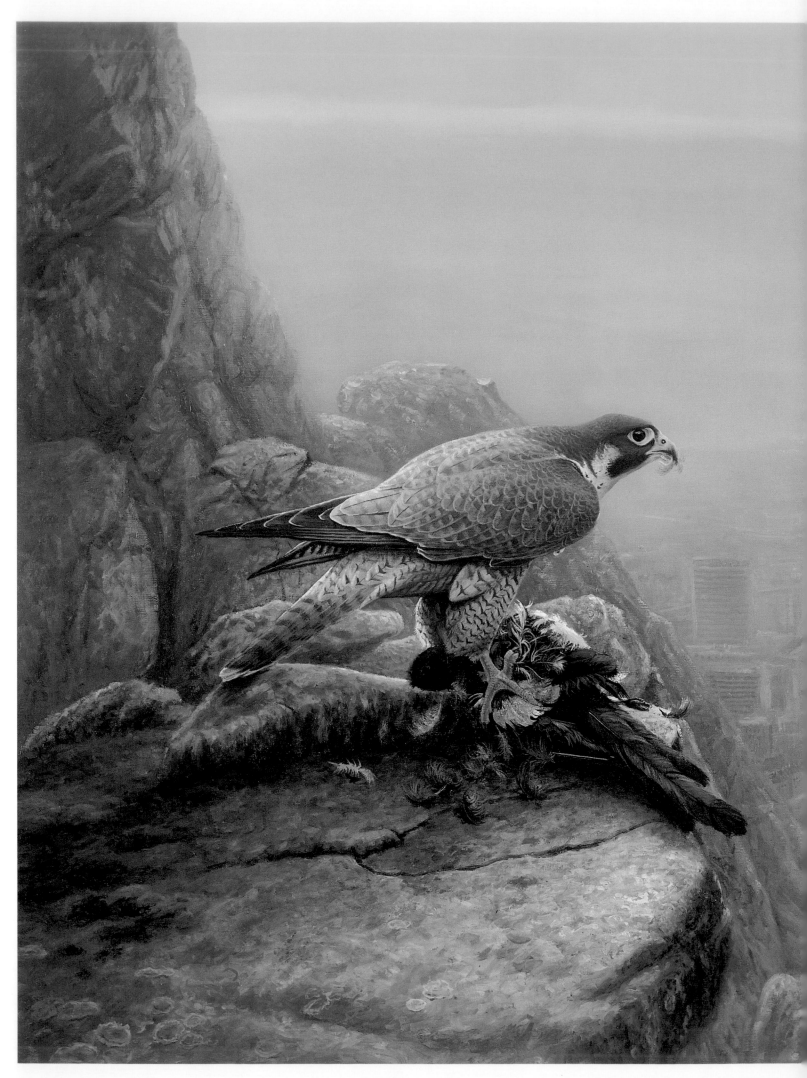

Bernd
Pöppelmann

PEREGRINE OVER TOWN
oil on linen, 39" x 54" (99cm x 137cm)

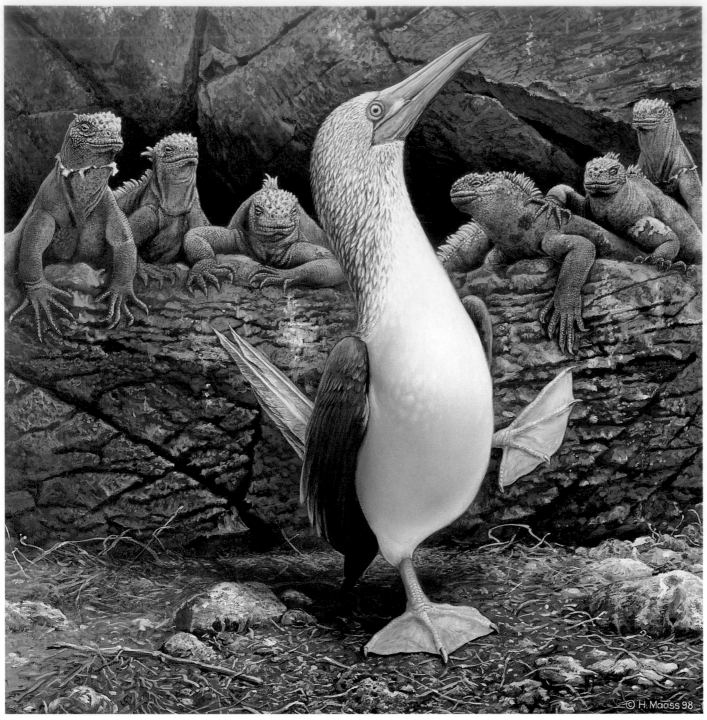

THE JURY (BLUE-FOOTED BOOBY AND MARINE IGUANAS)
acrylic on hardboard, 23 ½" x 23 ½" (60cm x 60cm)

Sueellen Ross

THE SUN PROVIDES A NEW VIEW

We had observed this bittern many times in the Seattle Zoo's Northwest Marsh exhibit. He was usually in the reeds with his bill up, looking more like a reed than a bird. On this brilliant August day, he was out in the open. Motionless, he gazed out over the green pond. The sunlight lit up his feathers, reflecting the amber and violet colors of the partially submerged reeds. This quiet brown bird suddenly glowed when the sunlight struck him. All of my mixed-media paintings use the same layer-by-layer application of India ink, watercolor and colored pencil. First, I do a very detailed graphite pencil drawing. Then I select those areas of the drawing that I want to be my darkest value; I fill these in with India ink. Then I put in as much color as I can with watercolor. Finally, I touch up, highlight, soften and enhance the painting with colored pencils.

Harro Maass

INSERT A LITTLE IMAGINATION

In real life it is unusual for boobies and iguanas to be so close together. The blue-footed booby prefers slightly higher regions of the Galápagos Islands and the iguanas live on the flat rocks by the sea. Can you imagine how boring it must be to show off your extraordinarily fantastic blue shoes only to those who have the same fantastic blue shoes? Sometimes you try to find a new audience. Even a dedicated realist such as myself can have enough of reality. I created a scene where iguanas watch the performance of this comic bird. More bored than impressed, they are, after all, of the reptile nobility and that is enough in itself.

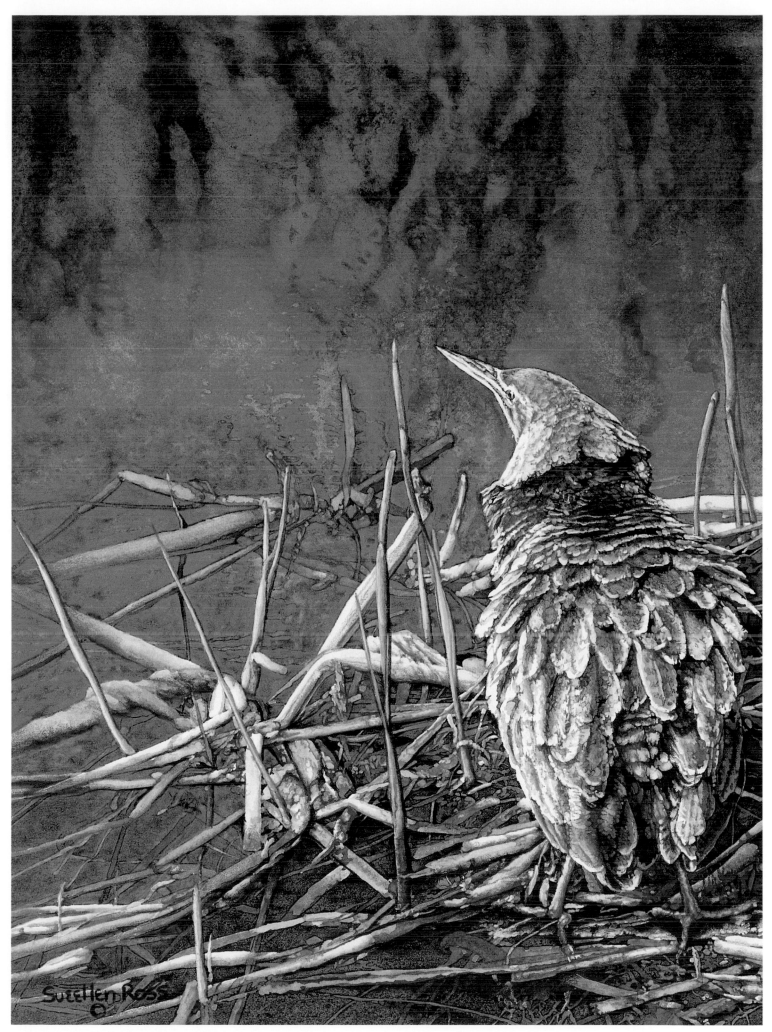

RUFFLED BITTERN (AMERICAN BITTERN)
India ink, watercolor and colored pencil, 11" x 8 ¾" (28cm x 22cm)

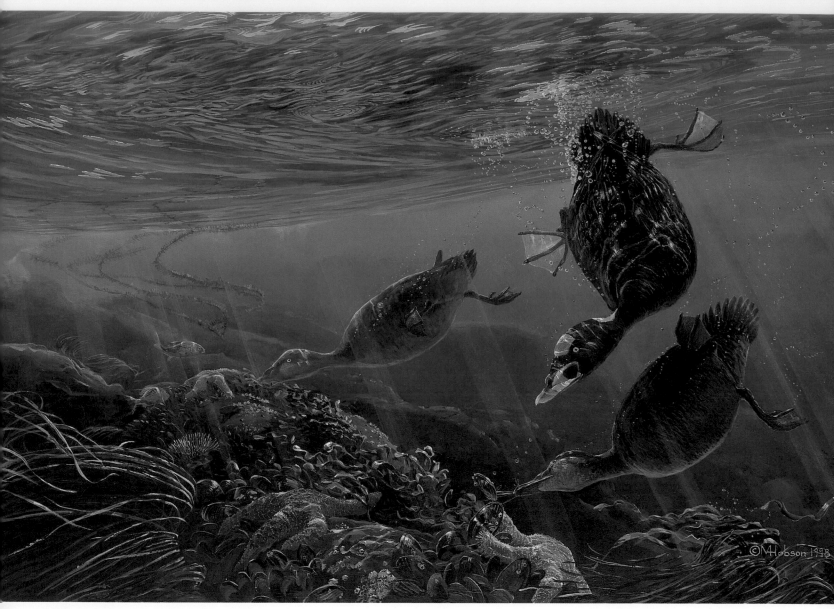

FANCY FOOTWORK (SURF SCOTERS)
acrylic on Masonite, 24" x 36" (61cm x 91cm)

Mark Hobson

AN UNDERWATER VIEW

As an artist that scuba dives, I often wondered what it would be like
to paint the reflections on the underside of the water's surface. *Fancy
Footwork* is an attempt to confront this challenge more than it is a
painting of ducks. In fact, I decided to paint surf scoters late in the
planning process, because of the bright color of the male's beak and
feet. The orange was the perfect complement to the emerald green
of the background. Another important choice was to set the scene in
shallow water. Light is not muted the first few feet below the sur-
face. Thus, the purple and orange highlights from the urchins and
sea stars are intense enough to reflect on the surface "ceiling." The
patterns of light that flicker under water are as if a huge net system
lies over everything that receives direct sunlight. To capture the real-
ism of these patterns, it helps to enhance the points where strands of
light cross one another with brightness. I enhanced the foreground
strands of light with touches of blue and red on their edges.

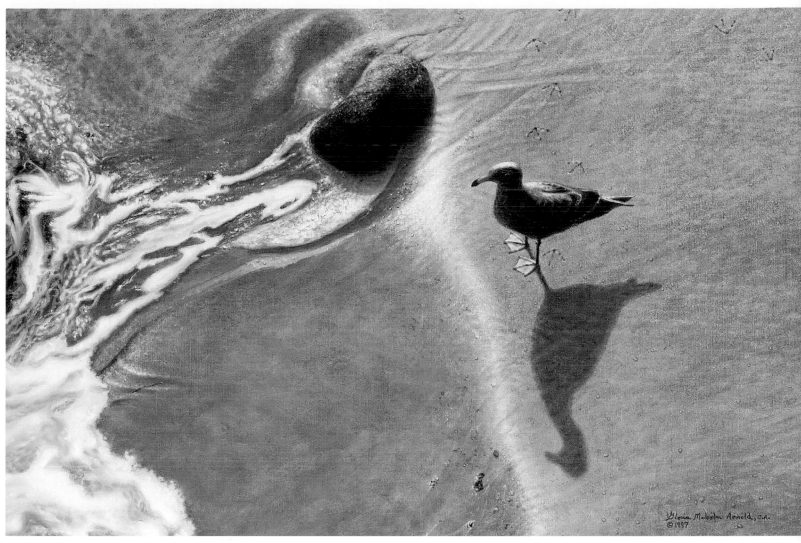

VIGIL BY THE SEA (SEAGULL)
oil on linen, 20" x 30" (51cm x 76cm)

Gloria Malcolm Arnold

WATCH BIRDS FROM ABOVE

There are many magical moments at the seashore. As I stood on the pier, I noticed this seagull engrossed in a watchful vigil accompanied only by the patterns of sand and water. The gull patiently waited as the waves endlessly splashed around him. This spoke to me both of timelessness and renewal. The viewpoint from the tall pier allowed me to watch him unnoticed. I wanted to paint him as realistically as possible, so I photographed him in several compositions and brought the photos back to the studio. I stippled and drybrushed sand textures with cool colors over a rich underpainting. I made the cast shadows look transparent by showing texture patterns through them. Light and shadow within the whites as well as selective dark accents give dimension to the swirling waves.

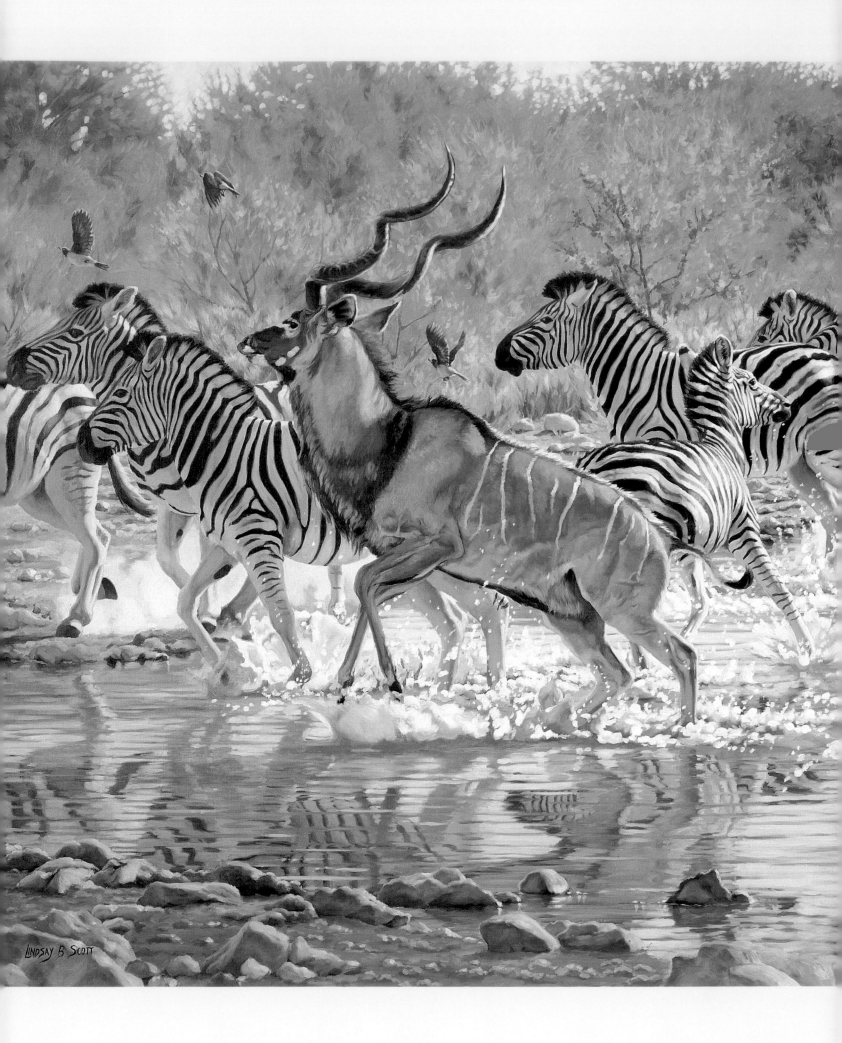

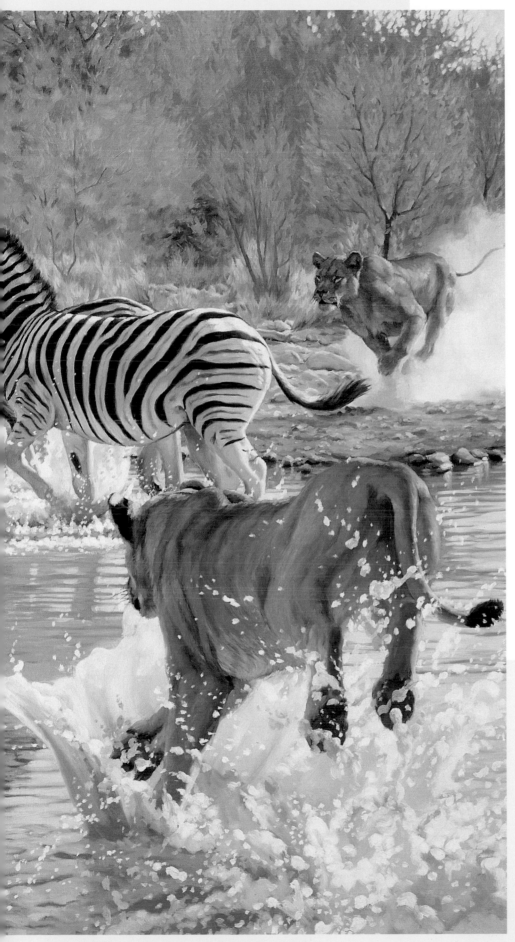

Action

In this chapter the art shows either typical or unusual action. It is as if reality has frozen in a moment of time.

In the dry African bush, the water holes are where the action is. Prey animals need to come here to drink, and they are very vulnerable in this situation. I have spent hundreds of hours at water holes watching the interaction and behavior of the different species. In the wild, the action is always so quick that it just leaves an impression of speed and action. To portray this, I studied slow-motion recordings of predators and their prey in action. Many elements point your eye towards the young zebra in the middle that is the object of the lion's interest. I used a limited palette to unify the complex action.

—LINDSAY SCOTT

AMBUSH (ZEBRA, GREATER KUDU AND AFRICAN LION)
oil on linen, 46" x 70" (117cm x 178cm)

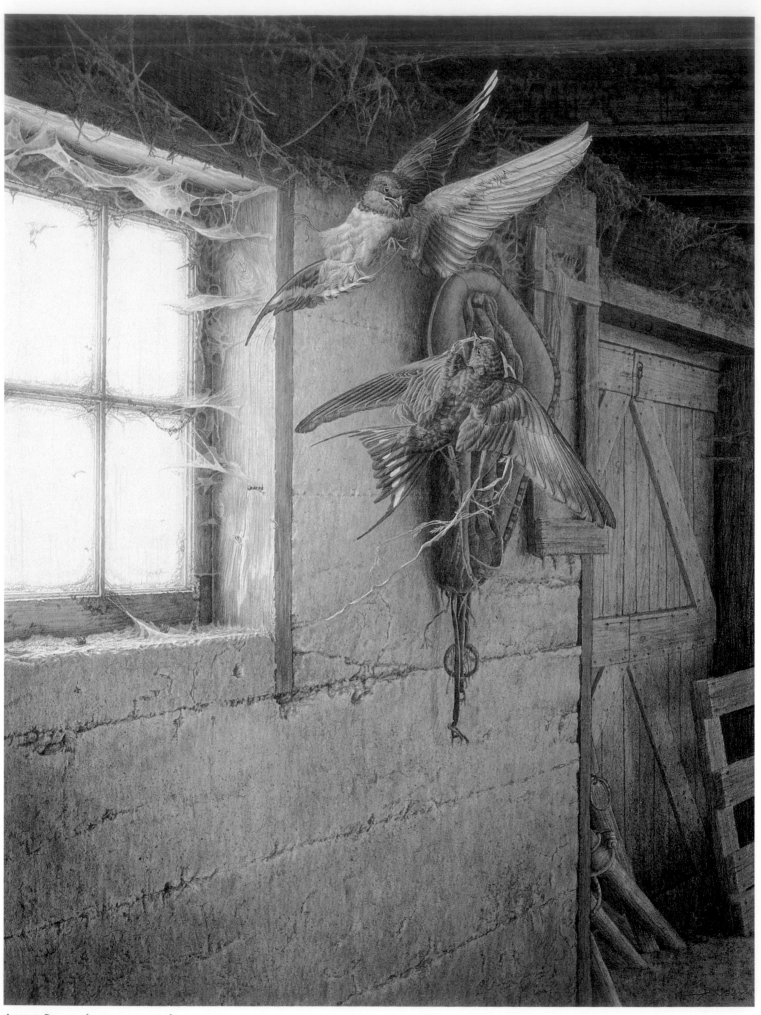

AERIAL BALLET (BARN SWALLOWS)
transparent watercolor on Arches paper, 27" x 20 ½" (69cm x 52cm)

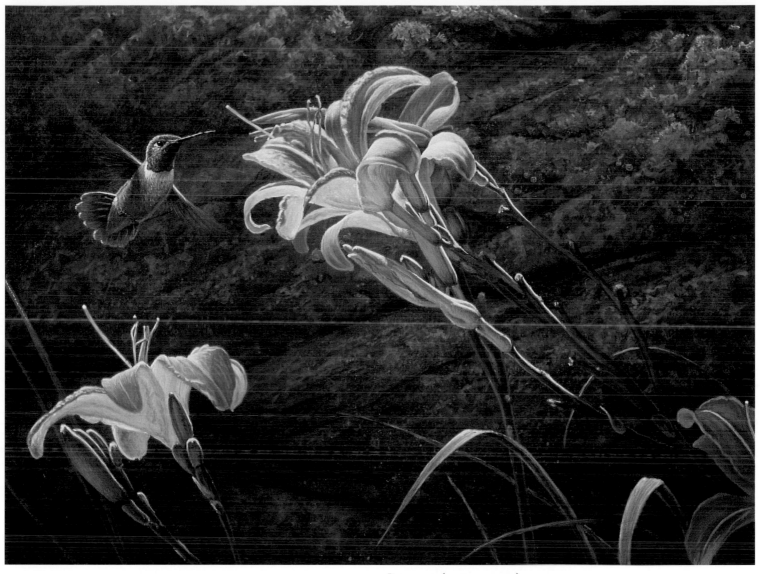

DAYLILIES (HUMMINGBIRD)
acrylic on board, 12" x 16" (30cm x 41cm)

Arnold A. Nogy

STUDY SKINS CAN AID REALISM

One spring day, while I was wandering the countryside looking at old barns to develop a painting I had in mind, the drama for another piece played itself out before me as two barn swallows flew in and out through a broken window past walls, beams and farm equipment. One would take straw from the other, then in a few moments it would be recovered. Their agility is virtually an aerial ballet. The few minutes I had to watch this were enough for the need to communicate this moment. I started drawing the barn from photos that I took but did much of the work in the barn. The birds were done life-size entirely from study skins provided to me by the zoology department of a university. I find this artistically liberating because I am able to paint a bird in any posture and not have to rely on photography at all.

George Lockwood

PAINT ONLY MOVEMENT YOU SEE

Sometimes I get the urge to use some bright colors, and this was one of those times. These daylilies grow in my yard. For a short time each day the sun hits the flowers but the background is in the shade, which makes the flowers appear to almost glow. I wanted to capture this. I made the background very dark, adding some cool blues and greens to make the flowers seem as bright as possible. I tied the two together by having the stems fade back into the shade. We have a lot of hummingbirds around our house, so I get a chance to look at them nearly every day. Their wings beat so fast that they only appear as a blur. Painting a static wing with feather detail just would not do. I simply tried to paint no more than I saw in an attempt to portray movement. I also contorted the body and fanned out the tail to convey action and avoid the more commonly portrayed profile.

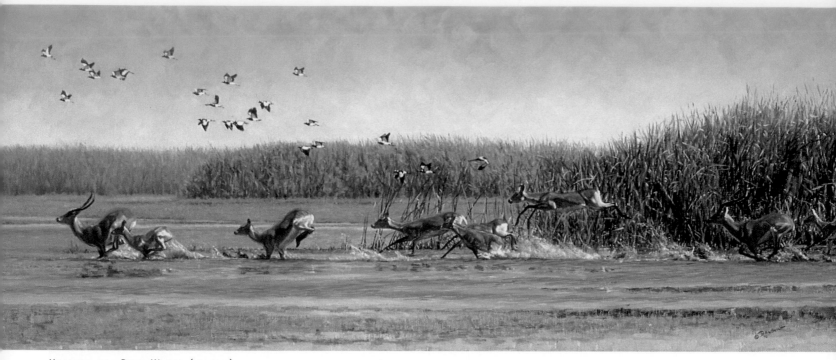

HEADING FOR DEEP WATER (LECHWE)
oil on linen, 12" x 25" (30cm x 64cm)

John Banovich

WATER CAN ENHANCE ACTION

Lechwe live throughout many swampy regions in southern Africa,
but for this particular study I journeyed to a remote area in Zambia.
As I waded in thigh-high mud and water (ruining a great pair of
hiking boots), the lechwe headed rapidly for deeper water when they
felt threatened. Roughly the same size as white-tailed deer, lechwe
possess elongated hooves to better steady themselves in the marshy
areas where they live. The focus of this painting is action clearly
enhanced by the painterly application of the oil. I portrayed the
movement of the lechwe in their postures (one up and one down,
like musical notes), but it's the water that gives the work action.

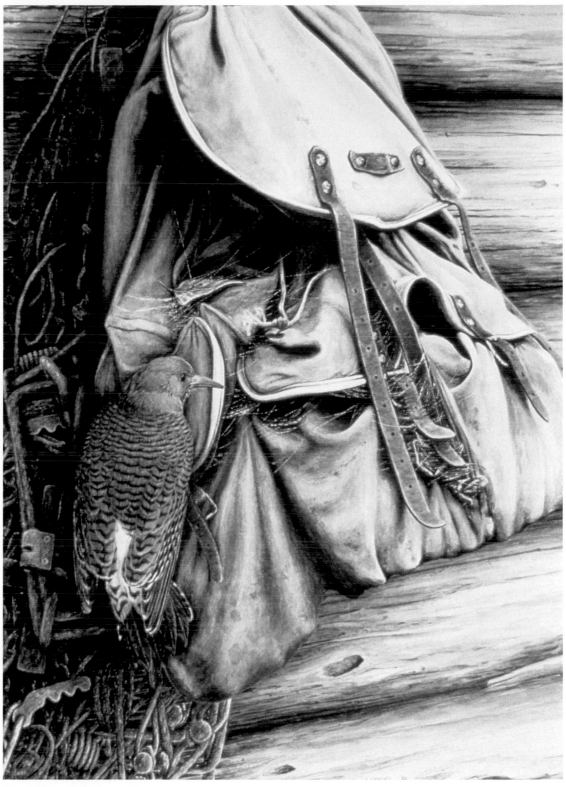

WEBS (NORTHERN FLICKER)
watercolor on Fabriano rag paper,
19 ¼" x 13 ¾" (49cm x 35cm)

Lex Alfred Hedley

SUGGEST AN UNKNOWN OUTCOME

As reference for this painting, I used detailed drawings of a rucksack and a window killed northern flicker. From there, I laid a wash directly onto the paper. Then I drybrushed texture over the rucksack and snares. I chose a color scheme based on the grays and reds of the flicker's plumage, accentuating the concentration on its face to emphasize its link to the unseen spider. This stare is a signal that something is about to happen. To maintain suspense and suggest an unknown outcome, I keep the spider's location from the viewer. Ironically, this spider's snare may lead to its own demise.

TUG O' WAR—LION CUBS
pastel on Canson paper, 28" x 42" (71cm x 107cm)

Dino Paravano

AMUSING PLAY AMONG BROTHERS

I came across this scene on a morning drive through a private game reserve. Under a thorn tree lay a couple of contented lionesses with some cubs that seemed to have had their fill from a wildebeest carcass. Two other cubs got hold of a bone, and neither one would let go. For a long time one would pull this way and the other that way. They would tire, close their eyes and rest awhile, then start their tug-o'-war all over again. The color and texture of the paper are very important to me because they influence tonal harmony. With the pastel I used bisque-colored paper because it worked best with the dry winter colors of the background and the lions. I block in and build on, leaving out unnecessary detail.

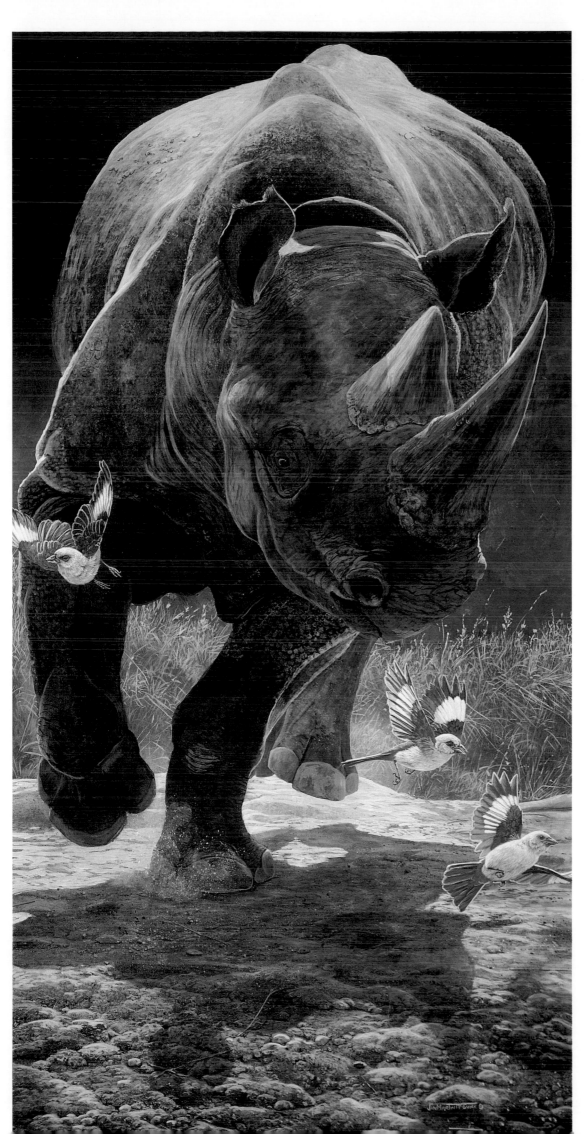

Ian Martin McGuire

FOUR TRICKS TO CONVEY MOTION

I had an idea in my head for a strongly backlit, big animal running towards the viewer. After my trip to Kenya, I decided a black rhino would fit the bill nicely. It can be hard to pull off motion in a painting. Cropping gives the feeling of size and power. Flying birds and kicked-up dust create motion. Highlighted color (the orange-like backlit areas on the ears and horn of the rhino, repeated in the birds) moves your eyes through the painting. I paint on very smooth Masonite with many transparent layers of washes to build up color, light and texture.

COMIN' THROUGH
(BLACK RHINO AND WHITE-HEADED
BUFFALO WEAVERS)
acrylic and Chromacolour paint on
Masonite, 48" x 24" (122cm x 61cm)

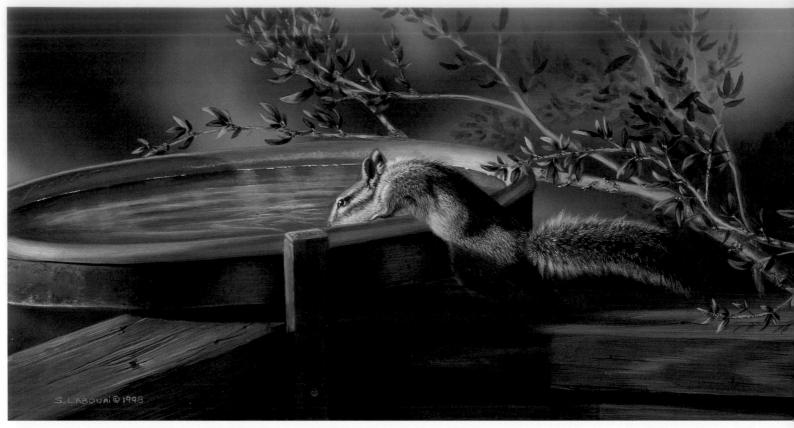

A TALL DRINK (MERRIAM CHIPMUNK)
acrylic on Masonite, 12" x 23" (30cm x 58cm)

Susan Labouri

OBSERVE ACTION ON YOUR FRONT PORCH

Action does not always need to be bold and energetic. Action can include the simplest of behaviors, things your subject does in every-day life. The key element is observation. Just step outside your door and watch. *A Tall Drink* is a good example of a scene that happens every day on my front deck. Using Masonite as a support, I airbrush about six coats of grayish-tinted gesso. This gives a smooth surface on which I can create any texture. There is the smoothness of the birdbath, the roughness of the wood and the texture of the iron-wood tree. One very important texture in wildlife art is fur. I start every furry animal with my airbrush, using the darkest colors to contour the muscles and body structure. I build the layers of fur after that. Sometimes I wash them back just to build them up again. It is not until the end that I pop in my lightest lights, darkest darks and the colors that are around the subject.

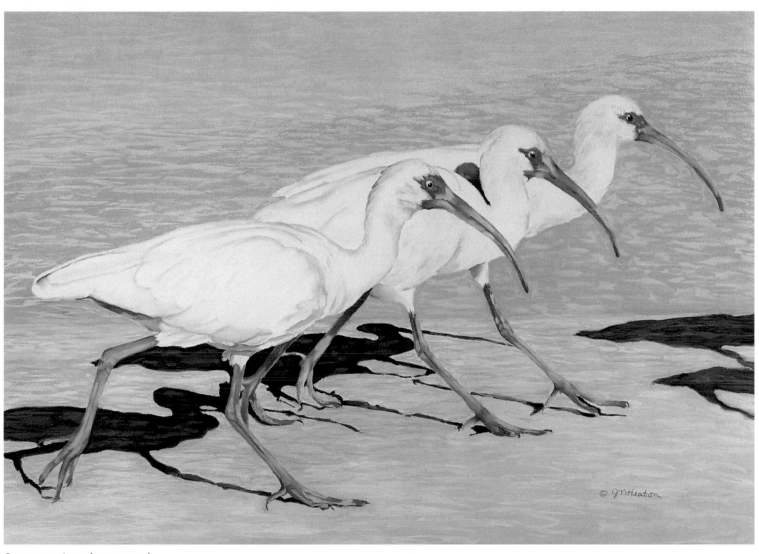

STROLLING IBIS (WHITE IBIS)
pastel on Schoellershammer paper, 28 ½" x 40" (72cm x 102cm)

Janet N. Heaton

SHADOWS DIRECT MOVEMENT

I grabbed the camera and started shooting after seeing a flock of two dozen white ibis in my front yard. The photos of the group of birds were interesting, but not as a painting. I found three birds that seemed to say, "Paint me." Their cast shadows cinched it for me. This is the most important part of the piece. The birds were originally feeding in the grass. I did not want to use the color green so I created a stylized habitat that they frequent—sand and water. The beautiful color of the ibis's bill and legs provides a strong visual interest.

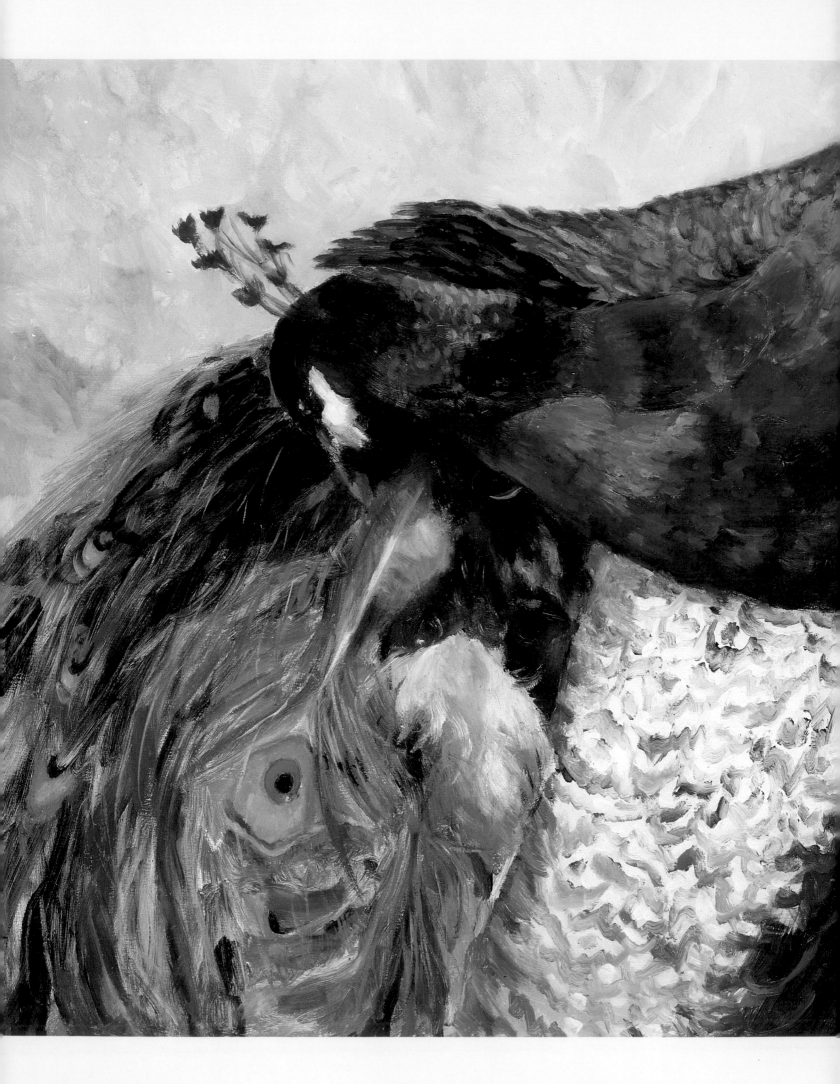

8

EMBELLISH YOUR PAINTING WITH

Color

The paintings in this chapter include the use of saturated color, a particularly colorful subject or the use of an interesting color scheme.

Sometimes you lose the softness of the feathers and contours of the shapes when you attempt to capture brilliant colors in birds. So I begin with an overall abstract design, then paint a naked bird. I use color and value to model the surfaces before painting the feathers. Most artists are aware of how color can express emotion, distance and so on, but many ignore the fact that color is the best tool for modeling surfaces. I sometimes kick the colors up for dramatic impact, but with peacocks you don't have to push the colors.

—JOYCE HALL

PREENING PEACOCK I (INDIAN PEAFOWL)
oil on composition board, 12" x 16" (30cm x 41cm)

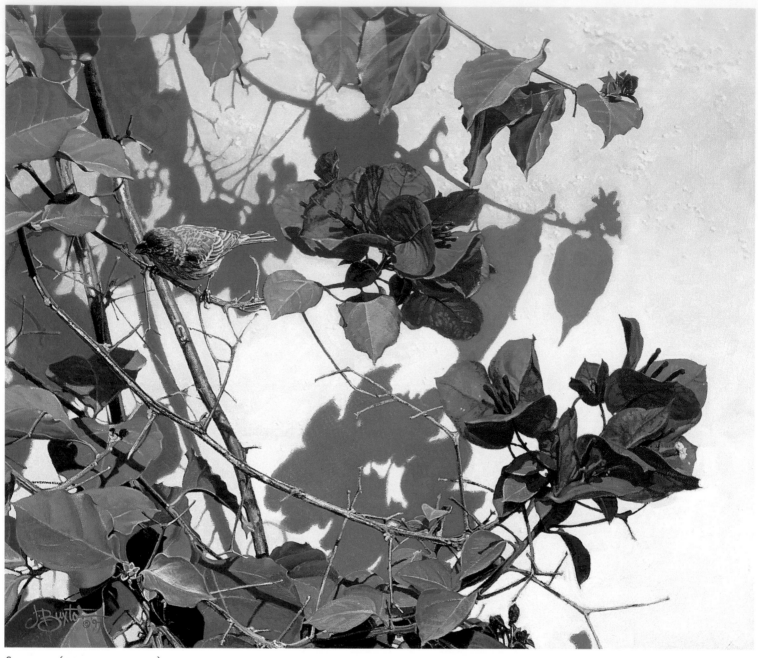

SHADOWS (MALE HOUSE FINCH)
alkyd on linen, 15" x 18" (38cm x 46cm)

John Buxton

CONTRAST COLORS OF FLOWER AND FEATHER

While on a visit to California, I was taken by the intense color of the winter bougainvillea against the white stucco. I took a few hurried photos. Back at my studio I worked out a composition from the photos. I wanted to add a bird. I chose to contrast the redder blossom with a house finch. By controlling the shapes and values of the shadows, I arrived at the desired repetition of shape and established a shallow depth. I added a subtle stucco texture for explanation.

Jan Martin McGuire

A COMPLEMENTARY SUBJECT ADDS PUNCH

It is easy to create a colorful painting when your subject is exotic, Neotropical rain forest birds. I saw these toucans in Guatemala a few years back. I love the sharp color contrast on their bodies, particularly their boldly patterned bills. I accurately represented the eye-catching complementary colors of red and green. I use a mixture of acrylics and a British paint called Chromacolour that has many of the same characteristics as acrylic, yet gives a softer, more velvety finish than the sometimes harsh, plastic appearance that acrylics can have.

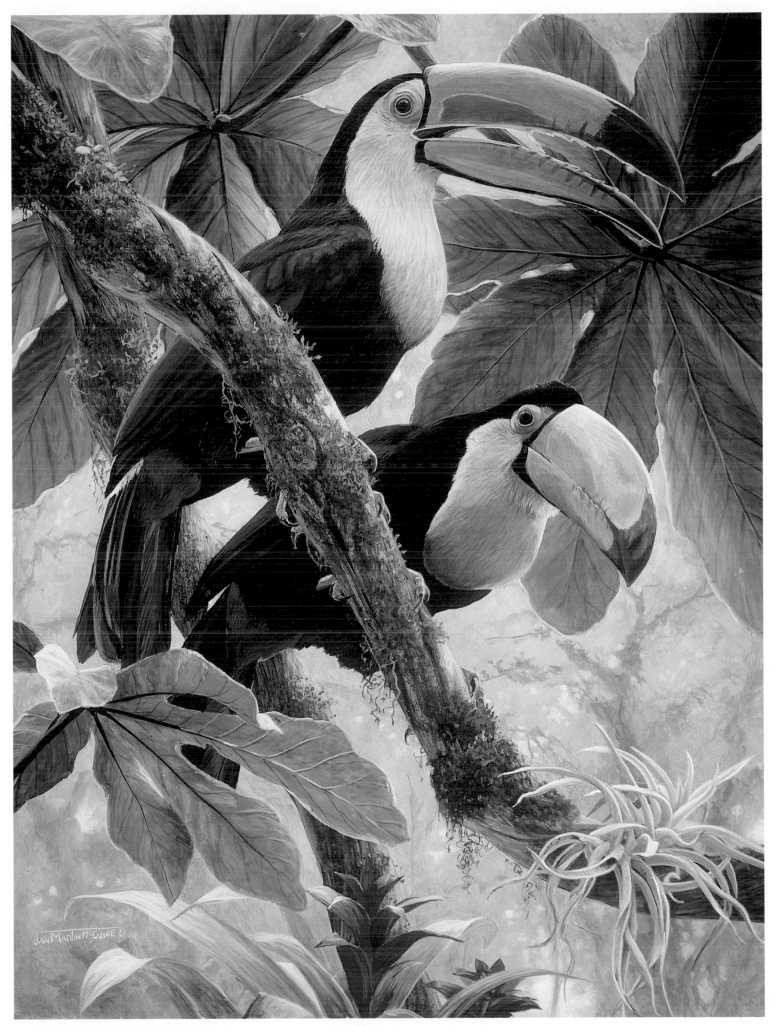

TWO TOUCANS (KEEL-BILLED TOUCANS)
acrylic and Chromacolour paint on Masonite, 18" x 14" (46cm x 36cm)

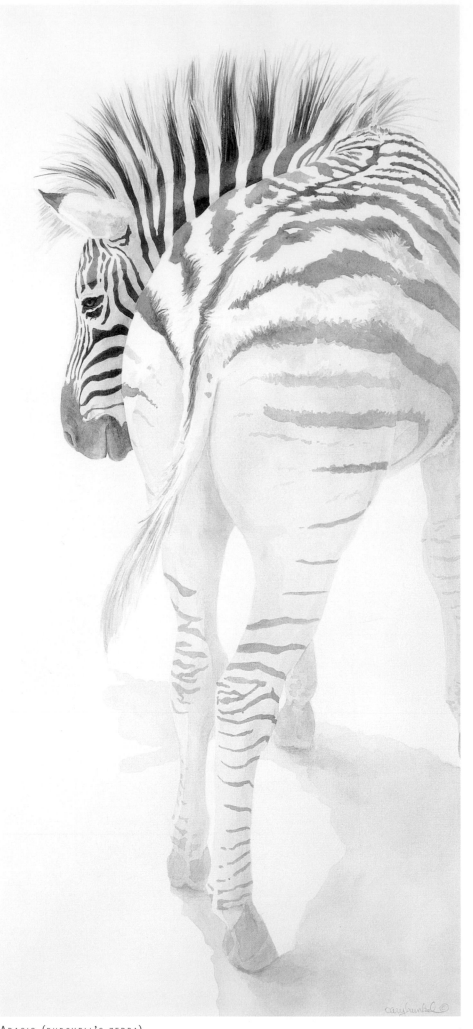

Cary Hunkel

WARM AND COOL GRAYS LEAD THE EYE

In my work I strive to create an impression rather than a depiction so that each viewer can almost feel the life in the animal. To do this I render the head and eye accurately while minimizing other details. With the glorious hues of our natural world removed, the elegant interplay of warm and cool tones becomes important. I did this painting with only two tubes of paint: French Ultramarine and Burnt Umber. I gradually built up layers of grays so that the gentle curve of the body leads the viewer's eye through the horizontal and vertical elements of the painting to its focal point—the zebra's eye.

ADAGIO (BURCHELL'S ZEBRA)
watercolor on watercolor paper, 27" x 13 ½" (69cm x 34cm)

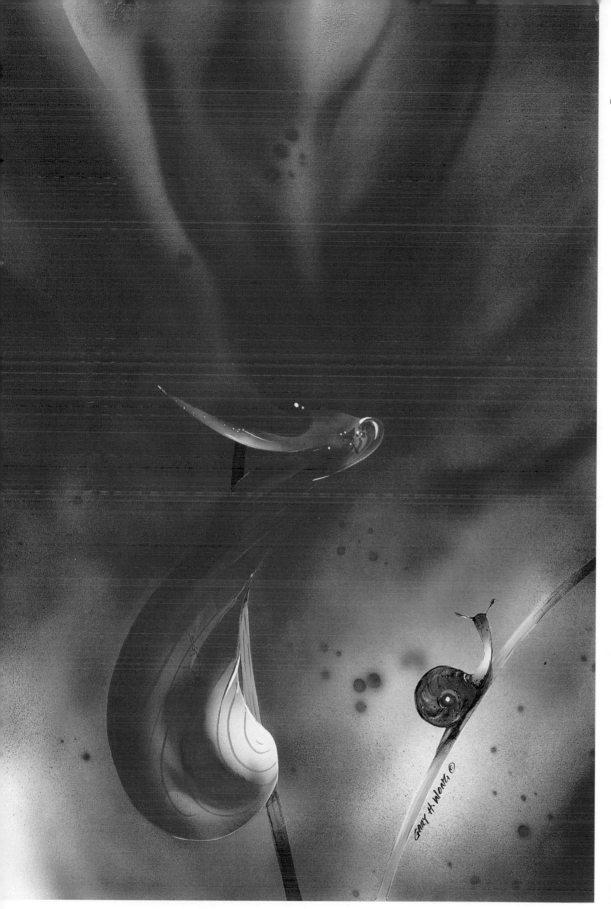

Gary H. Wong

I love the vividness and intensity of the cyclamen's magenta, purple and white petals. My wife had put a pot of magenta cyclamens under our patio shade. One morning a snail passed by and slowly climbed from one stem up to another. Its journey gave me the idea for *Garden Patrol*. I did not sketch the flower. I freely airbrushed its vivid magenta color onto the board. Then I used some opaque white to create the flower pattern and design. After I finished the cyclamen bloom, I painted the main subject—the snail.

GARDEN PATROL (GARDEN SNAIL)
airbrush paint on illustration board,
18" x 12" (46cm x 30cm)

RED AND GREEN (VERMILION FLYCATCHER)
gouache on illustration board, 19" x 19" (48cm x 48cm)

Harro Maass

A MOMENTARY FLASH OF RED IN A SEA OF GREEN

Green as far as the eye could see, the vermilion flycatcher the guide had promised us remained hidden in the epiphyte-covered trees, in swirls of the mist of Santa Cruz, in the Galápagos Islands. There was no sign of vermilion. Finally, it appeared; a tiny red spot flashed by. That was time enough to create a mental image. It was not the image of a specific bird but that of an almost abstract color-field painting—a small spot of brilliant red in an ocean of misty moss green.

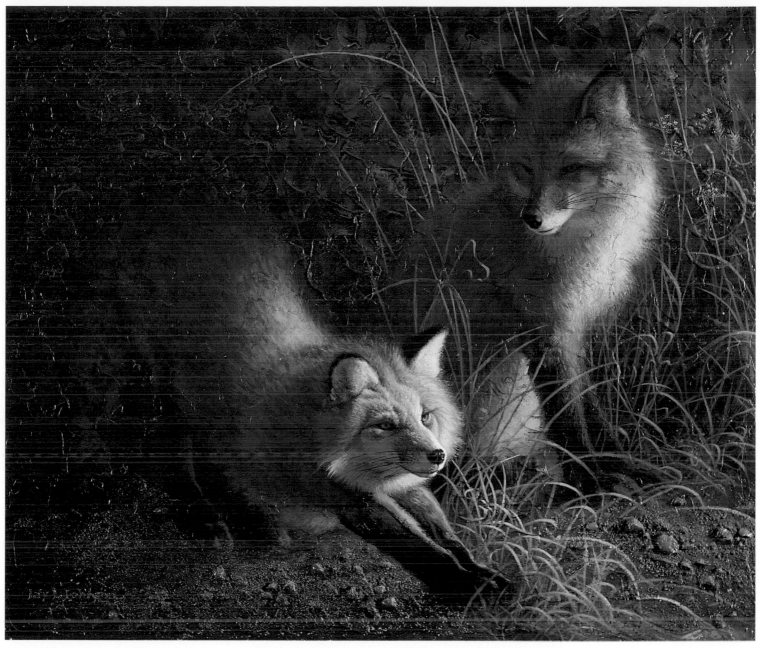

FOXFIRE (RED FOX)
acrylic on panel, 20" x 24" (51cm x 61cm)

Jay J. Johnson

SATURATED COLORS CAN PRODUCE RICH EMOTIONS

To achieve such a rich saturation of color in the foxes' fur without becoming too bright, I started with a dark background of Burnt Umber and Bone Black. Using an assortment of fiery colors straight out of the tube such as Red Iron Oxide and Cadmium Orange, I layered glazes on heavily with gloss medium. Over this dry, glossy coat of color, I put thin translucent glazes of background color over the shadowed areas with darker hues like Quinacridone Burnt Orange. Working from 35mm slides of foxes in captivity, I observed the details of the body fur and facial features while exaggerating the color. While painting the highlights of the front fox, I discovered that adding white to paints made them less vivid. I was better able to create the effect of bright light with such brilliant hues as Cadmium Yellow. Only the very tip of the front fox's nose has highlights of pure Titanium White to make it pop out. If used effectively, saturated colors can bring a painting to a much higher level of realism and emotion than muted colors. It is always a thrill for me to see foxes in the wild.

Gamini Ratnavira

TWO SPECIES, SAME COLORS

In the rain forest color serves several purposes. The animals, birds and plants use color to display, repel, conceal, communicate, warn and survive. Though tanagers feed on small reptiles, in this case the Amazonian frog uses his brilliant colors to warn of his toxicity. You can find both species up on the forest canopy. This particular frog hardly ever descends to the ground. It intrigued me to bring together two species found in the same Peruvian forest with almost identical coloration. First I painted the details of the birds with Sepia. Then I layered colors to develop the shape and form of the birds. I brought the brilliance out first with watercolor and then painted over the subjects with gouache.

WHO'S THE FAIREST? (PARADISE TANAGERS AND AMAZONIAN POISON FROG)
gouache and watercolor on clayboard, 16" x 11" (41cm x 28cm)

Daniel Smith

SET A BRIGHT SUBJECT AGAINST A MUTED BACKGROUND

Parrots hold a special place in my heart. We have two as pets in our home; an African Grey and an eclectus. They are great companions. Hyacinth macaws are not common in the pet trade due to their endangered status. They are very vulnerable to habitat encroachment because of their specialized diet. I studied and photographed this macaw in a captive setting. I chose to paint an animated pose; the cocked head and raised foot give the bird a sense of personality. It is a rare treat to have an occasion to use such bold primary colors on a subject. To enhance the color contrast, I chose a muted palette for the moody background. The bright yellow accents on the head make a perfect focal point.

HYACINTH MACAW
acrylic, 21" x 14" (53cm x 36cm)

Edward DuRose

WARM SUBJECT, COOL SHADOWS

My favorite time of the day to photograph reference material is early morning or late afternoon. This particular painting is of an area in Teton National Park. It was early evening, and the sunlight coming across the creek bed created cool shadows across the warm colors of the rocks. It was this color contrast that I tried to express throughout the piece. I unified the composition by repeating the blue and gold of the rocks in the color of the elk.

Frank Mittelstadt

NATURE PROVIDES A PERFECT COMPLEMENT

A friend of mine, who lives in a secluded wooded area, had erected a small corn crib in his yard to feed wildlife through the winter. The brilliant blue and purple plumage of the jay are a perfect complement to the equally intense yellows and oranges of the corn. The stripes on the bird's wings and tail also echo the pattern found in the ears of corn. To paint the corn I mixed gloss medium with the paint to imitate the waxy translucence of the kernels. Conversely, I used matte medium in the washes that define the bird's soft feathers and the dull finish of the corn husks. While working on this piece I placed ears of corn against the painting to check the colors. To my surprise, I rendered the scene exactly life-size!

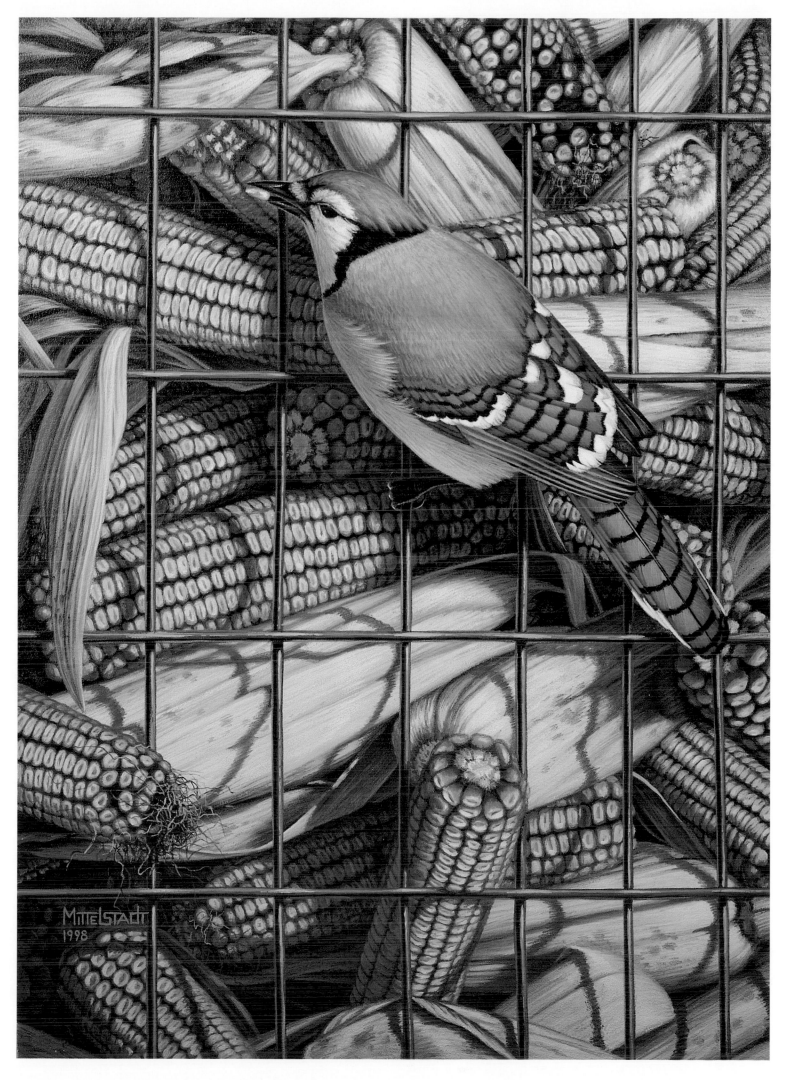

Zion's First Light (mule deer)
oil on board, 20" x 24" (51cm x 61cm)

Julio J. Pro

COLOR AND LIGHT REVEAL EACH OTHER

When light strikes a surface it enhances and makes color visible. Without light there cannot be color. So the artist must manipulate light and color into organized patterns that please the eye and tell a story. *Zion's First Light* tells the story of the first light of day revealing the colors and tender relationships of nature.

Kathleen Dunn

LET COLOR SOFTLY DOMINATE

My love affair with bigleaf maple, although I have painted it often, seemed incomplete until *Blue Velvet*. I finally tried to capture the essence of a maple in spring. Diagonals created by the mossy, backlit branches were the painting's strength until the light through leaves and flowers gave it magic. The jay counters the swing of the branches. Her iridescent blues lend impact, while the indecision in her pose creates the tension that in a moment—when you blink—she may fly away. Color dominates over structure to draw the eye to the bird and complete the drama.

Blue Velvet (steller's jay)
oil on board, 37" x 20 ½" (94cm x 52cm)

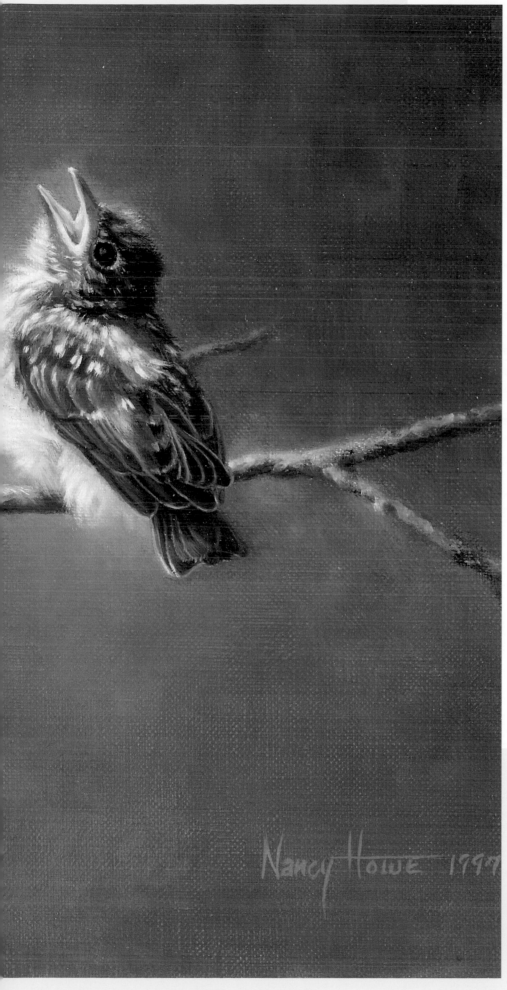

9

DEPICT AN EXPRESSIVE
Pose or Behavior

These paintings portray either an unusual or particularly expressive pose, attitude, place, position or behavior.

A friend who had hand-reared two orphaned bluebirds asked me if I wanted to observe and photograph them up close before releasing them into the wild. As they had not yet grown into their full-color blue plumage, it was clear that a painting of these youngsters should capture their natural character. I selected three poses that function well in a composition. I suggested only a minimal background in a limited complementary palette that echoes the colors in the birds.

—NANCY HOWE

LITTLE BITS OF SKY (EASTERN BLUEBIRD FLEDGLINGS)
oil on linen, 10" x 14" (25cm x 36cm)

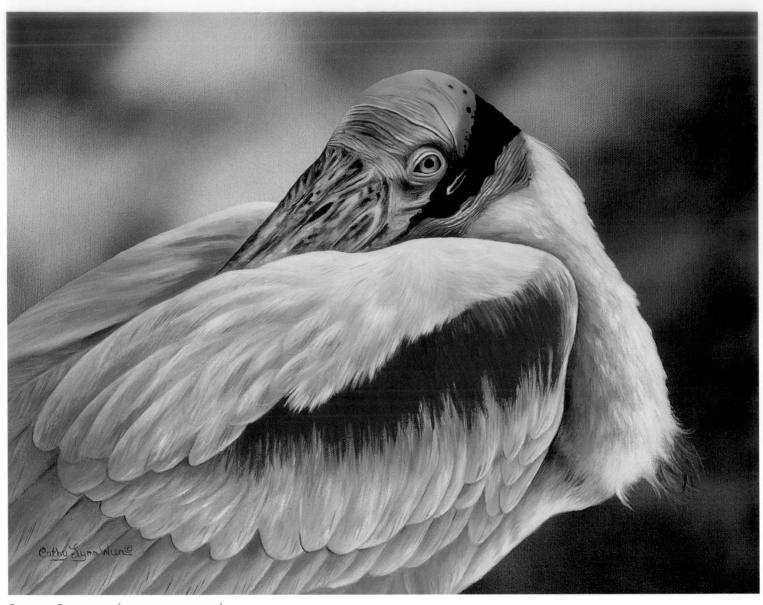

RESTING SPOONBILL (ROSEATE SPOONBILL)
acrylic on canvas, 14" x 18" (36cm x 46cm)

Cathy Lynn Wier

POSTURE REVEALS DRAMA OF CONTRASTS

The fortunate occurrence of a cooperative subject permitted the detailed examination necessary for this work. A delicate pale pink body with brilliant red shoulder coverts provides a range of color intensity. I duplicated the shades with Naphthol Red Light, Naphthol Crimson and Deep Violet blended with Titanium White. I applied the color in semitransparent coats. The posture enhances the dramatic contrast of the featherless head and soft pink body. The eye is the focal point. Rendered in red-orange and highlighted with yellow, its large pupil reaches out to the viewer. The complementary green tones used in the background enhance depth and increase contrast.

John Buxton

AN UNEXPECTED PERCH

As I developed my painting, we had strong spring storms. I wondered how young birds survived. Some would surely blow from the nest too early. I did not wish to show a poor wet fledgling or anything negative—just a youngster someplace where it should not be. My young robin is too young to fly but found a perch on top of a basket handle.

OUT 'N ABOUT (YOUNG ROBIN)
alkyd on linen, 25 ½" x 15" (65cm x 38cm)

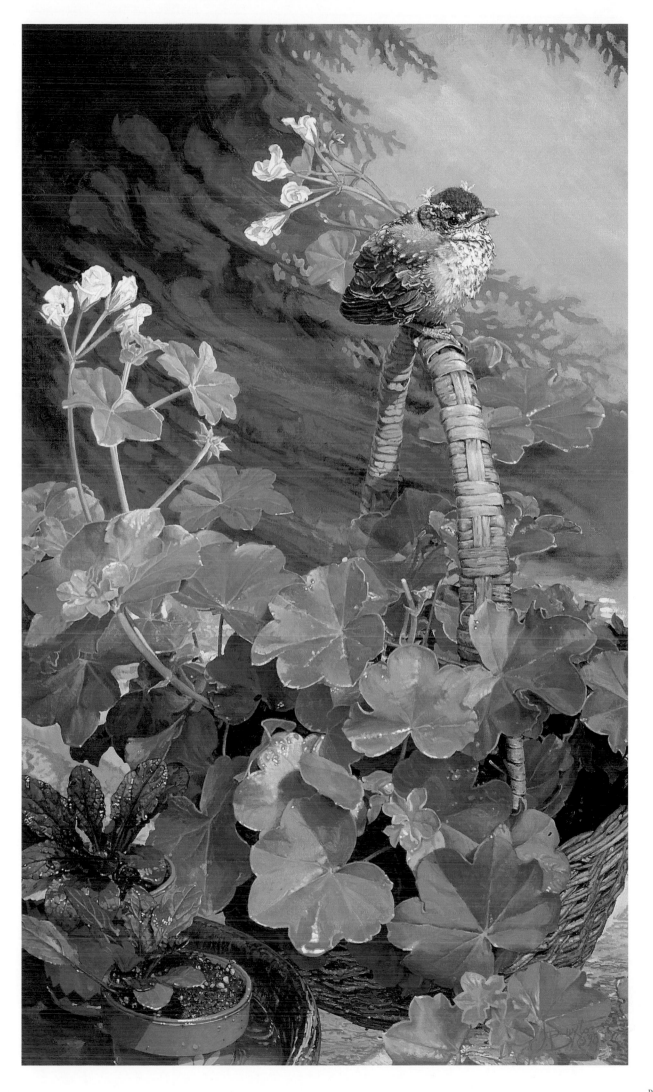

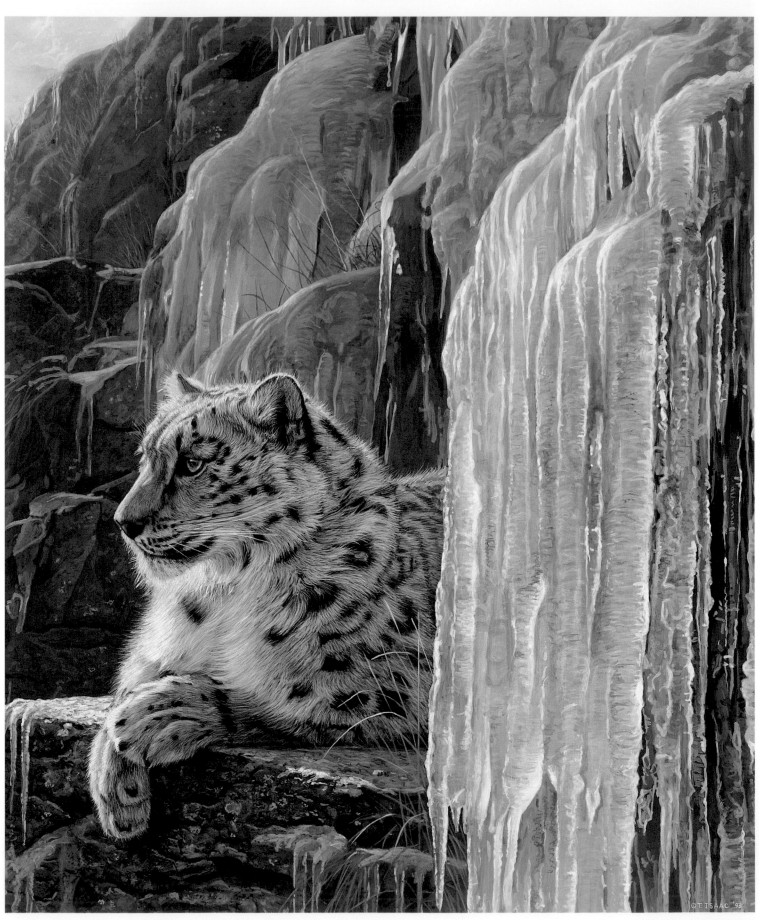

CRYSTAL PALACE (SNOW LEOPARD)
acrylic on Masonite, 22" x 18 ½" (56cm x 47cm)

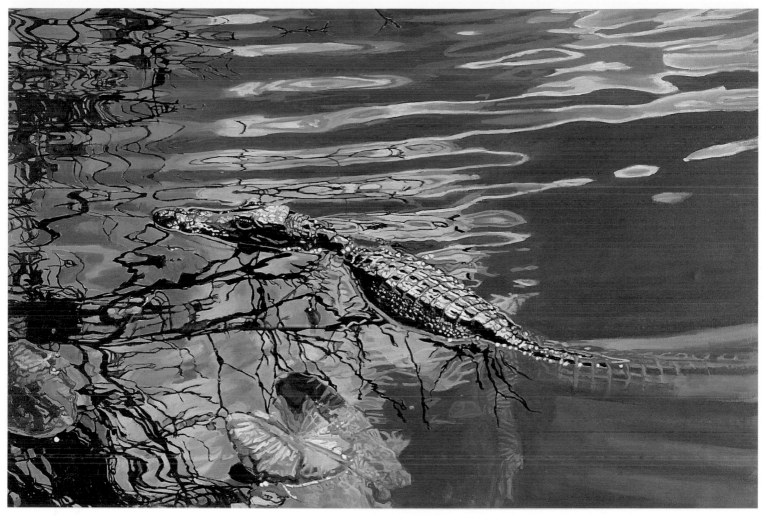

MOONLIT GATOR (ALLIGATOR)
oil on Belgian linen canvas, 28" x 42" (71cm x 107cm)

Mary Louise O'Sullivan

A WELL-DESIGNED 'GATOR

In south Florida, alligators are part of life, kind of ho-hum. One can not only photograph alligators but also pick a specific pose, scene, size and setting. I love their patterns when they are partially submerged, particularly when in proximity to a similar design in the water—in this case a tapestry of geometric branches and reflections. I use photography as an aid, and I did many different exposures of this subject. I found the underexposed photos more interesting, almost eerie—appearing to be night. I prime my canvasses with colored gesso—usually either a middle gray tone, or umber. If the subject is black, white or there is blue water involved, I usually go for the gray. I find it sets a mood and gives unity to the whole. I found the bright droplets of water on this alligator similar to jewels set in filigree.

Terry Isaac

UNIQUE SETTING CALLED FOR SNOW LEOPARD

When I first saw and photographed the reference for the icicles, I thought that a snow leopard would make a good subject. In nearly all my paintings, the setting generates the inspiration and concept. Then I choose an appropriate subject to fit the scene. Beautiful, endangered snow leopards live in the cold, mountainous countries of Central Asia and Russia. I painted this one on a rocky outcrop surrounded by ice. The cat has an attitude of awareness. The eyes are the focal point.

NO, YOU GO FIRST! (TIGER CUBS)
Lesley Harrison, pastel on velour paper,
13" x 26" (33cm x 66cm)

Lesley Harrison

COMBINE GOLD TIGERS AND BLUE WATER

Tigers are a favorite subject because they like to be in water, another favorite subject.
In *No, You Go First!*, the tigers' beautiful, gold, muscular bodies against that blue-green
water make a fabulous combination. Water is a difficult thing to paint. It's so easy to
overwork. Put half as much into it as you think you should. You might see that it
looks fresher and clearer if you do not belabor it.

RECLINING TIGER
acrylic, 24" x 40" (61cm x 102cm)

Matthew Hillier

UNDERWATER STRIPES

Unlike other cats, tigers spend lots of time in and around water, particularly in the
intense heat of the dry season in India. I enjoyed the challenge of the tiger stripes
underwater. It was a great excuse to use a looser treatment on the submerged fur.

WATCHIN' CLOUDS (CHEETAH)
Lesley Harrison, pastel on velour paper,
12" x 17 ½" (30cm x 45cm)

Lesley Harrison

CATCH A DAYDREAM

I always look for unusual poses to paint. This cheetah spoke to me because, as a child,
I used to love to lie down in the grass, look up at the clouds and daydream. When
someone sees my works, the question is always, "How do you get that detail in pastel?"
I keep a piece of sandpaper mounted on a block of wood next to my table and sharpen
the pastels whenever I need fine detail such as the hair on this cheetah.

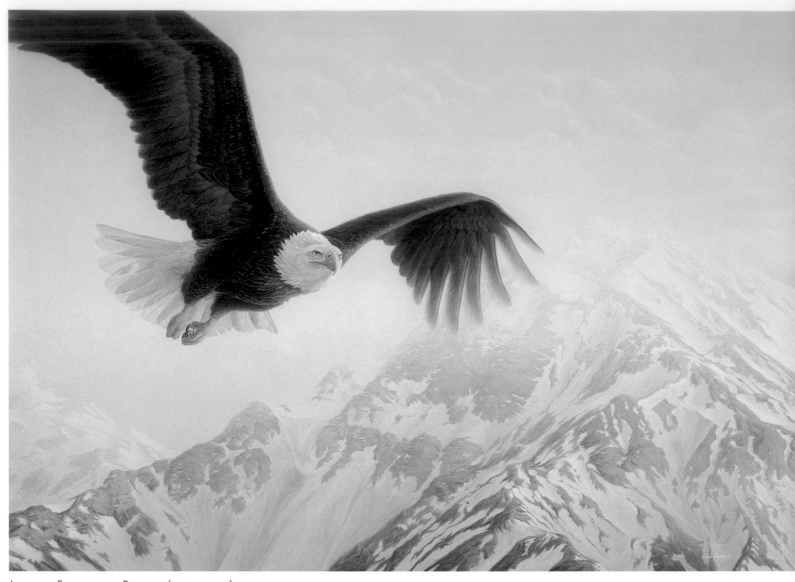

LAND OF EAGLES AND DREAMS (BALD EAGLE)
acrylic on composition board, 33" x 48" (84cm x 122cm)

Linda Rossin

FLYING ON DREAM-LIKE HEIGHTS

While in Alaska during the spring, I found the patterns of melting snow and the dream-like atmosphere of early morning particularly interesting. These elements were at the core of my composition. Although bald eagles remain close to food sources, they can fly to amazing heights. I manipulated negative and positive space around the eagle. I also indicated a forward wing motion to reflect the mountain shapes. To capture the warm morning light, I used a flesh-pink base as a ground. Primary colors plus white made up the rest of my palette, with subtle shifts in color temperature. I worked from dark to light, pushing back the patterned mountains while simultaneously thickening the atmosphere. I used looser brushstrokes except on the eagle's determined expression.

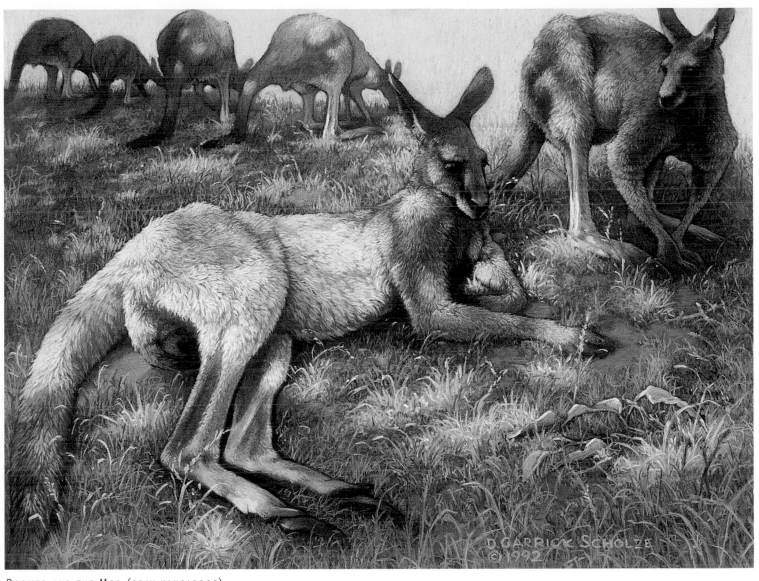

BOOMER AND THE MOB (GRAY KANGAROOS)
pastel on Crescent board, 21½" x 29" (55cm x 74cm)

Diane Garrick Scholze

PORTRAY ANIMALS' HUMOROUS ATTITUDES

Animals have definite personalities reflected in their body positions, movements and interactions. Observe this family group of gray kangaroos in Brisbane, Australia. The large dominant male, or boomer, holds the leadership position. However, when confronted with danger, it's every joey (young kangaroo) for himself! The females, or does, try to keep the peace. Composition is a major concern in this piece. The position of the large male with his great and curvaceous tail dictates the position of the smaller female, who seems concerned. The lineup of other mob members with their backsides to the situation sets up a rhythmic pattern that leads the eye into the boomer's contemplative (or pouting) face. Comical in body configuration, language and actions, kangaroos make most delightful subjects.

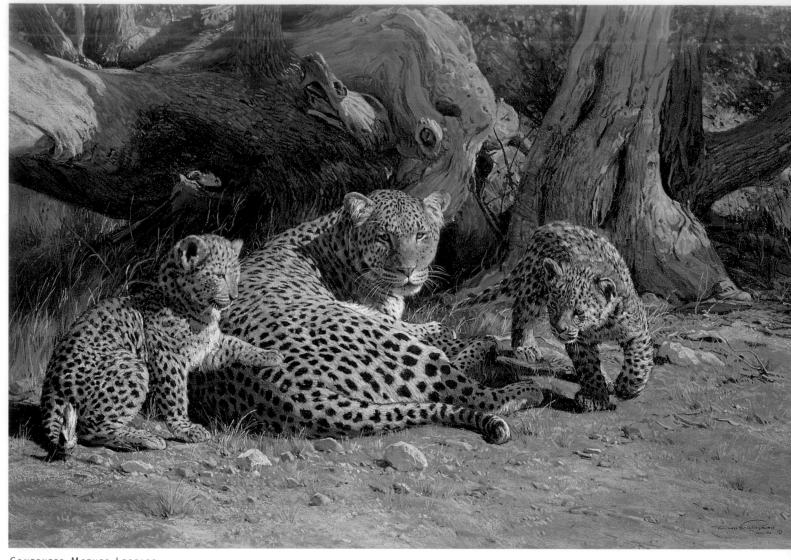

CONTENTED MOTHER LEOPARD
pastel on Canson paper, 28" x 42" (71cm x 107cm)

Dino Paravano

MOTHERHOOD IN THE WILD

Leopards are elusive creatures rarely seen in the wild, so it is a great thrill when you do see them; doubly so when one comes across a female with cubs. I think this scene defines the essence of motherhood. The cubs bite, nudge and walk all over the mother who, ever tolerant, remains composed and relaxed throughout. After a number of sketches and drawings, I decided to do this in pastel using bisque-colored paper, because it blended with both the cats' fur and the ground. The paper's color, tone and texture influence the overall harmony of the piece.

John Banovich

PATIENCE IS REWARDED

Patience is necessary when waiting to watch a giraffe bend down to drink. Giraffes only move when completely sure no predators wait in ambush. First they spread their legs apart. Once in the spread-eagle position, they cannot immediately move their approximately three-ton torsos. The giraffe is able to whip its head up and down because special valves in its neck veins keep it from getting dizzy. Its heart weighs forty times more than a human's and pumps ten times as much blood. Although its neck is over seven feet long, it only has seven bones (the same as humans or even mice), but each bone is up to one foot long. One evening in Namibia, I witnessed twelve giraffes as they made their way to a water hole to drink. Some were more cautious than others were. The composition I chose is one of tension. Only the ripples in the water express movement. I found the reflected pattern of the giraffe's torso being interrupted by the movement of the surface of the water most interesting.

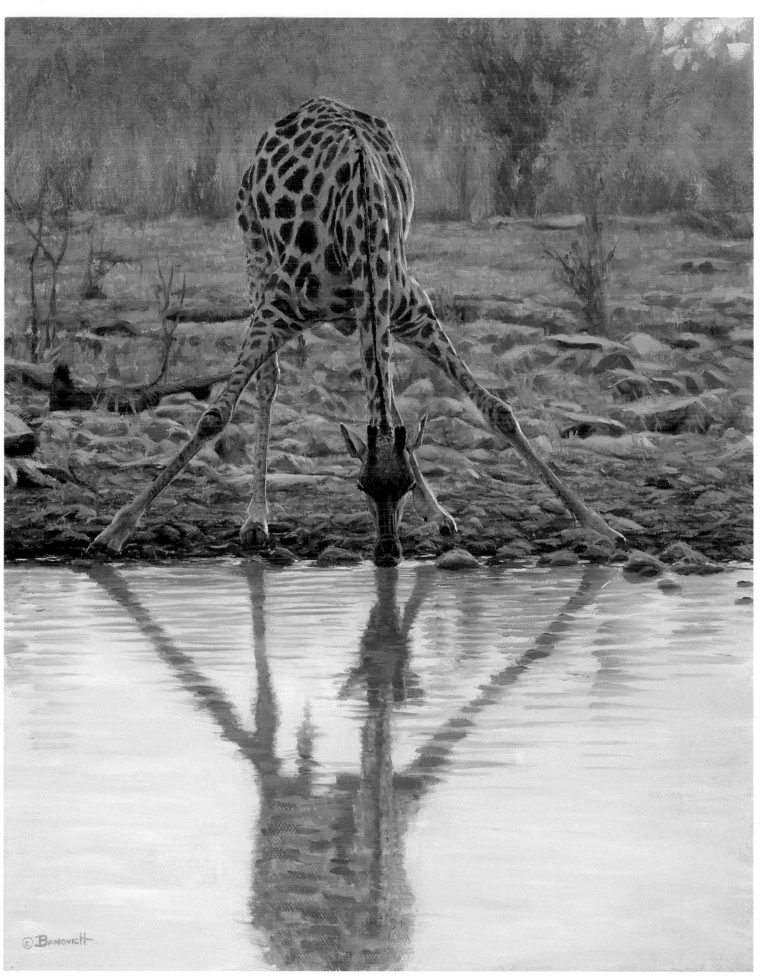

THE LONG DRINK (GIRAFFE)
oil on linen, 14" x 11" (36cm x 28cm)

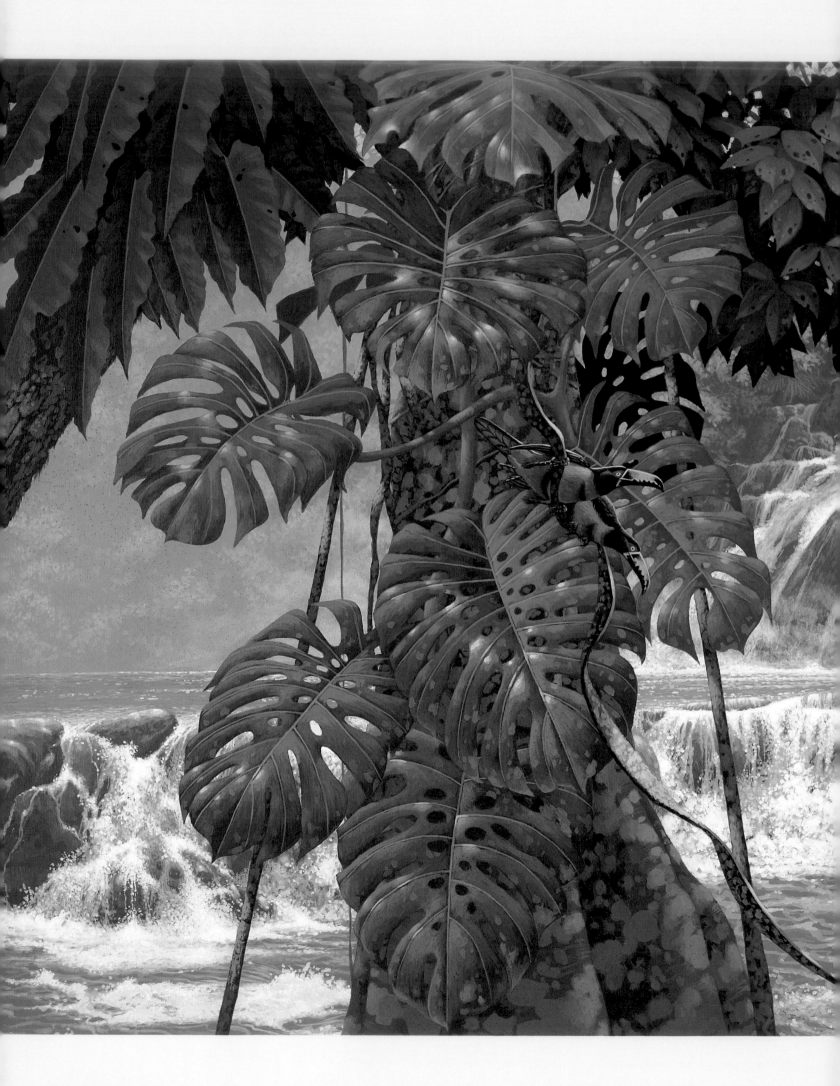

FEATURE THE

Habitat or Environment

The paintings in this chapter pay special attention to the environment. They may show an exotic environment, or perhaps simply concentrate on the features of a habitat, showing how wildlife fits into and participates in the environment.

A place of extraordinary beauty lies deep in the jungles of southern Mexico. A place of cascading water and turquoise pools fringed with white froth; a place unspoiled by humans. A place called Agua Azul!

—RICHARD SLOAN

AGUA AZUL (COLLARED ARACARI)
acrylic, 30" x 40" (76cm x 102cm)

VERREAUX'S SIFAKA
acrylic on illustration board, 18" x 24" (46cm x 61cm)

Carel Pieter Brest van Kempen

A PLACE OF UNIQUE FLORA AND FAUNA

Madagascar is one of my favorite places on earth. Famous for its unique wildlife, its flora is also one of the planet's richest. For a land mass of modest proportions, the island's climatic diversity is surprising. The high interior mountains tend to draw precipitation away from the western lowlands. The result is a number of extremely dry habitats occupied by a riot of bizarre plant species found nowhere else. The western edge of the central plateau has magnificent formations of sandstone and jagged limestone known as "tsingy." The vegetation here is deciduous scrub land with a number of spectacular trees. This region is also the home of Verreaux's sifaka [sh'fock], one of the most elegant of the Madagascar lemurs. These primates typically cling to vertical trunks and leap powerfully from one tree to the next. Other creatures portrayed in this piece are ring-tailed lemurs, Madagascan kestrel, common day gecko, Namaqua dove, and Oustalet's chameleon. The effects here were achieved with a detailed underpainting of Raw Umber covered by successive layers of transparent glazes and details.

SAMBURU BACHELORS (AFRICAN ELEPHANTS)
acrylic on Masonite panel, 13" x 19" (33cm x 48cm)

Jim Beaudoin

PORTRAY A DUSTY GOLDEN GLOW

To escape the harsh, arid semidesert of Samburu Game Reserve in Kenya, a pair of bachelor bull elephants wander slowly through the forest along the Ewaso Nyiro river. This corridor of riverine forest with its acacia trees and unique doum palms provides welcome relief from the parched bush country. We watched them as they occasionally reached up and pulled branches down. Because of all the dust in the air, a golden glow bathed the entire scene. I wanted to capture the mood of contented companionship that radiated from these old comrades. The foreground spray of borassus palm contributed a sense of scale and drama as well as a sense of place. To communicate my emotional response to the scene, I tried to apply the paint somewhat loosely with bigger brushes and wedges of plastic sponge. I hoped to depict the personality of the animals as well as their outward appearance.

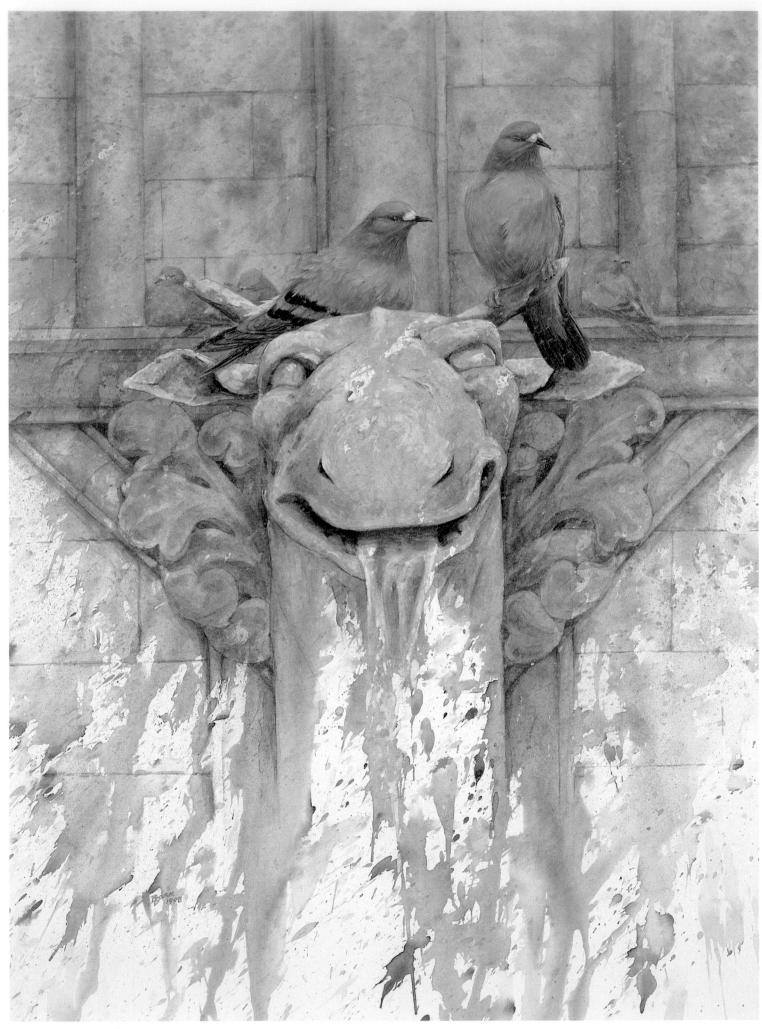

THE ROOST (PIGEONS)
watercolor and gouache on hot press watercolor board, 19" x 15" (48cm x 38cm)

INDIAN TIGER FIRST IMPRESSION
acrylic on paper, 12" x 16" (30cm x 41cm)

Charles Timothy Prutzer

PAINTING ON LOCATION IN THE BAMBOO

In 1997, I went to Madhya Pradesh, central India, to paint the tiger from life. After I located the tiger, one of the challenges on the project was to balance a sketchbook and draw while seated on the back of an elephant. Even when the elephant stands still, it constantly adjusts its weight. I gave special attention to the tiger as an inseparable part of the environment. After I made the field drawings from the elephant's back, I executed the painting from memory on heavyweight, hand-tinted rag paper while seated in a blind in the jungle. Painting in the bamboo while I breathed in the very air of the jungle added to the painting's authenticity.

Beatrice Bork

BIRDS ADAPT TO MANMADE ENVIRONMENT

Some animals—particularly birds—have been able to adapt to the manmade environment. In *The Roost*, I wanted to convey how these birds use the structure and color of the architecture for camouflage, as well as to depict a little irony. Gargoyles were at one time believed to ward off evil spirits. Where people once found spiritual refuge, the birds find safety from predators in the architecture.

FREAK WAVE (SNOWY EGRETS)
oil on Masonite, 22" x 28" (56cm x 71cm)

Ulco Glimmerveen

A SEASHORE SETTING

I have spent quite some time sitting dreamily at seashores all over the world, on sand or rocks, watching the waves. The repeated sounds of the water have the power to hypnotize—the incessant movement of liquid forms, the constant change of shape and light, the patterns of foam—until a freak wave appears to shake one's attention. As a boy I greatly enjoyed these larger-than-average waves as I tried to defy them. For the apparently fragile snowy egrets, freak waves are merely a nuisance that disturb their patrol for food. No big deal. They simply fly up and settle down a bit at a greater distance. With rather thin mixtures of oil paint and Liquin medium over a sketch on gessoed Masonite, I presented some of these elements. Different kinds of light pass through and over the liquid shape of the wave. There are patterns in the foamy water. The nearer egret has just discovered an edible item, while the larger-than-usual wave catches the other's attention. This interaction between environment and birds evokes several questions. Will the egrets fly or defy? Will the edible item survive or die?

REFLECTIONS OF THE TAJ (BLACK-WINGED STILT)
transparent watercolor on Crescent watercolor
board #114, 18" x 28" (46cm x 71cm)

David Rankin

A UNIQUE VIEW OF A FAMOUS MONUMENT

Over the years I have done many paintings of the fabled Taj Mahal in Agra, India. If you visit the Taj and venture down along the Yamuna River, you will notice hundreds, even thousands, of various water birds working the shallow waters. I focused on the stilts with the Taj Mahal's reflection shimmering in the first light of dawn. To get this view I had to actually wade across the river to the vast sandbar that lines the north side of the Yamuna as it curves eastward along the back of the Taj ramparts. In the field I constantly look for natural abstraction (the term I have come up with to better describe my attempt to paint realistic subjects based on abstract designs found in nature). On location in India, I do many field sketches of bird postures, architectural shapes and painting ideas. I also take lots of 35mm slides; on some trips I have taken over one hundred rolls. I now also take footage with my camcorder; I can freeze frames on a big screen back home to sketch details with ease. I wanted the stark white bird shapes to stand out sharply against the water. Therefore, I masked the birds before I ran a wash of light Cadmium Orange over the whole surface and then other colored washes. After all this dried, I laid in the reflected shape of the Taj itself. I removed the frisket, then painted the birds and their reflections. The only black is in the birds. The Taj reflection is a dark, warm, pinkish gray. This separates the birds from the reflected surface and helps build the juxtaposition of visual planes.

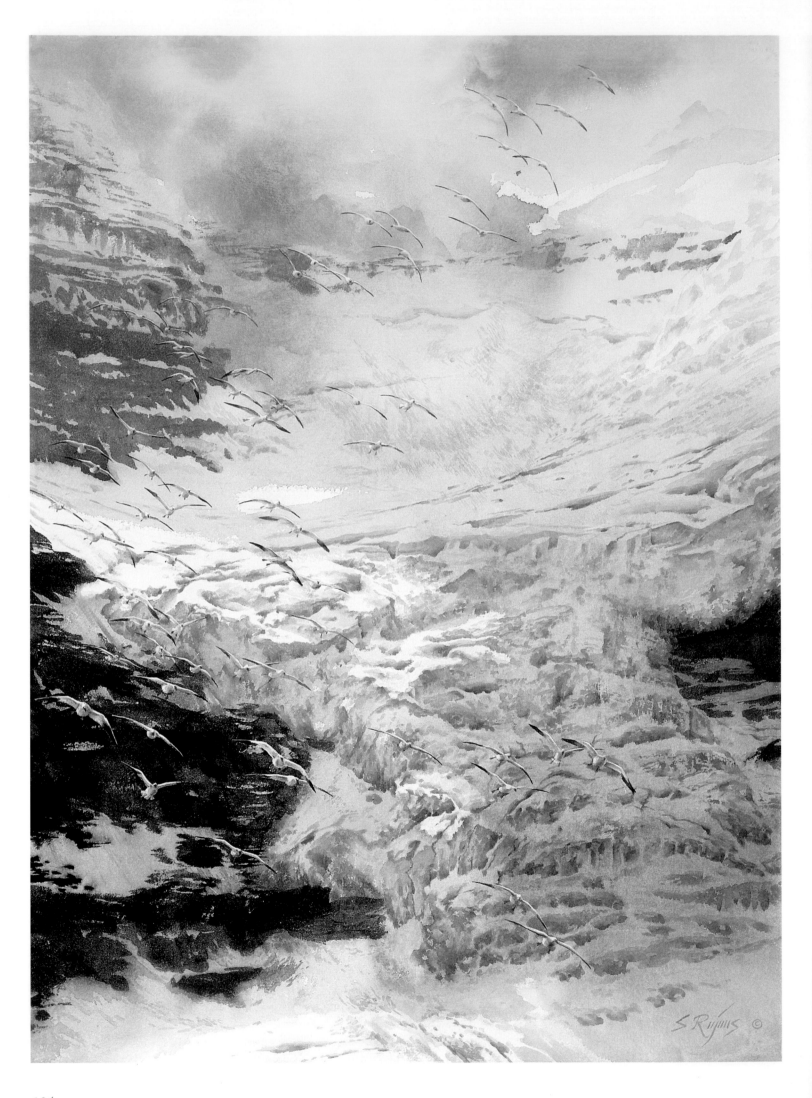

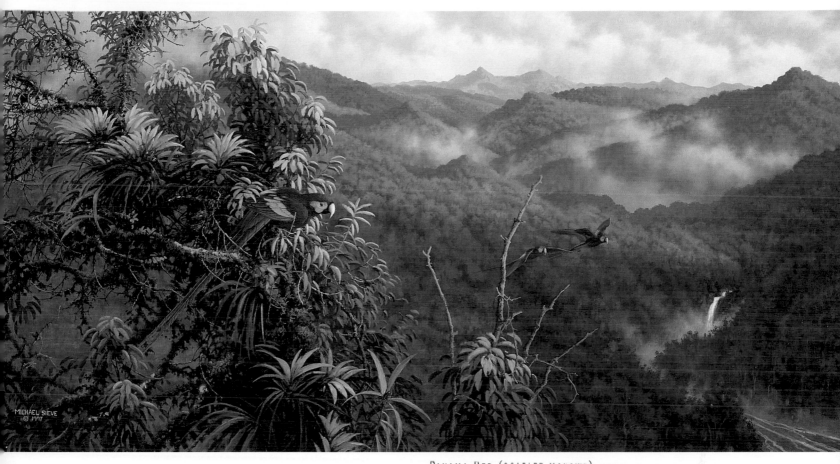

PANAMA RED (SCARLET MACAWS)
oil on canvas board, 20" x 42" (51cm x 107cm)

Michael Sieve

A SHOCKING COLOR AGAINST A COMPLEX ENVIRONMENT

Recently my photo buddy and I traveled to the Central American rain forests in search of macaws and toucans. This is a difficult and complex environment to understand. The number of plant species and their density is hard to comprehend. We searched in Costa Rica for many days before we finally located and photographed the birds near the Panama border. We photographed a pair of macaws in several places, including a huge hollow tree and near the coastal mangrove swamps where they spend their nights. The outrageous brilliance of these birds against the intense green background of forests and hills is a sight that I will never forget. I chose this particular foreground tree because of its biological complexity; bromeliads, vines, orchids, figs and much more all use this single tree as their support.

Sharon Rajnus

VIEW A POWERFUL LANDSCAPE FROM ABOVE

Two factors combined to create this painting: a powerful landscape along a northern migration route and the multitude of snow geese that miraculously make the trek each year. *Cascading Snows* is one in a series on the Far North. The images of this land are powerful and timeless. The wildlife flourishes and multiplies against tremendous odds. It is this contrast that intrigues and inspires me. Family travel in Alaska and Canada in our small airplane has provided abundant painting material. The particular colors of glacier, snow and ice captured me long ago. I find watercolor the perfect medium to render the crispness of the scene and the flavor of that particular landscape.

CASCADING SNOWS (SNOW GOOSE)
watercolor on Arches 300 lb. rag paper,
30" x 22" (76cm x 56cm)

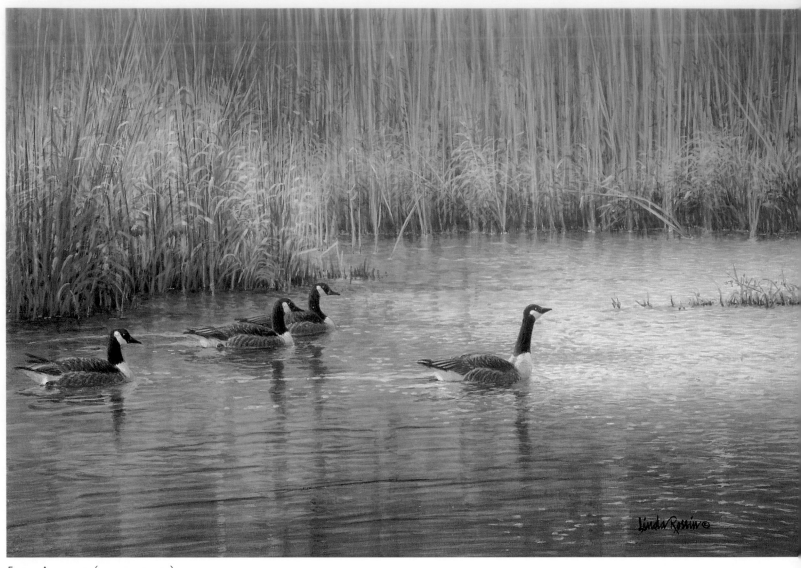

Early Arrivals (canada geese)
acrylic on composition board, 6 ½" x 9 ½" (17cm x 24cm)

Linda Rossin

VERSATILE HABITAT
COMES ALIVE AT SUNSET

Located on the eastern flyway, Brigantine is one of New Jersey's
bird-watching hot spots. Habitats vary from woodland to shore,
offering both fresh and salt water. Dramatic natural light exists in
one area or another almost any time of day, making this sanctuary
an ideal place to paint. One day in late February, a flock of geese set
down on this freshwater pond. As I observed them, the sun was
slowly setting. All of a sudden, the tall grassy reeds came to life and
glowed. It was that brief moment that ultimately inspired this work.
Thin layers of scumbling and glazing kept the overall habitat soft. I
used opaque paint on the lightest lights of the reeds to achieve that
special glow. To separate the geese from their surroundings, I selec-
tively applied opaque paint to their necks and backs.

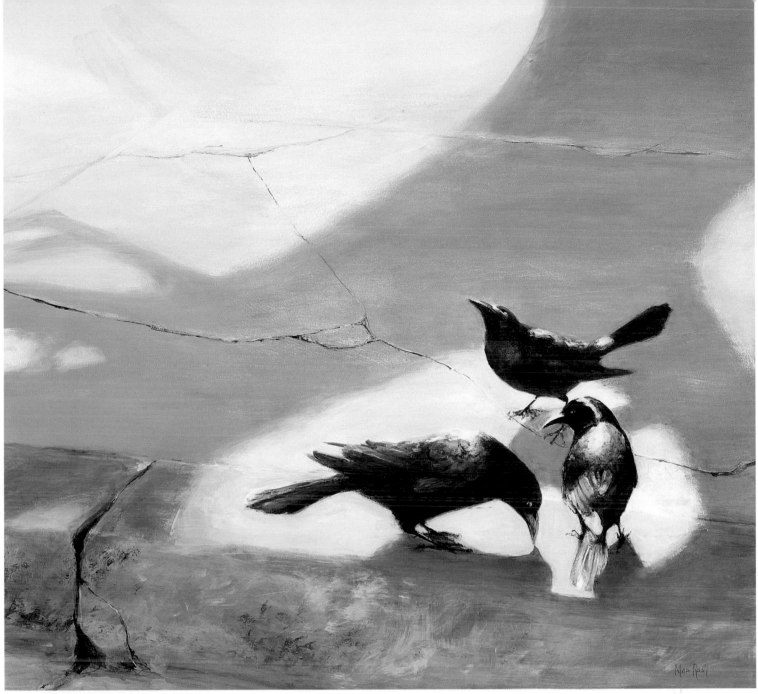

YELLOW CURB (EASTERN GRACKLES)
acrylic on Masonite, 30" x 32" (76cm x 81cm)

Mae Rash

URBAN ENVIRONMENT
PROVIDES NEW VISUAL CONCEPTS

Yellow Curb is one in a series entitled *Street Birds* that shows common birds in the urban environment. If one cannot travel to exotic places to see animals firsthand, one may find wildlife just as interesting outside the front door. Asphalt and cement have become a natural environment for numerous species of birds, providing new visual concepts to experiment with. The challenge in this painting was the composition. The bright yellow curb is a strong diagonal running directly into the lower right corner (usually an artistic taboo). The dark grackles on top give more weight. The counter balance was the use of the strong light broken by a tree's shadow. Painting the shadow of the tree and not the tree itself extends the viewer's imagination to include what is not there. I painted the dark iridescent birds with iridescent acrylics. I used many shades of yellows, grays and purples to describe the bright, flat yellow of a real curb. Cracks in the sidewalk and a broken curb soften the straight, angular lines to complement the forms of the grackles.

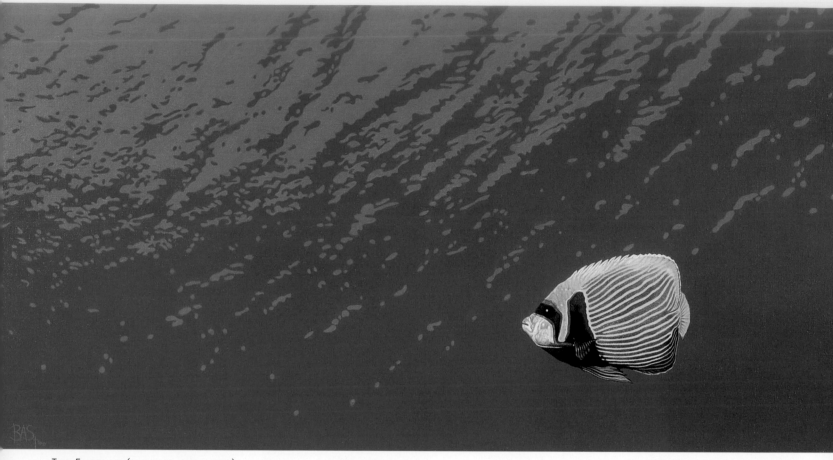

The Emperor (emperor angelfish)
oil on canvas, 20" x 40" (51cm x 102cm)

BAS

LIGHT GIVES FORM TO UNDERWATER ENVIRONMENTS

This is a very minimal painting, its simplicity being its strength. On a research trip to Sulawesi, Indonesia, where I concentrated on the underwater environment surrounding coral reefs, the uniqueness of this world of water impressed me. So different from our familiar land environment, this liquid atmosphere provides new visual stimuli. Light on the water's surface as seen from below gives substance and form to the endless expanse of sea. The light gives the most obvious proof of movement while unseen ocean currents carry the fish. Although a relatively small element, the emperor angelfish is prominent with its colorful and solid form. I used a wet-in-wet method with one glaze over the water to add richness of hue and depth to the water.

Andrew Kiss

ASTOUNDING HABITAT OF MOUNTAIN GOATS

I spend quite a bit of time in Banff National Park in Alberta, Canada, and very often see goats. I have taken many photos of these animals climbing extreme slopes, almost vertical; their footing astounds me. They traverse areas inaccessible to predators or humans and travel along with ease. Ice forms along the cliffs in late fall, before snow falls. The early daylight makes the ice translucent, and the mountain goat is a perfect subject to fit into the composition. It is a habitat in which goats can adapt and survive remarkably well.

On Ice (mountain goat)
oil on canvas, 24" x 14" (61cm x 36cm)

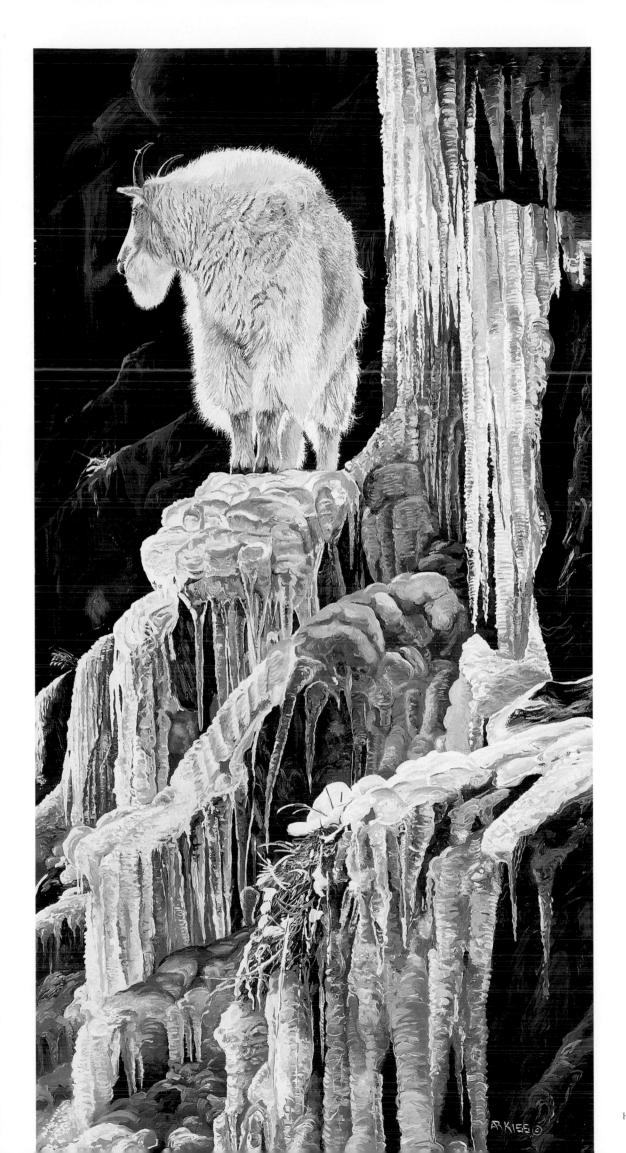

MANATEES
Linda Thompson, acrylic on canvas,
18" x 14" (46cm x 36cm)

Contact the following artists for information on prints, galleries and shows.

THOMAS ANDERSON
16341 Ace Lane
Huntington Beach, CA 92649
(714) 840-6844
p. 12 *Mergansers at Sunset* © Thomas Anderson

GLORIA MALCOLM ARNOLD, C.A.
301 E. Center St., Lee, MA 01238
p. 89 *Vigil by the Sea* © Gloria Malcolm Arnold

CHRIS BACON
Burlington, Ontario, Canada
(905) 637-0388
fax (905) 637-1457
p. 45 *Spring!* © Chris Bacon; received the Award of Excellence at the Art and the Animal 37th Annual Members Exhibition of the Society of Animal Artists, 1997

VICTOR V. BAKHTIN
Baraboo, WI
For commissions contact George Archibald, (608) 356-9462
p. 52 *Surfing* © Victor Bakhtin, private collection of John and Ruth Nugent
p. 60 *Spring Shadows* © Victor Bakhtin, private collection of Jun and Sandy Lee

JOHN BANOVICH
Banovich Art, 362 Latham Way
Camano Island, WA 98292
(360) 387-7287
p. 47 *Right of Way* © John Banovich, private collection of Dr. Phil and Janet Legget
p. 62-63 *Lion Eyes* © John Banovich
p. 81 *Extreme* © John Banovich
p. 94 *Heading for Deep Water* © John Banovich, private collection of Mr. and Mrs. Hugh and Judy Corrigan

CAPTURE THE ACTION
The challenge in underwater painting is to stop the action without stopping the viewer's anticipation of the next wave. Manatees are slow-moving, gentle mammals in a habitat that is often very hostile to them.
—LINDA THOMPSON

p. 125 *The Long Drink* © John Banovich, private collection of Mike and Dru Lieb

BARBARA BANTHIEN
127 Leland Way, Tiburon, CA 94920
p. 26 *October* © Barbara Banthien, collection of Mr. Gust Hronis

BAS
Horizons, Rest Bay Close, Porthcawl,
Great Britain CF36 3UN
Phone and fax 01656 783884
p. 14 *Feather and Form* © BAS
p. 138 *The Emperor* © BAS

JIM BEAUDOIN
1488 Blossom Lane, St. Paul Park, MN 55071
(651) 459-7129
p. 129 *Samburu Bachelors* © Jim Beaudoin, private collection

ALEJANDRO BERTOLO
1836 Tupper St.
Montreal, Quebec H3H 1N4
Canada
(514) 931-0458
p. 70 *Marsh Wolf* © Alejandro Bertolo

BEATRICE BORK
P.O. Box 572, Whitehouse Station, NJ 08889
p. 130 *The Roost* © Beatrice Bork

CAREL PIETER BREST VAN KEMPEN
P.O. Box 17647, Holladay, UT 84117
p. 82 *Call of the Monsoon* © Carel Pieter Brest van Kempen, collection of Carl and Paula Brenders
p. 128 *Verreaux's Sifaka* © Carel Pieter Brest van Kempen, collection of the artist

KENNETH H. BRONIKOWSKI
2106 W. Grange Ave., Milwaukee, WI 53221
(414) 281-7998
p. 35 *Great Blue Heron* © Kenneth H. Bronikowski
p. 57 *At First Light* © Kenneth H. Bronikowski

DIANE BURNS
P.O. Box 174, Half Moon Bay, CA 94019
p. 17 *Pas de Deux* © Diane Burns

JOHN BUXTON
4584 Sylvan Dr., Allison Park, PA 15101-2218
p. 102 *Shadows* © John Buxton and Paramount Press Inc., collection of Sarah Scott
p. 117 *Out 'n About* © John Buxton

KATHY CENCULA
761 Beach Place, Mundelein, IL 60060
(847) 566-7574
p. 13 *Life Lines* © Kathy Cencula Comer

JOHN CODY
The John Cody Gallery, 511 Parkway, Suite 113
Gatlinburg, TN 37738
(800) 433-1132
or
2704 Woodrow Court, Hays, KS 67601
p. 19 *Moon Moth of Borneo* © John Cody, collection of Mr. and Mrs. Joseph Russell

SHANE DIMMICK
P.O. Box 943, Evergreen, CO 80437-0943
p. 10-11 *Gaggle* © Shane Dimmick

KATHLEEN DUNN
Edgewood, WA
Douglas Gallery, 120 N. Wall St.
Spokane, WA 99201
(509) 624-4179, (800) 700-4179
Corbett Gallery, 459 Electric Ave., Suite B
P.O. Box 339, Bigfork, MT 59911
(406) 837-2400
www.natureartists.com/dunnk.htm
p. 113 *Blue Velvet* © Kathleen Dunn

EDWARD DUROSE
807 Terrace Dr., Roseville, MN 55113
p. 110 *Pilgrim Creek—Elk* © Edward DuRose

RANDAL M. DUTRA
p. 83 *Dust Devil—American Bison Bull* © 1998 Randal M. Dutra

MARK EBERHARD
913 Stanton Ave., Terrace Park, OH 45174
(513) 831-4049
eande@one.net
p. 15 *Grackles* © Mark Eberhard
p. 32 *Judge Not* © Mark Eberhard
p. 44 *Little Green Heron* © Mark Eberhard, collection of Sarah Scott

BETH ERLUND
22528 Blue Jay Rd., Morrison, CO 80465
p. 74 *I Could Be You* © Beth Erlund, collection of Mr. Charles Rodriquez

WALTER FERGUSON
P.O. Box 1530, Beit Yanai 40293, Israel
p. 66 *Old Man of the Forest* © Walter Ferguson

JANET FLYNN
J.D.'s Studio, 409 Sixth St., Baraboo, WI 53913
(608) 356-5785
p. 16 *Heads Up* © Janet Flynn

MARGARET FRANCIS, ACA
1110 Carroll Dr., Garland, TX 75041
(972) 278-7835
p. 34 *The Sun Seekers* © Margaret Francis

JOE GARCIA
P.O. Box 2314, Julian, CA 92036
(760) 765-2067
p. 23 *Odd Man Out* © Joe Garcia; included in the Birds in Art exhibition, Leigh Yawkey Woodson Art Museum, 1998

BERND PÖPPELMANN

Hemberger Damm 87, 48282 Emsdetten, Germany

(0) 2572 5112

fax (0) 2553 98348

p. 84-85 *Peregrine Over Town* © Bernd Pöppelmann

JULIO J. PRO

9811 Rathburn Ave., Northridge, CA 91325

(818) 349-0161

p. 112 *Zion's First Light* © Julio J. Pro; included in Arts for the Parks national art competition Top 100, 1996

CHARLES TIMOTHY PRUTZER

P.O. Box 49431, Colorado Springs, CO 80949

p. 131 *Indian Tiger First Impression* © Charles Timothy Prutzer

SHARON RAJNUS

30485 Transformer Rd., Malin, OR 97632

(541) 723-4371

p. 134 *Cascading Snows* © Sharon Rajnus, collection of Donald and Susan Smith

DAVID RANKIN

2320 Allison Rd., Cleveland, OH 44118

Phone and fax (216) 932-2125

p. 133 *Reflections of the Taj* © David Rankin, collection of Betty Treadwell

MAE RASH

12201 Blaketon St.

Upper Marlboro, MD 20774

(301) 249-3166

p. 80 *Truck Stop #2* © Mae Rash

p. 137 *Yellow Curb* © Mae Rash

GAMINI RATNAVIRA

Hidden Forest Art Gallery, 936 S. Live Oak Park Rd., Fallbrook, CA 92028

(760) 723-9256

www.biohaven.com/ratnavira, Gamini@tfb.com

p. 108 *Who's the Fairest?* © Gamini Ratnavira

KEVIN REDMAYNE

91 Oceanic Dr., Warana Beach, Queensland 4575, Australia

Phone and fax (07) 54932521

p. 20 *Sonoran Sunset* © Kevin Redmayne, collection of Mrs. Joan Watts

ANDREA RICH

706 Western Dr., Santa Cruz, CA 95060

darich@prodigy.net

p. 22 *Black-Crowned Night Heron* © Andrea Rich

p. 22 *Pileated Woodpecker* © Andrea Rich

SUEELLEN ROSS

1909 S.W. Myrtle, Seattle, WA 98106

(206) 767-6500

fax (206) 763-1028

p. 87 *Ruffled Bittern* © Sueellen Ross

LINDA ROSSIN

Linda Rossin Studios, 11 Cobb Rd.

Mountain Lakes, NJ 07046

p. 122 *Land of Eagles and Dreams* © Linda Rossin

p. 136 *Early Arrivals* © Linda Rossin

L. (LINDA) KENT ROUS

Cimarron Gallery, 311 E. Grand Ave.

Ponca City, OK 74601

(580) 765-3200

p. 71 *The Ol' Man* © L. Kent Rous

PATRICIA SAVAGE

816 Valerie Dr., Raleigh, NC 27606

p. 69 *Search is On* © Patricia Savage

DIANE GARRICK SCHOLZE

P.O. Box 358, Monmouth, OR 97361

(503) 606-0737

fax (503) 606-9025

www.natureartists.com/scholzdg.htm, www.fineartamerica.com

p. 65 *Out on a Limb—Koalas* © Diane Garrick Scholze

p. 123 *Boomer and the Mob* © Diane Garrick Scholze

LINDSAY SCOTT

fax (805) 648-4215

Scottart@west.net

p. 38 *The Dance* © Lindsay Scott

p. 90-91 *Ambush* © Lindsay Scott

MICHAEL SIEVE

Wild Wings, 50 Highway 61

Lake City, MN 55041

(612) 345-5355

p. 135 *Panama Red* © Michael Sieve; published as a limited-edition print by Wild Wings

VICTORIA SIMS

2496 Rudder Rd., Oceanside, CA 92054

p. 4 *Still...The Everglades* © Victoria Sims, collection of Ms. Sara Scott

RICHARD SLOAN

p. 1 *Morning Mist* © Richard Sloan

p. 78-79 *The City at Sunrise* © Richard Sloan

p. 126-127 *Agua Azul* © Richard Sloan

DANIEL SMITH

588 Limestone Rd., Bozeman, MT 59715

p. 31 *Ancient Mariners* © Daniel Smith

p. 109 *Hyacinth Macaw* © Daniel Smith

MR. DEE SMITH

9547 N.E. 306 Court, Salt Springs, FL 32134

p. 51 *The Suitor* © Dee Smith

p. 56 *Still Waters* © Dee Smith

SHARON STOLZENBERGER, OWS, SAA

P.O. Box 292524, Kettering, OH 45429

p. 16 *Vibrations* © Sharon Stolzenberger, private collection

FRANCIS EDWARD SWEET

F.E. Sweet Studios, 1402 Port Echo Lane

Bowie, MD 20716

(301) 249-6572

p. 72 *Bull Elephant* © Francis Edward Sweet

p. 73 *The Stare* © Francis Edward Sweet; displayed at Bennington Center for the Arts, Vermont

FREDERICK SZATKOWSKI

27 Erie Ave., Depew, NY 14043-3026

(716) 681-3213

p. 5 *Australian Bluewings* © Frederick Szatkowski

LINDA THOMPSON

c/o Nancy Clapp, 4300 Mink Rd.

Sarasota, FL 34235

(941) 359-2921

p. 140 *Manatees* © Linda Thompson; Judges' Merit Award, Ducks Unlimited 26th Annual Wildlife Show; published by Mill Pond Press, Venice, Florida

MICHAEL TODOROFF

31511 Capri Terrace #416

Westland, MI 48185

(734) 522-7646

p. 42 *Inner Circle* © Michael Todoroff

p. 46 *Clover* © Michael Todoroff

GIJSBERT VAN FRANKENHUYZEN

Hazelridge Workshop & Gallery, 7409 Clark Rd. Bath, MI 48808

Phone and fax (517) 641-6690

robbyn@netimation.com

p. 48-49 *Wildebeest* © Gijsbert van Frankenhuyzen; exhibited at Michigan State University Museum of Natural History

p. 58 *Mara Sunset* © Gijsbert van Frankenhuyzen; included in the Birds in Art exhibition, Leigh Yawkey Woodson Art Museum, 1997

PIETER VERSTAPPEN

Wildlife-Art, Kanaacdijk 3, 5768 Re Meyel, Netherlands

p. 40 *Weasel Hunt* © Pieter Verstappen

LINDA WALKER

1605 Sunnyside Rd. S.E., Bemidji, MN 56601

(218) 755-9217

p. 68 *Quills and Roses* © Linda Walker, private collection

SUE WESTIN

Gold Leaf Studios, 2237 Rte. 30

Dorset, VT 05251-9644

(802) 867-5565

p. 30 *Sun Life* © Sue Westin, collection of Gold Leaf Studios

CATHY LYNN WIER

2200 N.E. Twenty-fifth Ave.

Pompano Beach, FL 33062

(954) 943-0239

p. 116 *Resting Spoonbill* © Cathy Lynn Wier

VICTORIA WILSON-SCHULTZ

4333 Foxrun Dr., Chino Hills, CA 91709

Phone and fax (909) 606-4842

p. 39 *Princes of the Serengeti* © Victoria Wilson-Schultz, collection of Steve and Teresa Bailey

GARY H. WONG

Gary's Art Studio, P.O. Box 1522

Monterey Park, CA 91754

p. 105 *Garden Patrol* © Gary Wong, collection of the artist

Index